DEAD GROUND

DEAD GROUND

WAR AND PEACE:
REMEMBRANCE AND RECOVERY

A CULTURAL READING OF
MEMORYSCAPES FROM THE
GREAT WAR, 1914–1918

PAUL GOUGH

Sansom &
Company

First published in the UK in 2018
by Sansom and Company
A publishing imprint of Redcliffe Press Ltd.,
81g Pembroke Road, Bristol BS8 3EA

www.sansomandcompany.co.uk
info@sansomandcompany.co.uk

ISBN 978-1-911408-45-1

British Library Cataloguing-in-Publication Data

A catalogue record for this book is available
from the British Library

Cover and text design by Kit Tran
Page layout and typesetting by Kit Tran

Edited by Justina Ashman, Carina Beyer,
Ben Callinan, Lauren Carta, Madelaine Geary
and Alexandra Milne

Produced by the Bowen Street Press,
RMIT University, Melbourne
Printed and bound in Australia by Valiant Press

Front cover image:
Paul Nash
Rain: Zillebeke Lake
1918
Lithograph on paper
47 × 61 cm
© Imperial War
Museums
(IWM: ART 1603)

Back cover image:
Muirhead Bone
The Battle of the Somme
1918
Lithograph on paper
50.5 × 37.8 cm
© Imperial War
Museums
(IWM: ART 6844)

This book was supported in part by
the Australian Government through
the Australian Research Council's
Discovery Projects funding scheme—
project DP170101912: 'World-Pictures:
Path-finding across a Century of Wars,
1917–2017', a research and practice
collaboration with Lyndell Brown,
Charles Green and Jon Cattapan,
2017–2019.

Australian Government
Australian Research Council

For Izzy

CONTENTS

INTRODUCTION

AFTER THE BATTLE HAS MOVED ON

Paul Nash
After the Battle
1918
Watercolour and ink on paper
71.2 × 83.2 cm
© Imperial War Museums
(IWM: ART 2706)

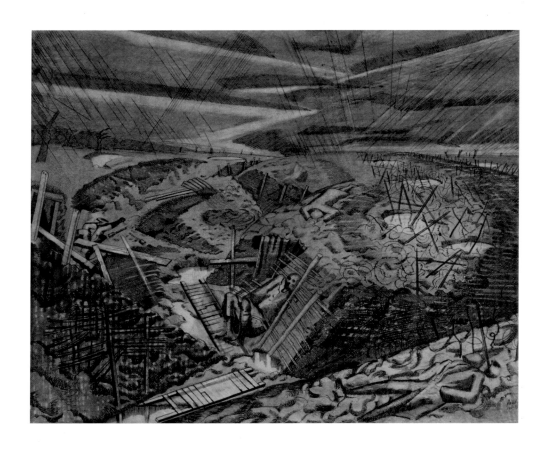

In the middle year of the First World War (1914–18), across a fifteen-mile arc of French countryside that stretched from the tiny village of Gommecourt in the north to the wide marshes of the River Somme in the south, a vast volunteer army of eager young British and Empire civilian–soldiers had been concentrated into a network of frontline trenches. On the cloudless morning of 1 July 1916 at 7.30 am, 100,000 of these troops clambered up ladders and set out to cross no-man's-land at walking pace. Very few reached their first objective. An immense number were systematically mown down by well-concealed German machine guns, which had been largely untouched by a week-long barrage of ineffective British artillery fire. Over 57,000 British casualties were incurred on that first day of battle, some 20,000 of them fatalities. The First of July 1916 ranks as one of the most tragic overtures to any military campaign ever recorded. [1] The next day, however, the remnants of the battered infantry battalions climbed out of their trenches and dugouts once more and engaged in five further months of brutal battle. [2]

Today the benign landscape is peppered with memorial stones, plaques and near countless military cemeteries, those 'silent cities' that are strung out along the edges of the old Western Front like the beads on a rosary. [3] Incredibly, nature has done its best to conceal the trauma of the dreadful conflict that raged across the Picardy countryside during the second half of 1916 and then again in the spring of 1918. What was once a mangled pastoral is now a serene landscape of gentle valleys, long slopes and broad downs dotted with small copses.

During the war, one young British officer, Alexander Douglas Gillespie, wrote from the trenches that when the war ended there would be no need for monuments and memorials. Instead, the governments of France and England should construct one endlessly long avenue from the Vosges to the sea. 'It would', he wrote, 'make a fine broad road in the "No Man's Land" between the lines, with paths for pilgrims on foot, and plant trees for shade, and fruit trees so that the soil should not be altogether waste'. [4] Either side of this *Via Sacra*, Gillespie suggested some of the shattered farms and houses might be left as evidence of the terrible conflict. The former inhabitants of those farms, villages and homes

(1)

Martin Middlebrook and Mary Middlebrook, *The Somme Battlefields: A Comprehensive Guide from Crecy to Two World Wars*. Harmondsworth: Penguin, 1991. See also Jay Winter, *Sites of Memory, Sites of Mourning: The Great War in European Cultural History*. Cambridge: Cambridge University Press, 1995.

(2)

There is now a huge historiography building on early pace-setting research by Bill Gammage, John Terraine and Martin Middlebrook. Historian Saul David's extensive review in the *Daily Telegraph* (29 June 2016) is a useful summary of the 1916–2016 centenary publications by Gary Sheffield, Randall Nicol, Robert Kershaw, Richard van Emden and Hugh Sebag-Montefiore.

See: www.telegraph.co.uk/books/what-to-read/battle-of-the-somme-centenary-the-best-new-history-books/.

A Pan MacMillan compilation drawn up in the same year takes a broader look and includes works by Mandy Kirkby and Gaby Morgan, as well as novels by Rebecca West and Pat Barker.

See: panmacmillan.com/blogs/history/somme-books-military-history-centenery.

(3)

See Denis Winter, *Death's Men*. London: Penguin, 1978.

(4)

Alexander D. Gillespie, 'The Sacred Way', *Letters from Flanders*. London: Smith, Elder and Co., 1916. Also quoted at length in Edward Bolland Osborn (ed.) *The New Elizabethans*. London: The Bodley Head, 1919, pp.112–114.

had other ideas and they diligently reclaimed the land from the filthy desecration of war, returning it to the healthy and placid downland that it is now.

Today the telltale signs of the static warfare are readily apparent: there is an absence of mature trees; inside the perimeter fence of any copse or woodland the earth is still convulsed, cratered and broken. After the spring ploughing, long smears of chalky soil indicate the places once dug out and occupied by the inhabitants of the deepest trenches and tunnels. Regular visitors and pilgrims are intimately acquainted with this militarised topography. It is a 'memoryscape', a land drenched in traumatic narratives, a tragic text that takes little decoding.[5]

'Those Somme pictures'

The first official British war artist of the Great War to attempt to decode this ravaged land was the Scottish printmaker Muirhead Bone, an etcher more used to describing industrial and architectural scenery than the sites of military conflict. Known to the art world as the 'London Piranesi', he had a reputation for highly detailed and accurate renditions of complex subjects—bustling shipyards, cathedrals under construction, dense cityscapes. After some months of bureaucratic wrangling, he joined the British army on the Somme in mid-1916, many months after the French and German governments had already commissioned painters to depict the face of modern war.[6]

Bone was a prolific worker. During a one seven-week tour of the old Somme battlefield in the late summer of 1916 he made over 150 finished drawings. By 1917 he had produced 500 charcoal, ink and wash images for the government—an effort that drove him to near collapse. There was an insatiable demand for his work. It reproduced well in black and white and was widely distributed in print portfolios, booklets and pamphlets aimed at influencing public opinion in neutral countries, such as the US.[7]

As much as he would have liked to feel more connected to the realities of war, Bone travelled deep behind the frontlines in a chauffeur-driven car, stopping frequently to render the extraordinary scenes that lay before him. Given the scale of the devastation, it was at times a frustrating, almost

[5]

Hugh Clout, *After the Ruins: Restoring the Countryside of Northern France after the Great War.* Exeter: University of Exeter Press, 1996.

See also Rose E. Coombs, *Before Endeavour Fades.* London: After the Battle Publications, 1976.

[6]

The phrase 'Those Somme pictures' comes from a letter written by Wilfred Owen (19 January 1917) quoted in Edmund Blunden, *The Poems of Wilfred Owen.* London: Chatto and Windus, 1931. Others felt rather differently. The young painter John Nash wrote from the trenches in 1917 to ask his girlfriend: 'Have you seen Muirhead Bone's drawings out here? I think they are good, how I wish I could be allowed to do the same.' Letter xiv, *Love letters from the Front: John Nash to Christine Kuhlenthal, France 1916–1917.* Allen Freer and Peter Widdowson (eds.)Gloucester: The Cyder Press, 2007, p.37.

[7]

Paul Gough, 'Fact and Fiction on the Western Front: Muirhead Bone on the Somme', in Paul Gough, *A Terrible Beauty: War, British Artists and the First World War.* Bristol: Sansom and Company, 2010, pp.43–70.

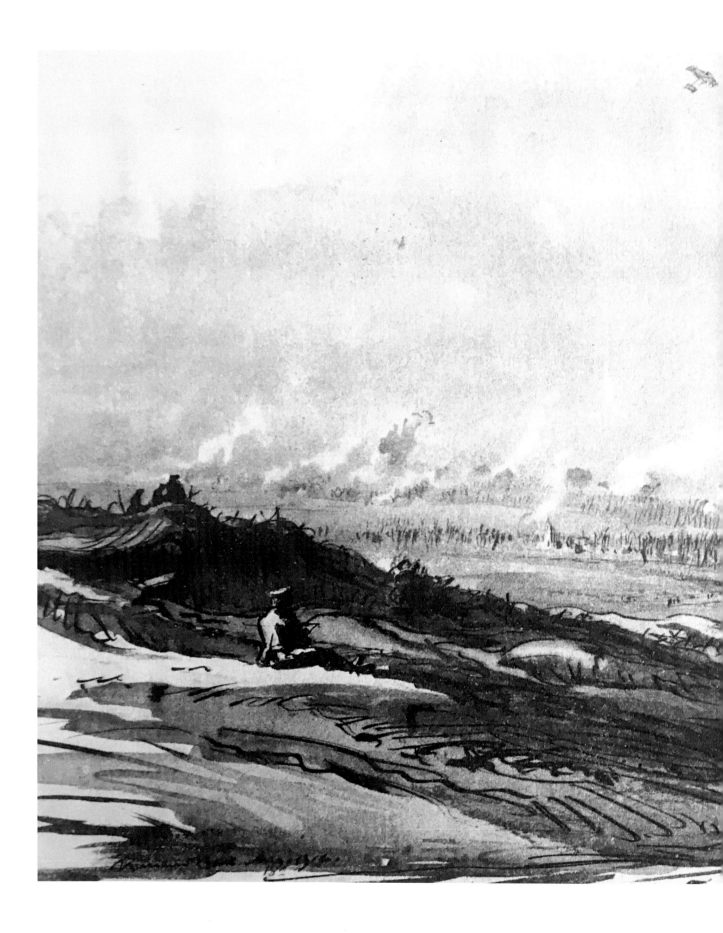

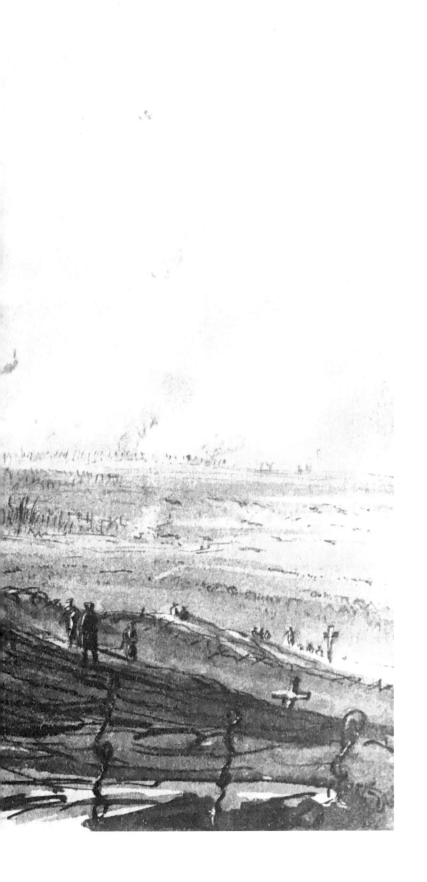

Muirhead Bone
The Battle of the Somme
1918
Lithograph on paper
50.5 × 37.8 cm
© Imperial War Museums
(IWM: ART 6844)

Muirhead Bone
The Chateau, Foucaucourt
1918
Lithograph on paper
50.5 × 37.8 cm
© Imperial War Museums
(IWM: ART 68448)

impossible, task. His eye was untrained in describing the voids created by modern war: 'I'm afraid that I have not done many ruins', he wrote to his sponsors in Whitehall, 'but you must remember that on the Somme nothing is left after such fighting as we have had here—in many cases not a vestige of the village remains, let alone impressive ruins!' [8]

In peacetime no subject matter, however technically complicated or vast in scale, had daunted Bone. But on the Western Front he struggled to find the true face of modern war; it was elusive, distant and nocturnal. By daylight the battlefield, or what he could safely see of it, was empty and deserted, with tens of thousands of combatants secreted deep in their troglodyte worlds. At night it was crowded with activity but simply too dark and dangerous to draw. Despite his tireless traipsing across the front and his unwavering diligence, some critics derided his efforts. Of his panoramic sketches of a distant artillery barrage, one critic scoffed, 'It is like looking at war through the wrong end of a telescope.' Indeed, so delicately detailed were his drawings of the empty battlefield, that his work was summarily (and rather unfairly) dismissed as being 'too true to be good'. [9]

In the years and decades after the Armistice, artists who roamed the quietened battlefields faced the same challenges. How could one capture the elusive impressions of conflict in a land that has now sealed itself against its traumatic past? How could any artist re-imagine the scale of the devastation that had been heaped upon a once pleasant landscape? How might any painter, poet or photographer seek out and identify the salient features of a truly historic terrain? It takes great discipline and a forensic approach to picture-making to tease out the hidden motifs of the Picardy and Flanders fields or the crumbling slopes of the forgotten Macedonian front and the creeks and ravines in Gallipoli.

On the Somme, in spite of the difficulties of working *en plein air* in hostile circumstances, Bone stubbornly persisted at his commission. Despite the indifference of the critics, his charcoal, ink and wash works were widely reproduced in official publications such as *The Old Front Line*. His objective graphic style reproduced well on the war-rationed newsprint of the day. They were highly valued

[8]
Muirhead Bone to Ernest Gowers, correspondence, Imperial War Museum, London (IWM), Department of Art, M999, Part 1, 30 September 1916.

[9]
Manchester Guardian, 30 August 1917.

C.R.W. Nevinson
La Mitrailleuse
1915
Oil on canvas
77.7 × 67 cm
© Tate, London 2018

as pictorial propaganda and exhibited in the UK and the US where tens of thousands of visitors queued to see them. Notwithstanding the frustrations of his military service, the fugitive nature of modern warfare and the petty criticisms of the press and *cognoscenti*, Bone had achieved the revered status of an officially sanctioned commissioned artist with military rank and access to the field of battle.

Hundreds of other British artists clamoured for that same status. They flooded the National War Museum (the forerunner of the Imperial War Museum) with requests to buy their work or to give them a coveted 'sketching permit' to visit the front. Artists from all quarters and of all styles wanted to see for themselves the battlefields (as one painter rather inelegantly put it) 'before they were all mended and tidied up'. 'I missed seeing the aftermath of the volcanic eruption at Messina in 1909', wrote another earnest painter as he pleaded for permission to see the ruins on the Somme or the battered landscape of the Salient at Ypres for himself. Like most of the others in the great pile of beseeching enquiries, his ambition would remain unrequited. By this date the government-supported schemes for commissioning official war artists had opted for artists with significant frontline experience. Among these preferred painters were young modernists such as Christopher R.W. Nevinson, who had already produced some of the most extraordinary representations of war ever seen in Europe. When *La Mitrailleuse* was exhibited in London in 1916, crowds thronged to see it. Critical and popular acclaim was unanimous. 'The best and the most ruthless illustration of the menace of this deadly machine war ... produced to date', wrote Charles Lewis Hind as he saluted the 'self-sacrificing automata' depicted so efficiently by Nevinson. [10] No less a figure than the eminent painter Walter Sickert revered it as 'the most authoritative and concentrated utterance on war in the history of painting'. [11] Despite his bombast and his unflagging self-advocacy, Nevinson knew how to create a taut image. This small but powerful canvas of a French machine-gun team was the synthesis of his precocious talents. It combined cold metallic colour, a tight geometric framework and a bold design to proclaim a powerful and unprecedented vision of modern warfare. Not only has the soldier become 'dominated by the machine', as Nevinson predicted would

[10]
Richard Ingleby, 'Utterly Tired of Chaos: The Life of C.R.W. Nevinson', *C.R.W. Nevinson: The Twentieth Century*. London: IWM, 1999, p.16.

[11]
Walter Sickert, *Burlington Magazine*, September/October 1916.

(12)

C.R.W. Nevinson, *Paint and Prejudice*. New York: Harcourt, Brace and Company, 1937, p.107, pp.72–74.

(13)

Paul Gough, 'A concentrated utterance of total war: Paul Nash, C.W.R. Nevinson and the challenge of representation in the Great War', in Joanna Bourke (ed.) *War and Art: A Visual History of Modern Conflict*. London: Reaktion, 2017, pp.270–282.

(14)

IWM Department of Art file 303/7.

happen, the soldier has become the machine. [12] Men and machine have merged into *automota*: each soldier sacrificed as integral components in the industrialised and mechanised forces of war. Along with his contemporaries—Paul Nash, Percy Wyndham Lewis, William Roberts, David Bomberg, all of whom had served at the front—Nevinson created a newly loud and jagged aesthetic that was in lock step with the new machine age. [13]

As these virile contemporary painters began to assert their influence, administrators of the official war art schemes were inundated with requests from artists who craved official accreditation or wished to sell war-related artworks. Algernon Mayow Talmage—Royal Academician, silver medallist at the Paris Salon and bronze medallist at the Pittsburgh International exhibition—was one such artist. In May 1917 he proudly presented his credentials to the war museum:

> *No picture that I am aware of has been really studied on the spot so as to get the real environment and atmospheric conditions and phenomenon. I have been painting in the open all my life and I feel that were it possible to give me opportunities to study this subject I could paint a picture which would be a value as a record and venture to hope as a work of art which would be something entirely different to the usual hackneyed and unconvincing picture.* [14]

Like so many others he was summarily turned down. The artistic order had moved on; he and his like had been left behind. Yet that is not the full picture. Their unrequited ambition raises a number of questions that are still relevant today. What was it that motivated these painters to want to travel to the place of war? What were they seeking in those desperate scenes of conflict? Months and years after the Armistice, how could they hope to capture the impact of the many years of fighting across French and Belgian Flanders, Macedonia or Gallipoli? How had this war seeped so deep into the creative consciousness? In the decades after the war, many artists from all across the British Empire sought access to the former battlegrounds to ponder these questions. Many of the landscape painters who eventually received permissions and sketching permits to travel to the ravaged sites of battle recognised that a traumatised topography can be the most powerful evocation of history, especially where

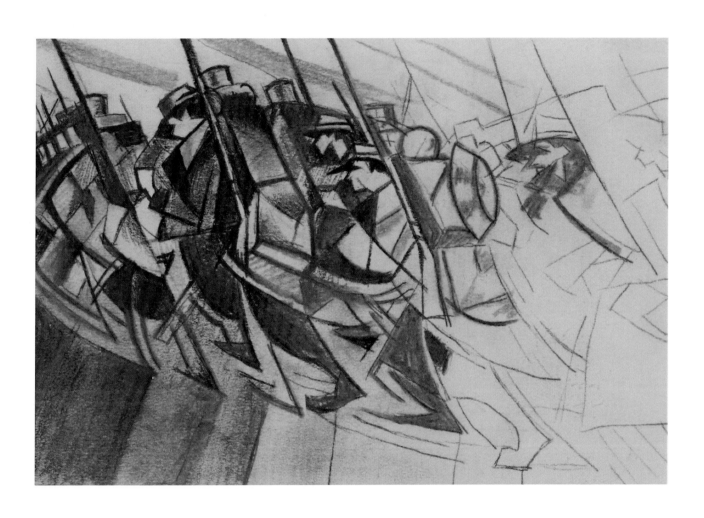

C.R.W. Nevinson
*Study for Returning
to the Trenches*
1914–1915
Charcoal and crayon on paper
14.6 × 20.6 cm
© Tate, London 2018

the historic dimensions lie hidden just under the battered earth. Ever since then, and even today, 100 years after the Armistice, there are professional artists drawn back annually to the Western Front in northern France and Belgium and the sandy creeks of the Mediterranean. They talk of the lure of the sacred earth, the thrill and yet the tragedy of exploring and re-visualising the trenches, tunnels and shell holes, the terrain littered with the material evidence of prolonged siege warfare. Robert Perry is one such painter. He makes annual visits to the battlegrounds on the Western Front, keeping an exact record of his explorations as he seeks the elusive subject matter that he then converts into striking *en plein air* paintings. In his diary for 15 February 2000, he recalls pushing through knee-high brambles, bushes and small trees, then pausing at a complex system of trenches and dugouts in the middle of Mametz Wood:

> *I sat and pondered. Were they German or British? I am filled with a desire to find out more. I know that Wilfred Owen and Siegfried Sassoon were both here and that a great tragedy took place when Welsh regiments, having penetrated the Wood, were mistaken by the British Artillery for German troops massing for a counter-attack and mercilessly shelled, suffering catastrophic casualties. I felt a strong impulsion to try to find the German trench which Sassoon captured single-handedly ... This is the way the Somme subtly draws one in and exerts its fascination. For many regular British and Commonwealth visitors (and Germans) it gets into the system like a drug. The more one learns, the more one wants to know. One becomes addicted.* [15]

(15)
Robert Perry, *An Artist's Diary: Robert Perry in the Somme Battlefields, Winter 2000.* Privately published, c.2001, p.10.

This volume of essays addresses a number of such concerns: how could the devastated terrain be rendered pictorially, how might the vast emptiness of the deserted battlefields be repopulated by visual methods and how could the dis-membered parts of the traumatised land be re-membered with respect and regard to human failing? Drawing on a body of previously published research with some additional material and a new suite of images from contemporary and current artists, this volume looks at the aftermath of the Great War and the impact of *terrain militaria* on a number of British and Commonwealth artists. In so doing, it explores how certain

painters and printmakers then and since have tackled the almost insurmountable obstacles of drawing on the front-line and then overcoming the bureaucratic impediments to access the ruined sketching grounds after the battle had moved on. But it also delves deeper into the persisting visual cultures of war, its deep-rooted imagery and the manner in which it has seeped into the pictorial language of so many painters, among them John Walker, Idris Murphy, Charles Green and Lyndell Brown.

The first section addresses the challenge of depicting emptiness. [16] How could any artist or photographer hope to capture the face of modern warfare when the human figure—for so long the primary motif in depicting narrative drama—was invisible, indeed deliberately concealed, during daylight? By looking at the work of artists and photographers as varied as Frank Hurley, Ellis Silas and Sidney Nolan—and thus accentuating the Australasian response when confronted by battle and the memory of battle—we explore the phenomenology of an emptiness crowded with danger and then later suffused with harsh, lingering memories.

Subsequent sections of this book explore the *leitmotifs* of the Great War battlefield. Initially, we examine the mnemonic role played by trees, woods and forests on and around the frontlines. [17] Drawing on the work of several current British artists, we look afresh at the totemic monumentality of trees with reference to the work of the British painter Paul Nash, an official war artist in both wars of the twentieth century and a seminal figure in any appreciation of a land or memoryscape touched by war and then recovered through a fragile peace. Nash's understanding of decay and regeneration and the cyclic concept of death and life through nature, will be one of the connective threads and tissues throughout this book. His commitment to the iconography of war and peace is a powerful touchstone and draws our attention constantly to what Fussell termed the 'persistence of memory', which attempts to position the memoirs, imagery and cultures of the Great War within Northop Frye's 'nodes' of ritual and myth. The author's work on the iconography of trees during and after siege warfare was first developed from fieldwork in northern Europe and those Mediterranean countries that

(16)

For initial explorations of the concepts of absence and emptiness, see Paul Gough, 'The Empty Battlefield', *Imperial War Museum Review*, 8, 1993, pp.38–48 and Paul Gough, *Performativities of Emptiness*, AHRC Landscape and Environment network conference, University of Bristol (7 June 2008).

For more recent research, see Paul Gough, '"Filling the Void": artistic interpretations of the empty battlefield', in Raelene Frances and Bruce Scates (eds.) *Beyond Gallipoli: New Perspectives on ANZAC.* Clayton: Monash University Publishing, 2016, p.131–152.

(17)

Paul Gough, 'Cultivating dead trees: The legacy of Paul Nash as an artist of trauma, wilderness and recovery', *Journal of War and Cultural Studies*, 4 (3) 2011, pp.323–340.

(18)

Lyndell Brown, Charles Green, Jon Cattapan and Paul Gough. *World-Pictures: Path-Finding Across a Century of Wars, 1917–2017*. Funded by the Australian Research Council Discovery Projects, 2017–2019. See also: Lyndell Brown, Charles Green, Jon Cattapan and Paul Gough, 'Revisioning Australia's war art: Four painters as citizens of the "global South"', *Humanities*, 7 (2) 2018, p.37.

(19)

'Collecting War: Trench Art, Souvenirs—Manufacture and Representation', presented at In Flanders Fields Museum, Ypres, Belgium (17–19 April 2009); National Memorial Arboretum with the Royal British Legion, symposia on Remembrance, Commemoration and Memorials, Staffordshire, UK (11 February 2010). The Çanakkale/Gallipoli Wars 2015 International Conference, Turkey (21–24 May 2015). The Myriad Faces of War Symposium, Te Papa Museum, Wellington, New Zealand (24–28 April 2017). BBC Radio 3 dedicated a program in its *Free Thinking* series to the topic: bbc.co.uk/programmes/b048bm10.

(20)

Jay Winter, *Sites of Memory, Sites of Mourning: The Great War in European Cultural History*. Cambridge: Cambridge University Press, 1995.

(21)

Ideas first shared at workshops at the *Touching War Symposium*, Institute of Advanced Studies, Lancaster University, UK (22 January 2009) and The Archaeology of Contemporary Commemoration, Theoretical Archaeology Group (TAG) Conference, University of Southampton (15–17 December 2008).

(22)

'Contested Remembrance', *Doing Justice to the Land*, MB Reckitt Trust Conference, St Paul's Cathedral, London, UK (24 February 2009). '"Turf Wars": the construction and reconstruction of memory on contested landscapes', for the *Memory and Dialogue on Debatable Land*, Belonging & Heimat Project, Manchester, UK (21–22 May 2010).

See: Paul Gough, '"Turf Wars": grass, greenery and the spatiality of commemoration. Recurring debates and disputes in the uses of horticultural iconography by the Commonwealth War Graves Commission in northern Europe', in John Rodwell and Peter Manley Scott (eds.) *Heimat & Belonging: At Home in the Future*. Berlin: LIT Verlag, 2016. www.lit-verlag.de/isbn/3-643-90638-0.

For the Lincoln Institute see: lincolntheologicalinstitute.com/belonging-and-heimat/.

were impacted by the war between 1914 and 1919. Funded by the British Council, the Canadian government, the UK Arts and Humanities Research Council and, more recently, the Australian Research Council, these expeditions produced papers, chapters and artworks that are the foundation of this present compilation. [18] Tracts of the research were presented at seminars and conferences, most notably at a series co-hosted by the Royal British Legion at the National Memorial Arboretum in Alrewas, England and subsequently at the In Flanders Field Museum at Ypres, Belgium, at Cannakale University in Turkey and more recently at Te Papa Museum in Wellington, New Zealand. [19] The research also generated television and radio programmes in the UK and Australia.

Both Jay Winter and Paul Fussell have described how difficult, if not impossible, it is now to grasp the 'actualities' of trench warfare. [20] Mythologies and representations are now so entrenched (to exploit the term) that the very language of the conflict has become almost immutable, encased in invented tradition and embedded in an orthodoxy of remembrance that is all pervasive. Both historians point out how the language and motifs (textual and visual) from the First World War, perhaps more than any other conflict, have burrowed their way into everyday usage. The implicit irony in many of the phrases, imagery and diction seems as true now as it must have been then in their original era. With this in mind, the next section of this book explores the troglodyte world of the labyrinth and examines the greensward that was laid across the levelled landscape once peace has been restored. [21] Entitled, rather provocatively, 'Turf Wars' the writing in this section was first developed as part of a seminar series with the Lincoln Theological Institute that brought together 15 theologians, landscape architects and academics from English and German backgrounds to share their understandings of 'belonging'. Guided by environmental ecologist John Rodwell, the group were later to secure project funding from the Jean Monnet Centre of Excellence at Manchester University. This resulted in a series of symposia—in such extraordinary venues as the Crypt of St Paul's Cathedral—and a multi-authored book examining the concept of *Heimat* in the past, the present and 'at home in the future'. [22]

A fifth section of this book develops research first aired at a conference held in Sweden on the discourses of haunting, which was then developed into a presentation given at a memorable gathering of historians, practitioners, writers and those linked to the business of funerals, cremation and burial, organised by the estimable Centre for Death and Society at Bath. [23] The author's contribution to this fascinating debate is exhumed here as a variant on a chapter published in *Deathscapes: New Spaces for Death, Dying and Bereavement*. Originally entitled 'The living, the dead and the imagery of emptiness and re-appearance on the battlefields of the Western Front', it suggests that the militarised terrain assumed the appearance and sense of a phantasmagoric, at times enchanted, place replete with myth and superstition punctuated by sublime moments of dread and fascination. Looking at the war through the eyes of a number of artists—Stanley Spencer, Will Longstaff and Otto Dix—this section of the book examines the contribution of painting and photography in appearing to bring the dead, the disappeared and the dying back to figurative life. This line of enquiry—and provocation—draws on Susan Sontag's insightful reading of Jeff Wall's epic photographic battlescape *Dead Troops Talk* and aims to connect Spencer's ontology of reconciliation with Wall's bleaker montage of debacle and death. [24] Some of the rewriting of this material has been informed by projects shared with artists in Australia, such as the painter Jon Cattapan and New Zealand enamellist Kirsten Haydon.

Addressing the vexed topic of commemoration, official and unofficial, is the focus of two further sections of this book. Taking as its locus of dissent and contestation the Newfoundland memorial landscape at Beaumont-Hamel on the Somme, we revisit the original arguments about the site, its layered topographies, its nomenclature and its means of preservation. [25] In so doing, we explore and analyse the many tensions that have arisen in this, one of the most popular destinations on the old battlefront. Drawing on fieldwork supported by the Canadian government, this section tries to explore complicated issues of historical accuracy, topographical legibility, freedom of access and assumed ownership. Referencing recent scholarship on indigeneity and the concept of sovereignty, the narrative aims to understand

(23)

Ideas first shared at *Spaces, Haunting, Discourse*, multi-disciplinary conference, Karlstad University, Sweden (15–18 June 2006) and 'The Social Context of Death, Dying and Disposal', symposium no.8, University of Bath (12–15 September 2007).

(24)

Paul Gough, 'The living, the dead and the imagery of emptiness and re-appearance on the battlefields of the Western Front', in Avril Maddrell and James Sidaway (eds.) *Deathscapes: New Spaces for Death, Dying and Bereavement*. Ashgate: Farnham, 2010, pp.263–281.

(25)

Paul Gough, '"Contested memories: Contested site": Newfoundland and its unique heritage on the Western Front' in *The Round Table: The Commonwealth Journal of International Affairs*, 96 (393) 2010, pp.693–705.

Robert Perry
*Beaumont Hamel Memorial
Park from Thiepval Ridge,
5.45 pm, 20 February 2000*
Gouache on paper
29.7 × 42 cm
© Robert Perry

recent disputes about moral ownership as examples of borrowed 'entitlement' and a resistance (by some British visitors) to recognise the historic value of Canadian (or more specifically, Newfoundland) heritage. This analysis of a site of disputed heritage is then broadened into a more discursive piece on the challenges of commemoration first published in *The Ashgate Research Companion to Heritage and Identity*. [26] The research project examined how the desire to produce a common understanding of the past resulted in material forms designed around the plinth and the pedestal. Europe's over-furnished cities and centres sprouted thousands of examples of such rhetorical *topoi*. Their mnemonic function is compared to its opposite, the 'reified place', which often took the form of preserved or reconstructed battlefields that became the focus of commemorative rites; the places to where 'one takes personal narratives'. Much of the research for this material was developed on location through the act of walking and experiencing the pull of memory at foreign sites and locales of embodied potentiality. It was also tested with academic and professional peer groups at a cycle of symposia and conferences under the banner *Conflict, Memory and Material Culture*, staged by University College London and the Imperial War Museum and, more recently, at the Royal Geographic Society's annual gathering in London. [27] Some of the material was also explored visually though painting, prints and drawings and exhibited by the author in England, New Zealand and Canada. [28]

A final section of the book reviews the visual potency of peace, a subject far more limited in its iconography than that of the military or martial. The work on the visual language of peace was nurtured by a research grant from the Arts and Humanities Research Council, which took the author to the renowned Great London Council (GLC) peace gardens of the mid-1980s and also the sites of popular protest at Greenham Common in Berkshire. In addition to a dedicated website, the findings of this fieldwork were tested in seminars and gatherings hosted by the Group for War and Culture Studies based at Westminster University, London and by colleagues working with Dr Hilda Kean at *Public History Now* events in Ruskin College, Oxford. [29] Public presentations, such as 'Forgive and Forget: The Case against Remembrance Sunday' were

(26)

Paul Gough, 'Commemoration of War', in Brian Graham and Peter Howard (eds.) *The Ashgate Research Companion to Heritage and Identity*. London: Ashgate, 2008, pp.323–347.

(27)

Ideas first shared at 'Bodies in Conflict: Corporeality, Materiality, Transformation in 20th Century War' as part of the *Materialities and Cultural Memory of 20th Century Conflict*, 3rd University College London/IWM Conference (16 September 2006) and subsequently at the *Materialities and Cultural Memory of 20th Century Conflict Conference*, IWM (26 May 2007) and the *Materialities of War: Conflict and the Senses Conference*, IWM, London (6–7 September 2013).

(28)

For example two one-person exhibitions at *Unseen Memorials*, Hall of Memories, National War Memorial, Wellington, New Zealand (November 2009–January 2010) and *Remembrance and Restoration: Exploring the Imagery of War, Resurrection and Recovery*, Otter Gallery, Chichester (19 November 2009–10 January 2010).

(29)

Places of Peace website is accessed at: paulgough. org/places_of_peace/index.html.

See also 'The challenge of representing "Peace" in sculptural form', *Fourth National Public History Conference*, Ruskin College, Oxford (26 April 2003). Paul Gough and Sally J. Morgan, '"A Faux Monument": Guerilla Interventions and the Contestation of Rhetorical Public Space', *Journal of War and Culture Studies*, 6 (1) 2013, pp.108–92.

also tested out in a range of public fora including a unique gathering of scholars in Yerevan, Armenia and, during one rather challenging instance, on BBC Radio 4 *Woman's Hour* in which the author was pitted against the redoubtable Baroness Betty Boothroyd, Speaker of the British House of Commons and an energetic advocate of a monumental war memorial scheme in central London.[30]

New material is introduced throughout the volume, as are new images. Some of the references have been updated where the literature has either matured or been developed during the recent 100th anniversary commemorative period. The author acknowledges the support of many organisations and institutions that have both supported the work and have allowed reproduction in whole or in parts from previously published material. The centenary of the end of the Great War has generated new research by the author, some of it presented at anniversary events in Macedonia (May 2018) and in Ypres, Belgium (August 2018). This material will be available on the author's website and through proceedings and publications linked to the symposia.[31]

(30)
BBC Radio 4, *Woman's Hour*, on the campaign for a national memorial to women's contribution to world wars with Baroness Boothroyd, 11 August 2002, bbc.co.uk/radio4/womanshour/2002_32_thu_03.shtml.

(31)
The Macedonian Front 1915–1918: Politics, Society and Culture in Time of War, Aristotle University of Thessaloniki, international conference (10–13 May 2018) www.hist.auth.gr/en/mfc18/main.

See also: *To End All Wars? International reflections on a hundred years of First World War Remembrance*, In Flanders Fields Museum, Ypres, Belgium (22–25 August 2018).

MYTHICAL PLACES

ARTISTIC INTERPRETATIONS
OF THE EMPTY BATTLEFIELD

'The Sphinx' seen from
North Beach, Anzac Cove,
the Dardanelles Peninsula,
Gallipoli/Gelibolu, Turkey

Filling the void

> *None but those who have endeavoured can realise the insurmountable difficulties of portraying a modern battle by camera. To include the event on a single negative, I have tried and tried, but the results are hopeless. Everything is on such a vast scale. Figures are scattered—the atmosphere is dense with haze and smoke—shells will not burst where required—yet the whole elements are there could they but be brought together and condensed. The battle is in full swing, the men are just going over the top—and I snap! A fleet of bombing planes is flying low, and a barrage burst all around. On developing my plate there is disappointment! All I find is a record of a few figures advancing from the trenches—and a background of haze.* [1]

These are the words of the incorrigible Australian photographer, Frank Hurley, describing the challenges of equipment and opportunity as one of two official war photographers with the Australian Imperial Force's Australian War Records Section, established in June 1917. Hurley became deeply frustrated by the practical difficulties of taking meaningful photographs on the battlefield and by the diffuse character of the war on the Western Front. The massive scale of the fighting around the trench lines, the noise, dust, cacophony of action and the barren emptiness of so much of the battlefield did not lend themselves to the busy, action-filled iconography that he felt befitted the incredible efforts and heroism of his countrymen. [2]

Before exploring the creative ploys Hurley used to meet his vision of this war, let us first examine the spatial, aural and sensorial nature of the conditions faced by many frontline combatants in France, Belgium, Turkey and other battlefields of the Great War, in an attempt to understand the challenges facing the artists and photographers whose objective was to record and interpret the face of total modern warfare.

Hurley, like many who tried to record the battlefield of the First World War, realised his photographs fell short of capturing the immense emptiness of the modern battlescape. Even when risking the dangerous vantage of a trench parapet, photographs could not visualise emptiness; they could only allude to absences. Words failed to convey the null and void and the intensity of loss:

[1]
Robert Dixon, *Photography, Early Cinema and Colonial Modernity: Frank Hurley's Synchronized Lecture Entertainments*. London: Anthem Press, 2011.

[2]
Alasdair McGregor, *Frank Hurley: A Photographer's Life*. Camberwell, Victoria: Viking Books, 2004.

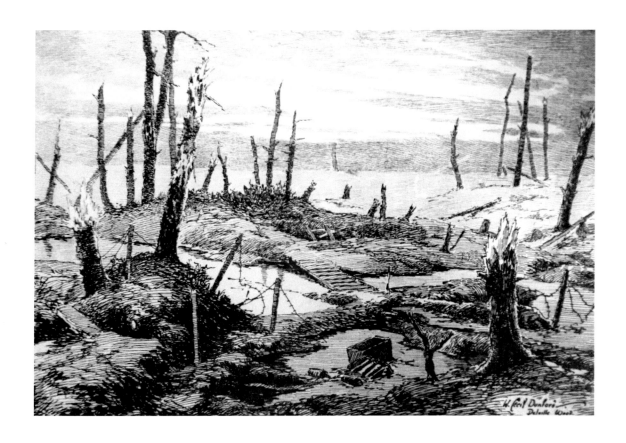

W. Cecil Dunford
Delville Wood
c.1916
Etching
12 × 16 cm
Private Collection

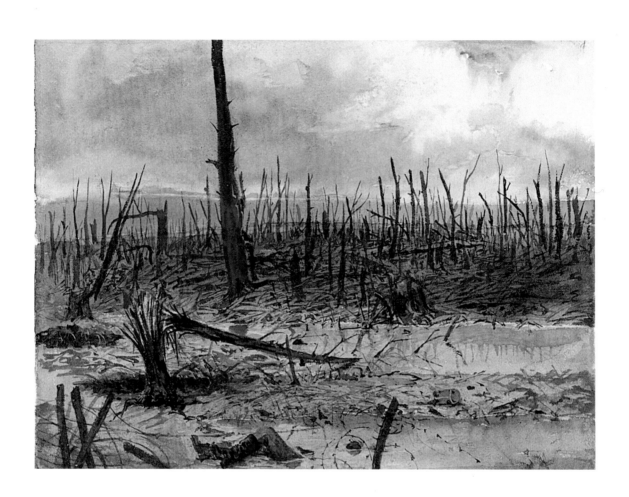

John B. Morrall
The Abomination of Desolation
c.1916
Watercolour on paper
8 × 10.5 cm
© Imperial War Museums
(IWM: ART 202)

It seemed quite unthinkable that there was another trench over there a few yards away just like our own … not even the shells made that brooding watchfulness more easy to grasp; they only made it more grotesque. For everything was so paralysed in calm, so unnaturally innocent and bland and balmy. You simply could not take it in. [3]

In Europe, the Great War continued the process of emptying the battlefield that began with the introduction of smokeless powder and the invention of the machine rifle. These allowed infantries to fire from well-concealed and distant positions. Improved detection and registration devices, refinements in the use of camouflage and the weight of firepower that could be brought to bear on a fixed front, meant that for long stretches of time the battlefield was deserted during daylight hours. Nonetheless, however empty, it was constantly scrutinised. A complete photographic record of the entire Western Front was taken twice daily by the Royal Air Force as a mechanical eye systematically gridded and re-gridded what many considered unmappable spaces. Becca Weir called this 'the paradox of measurable nothingness' [4] whereby the blasted topography had to be located, fixed, calibrated and named:

I learnt the names of every wood and all the villages (wrote one soldier). I knew the contour of the hills and the shapes of the lakes in the valley. To see so much and to see nothing. We might have been the only men alive, my two signallers and I. And yet I knew there were thousands of hidden men in front of me … but no one moved, everyone was waiting for the safety of darkness. [5]

On the Western Front, the compressed scale of the battlefield, where the opposing lines were sometimes only tens of yards apart, meant that even the most insignificant topographical features would be named, recorded and scrutinised. True of long stretches of the fighting lines in Flanders, it was also the case on the inhospitable slopes above the beaches of the Dardanelles. Small gullies, mounds and isolated trees were given appellations that were widely adopted; places associated with individuals were named and became part of the localised cartography. Naming, gridding and cartographic logic was used to fix on the seemingly empty spaces that characterised the battleground.

[3] Reginald Farrer, *The Void of War: Letters from Three Fronts*. London: Constable, 1918, p.113.

[4] Becca Weir, '"Degrees in nothingness": Battlefield topography in the First World War', *Critical Quarterly*, 49 (4) 2007, pp.40–55.

[5] Richard Talbot Kelly, *A Subaltern's Odyssey: A Memoir of the Great War, 1915–1917*. London: William Kimber, 1980, p.5.

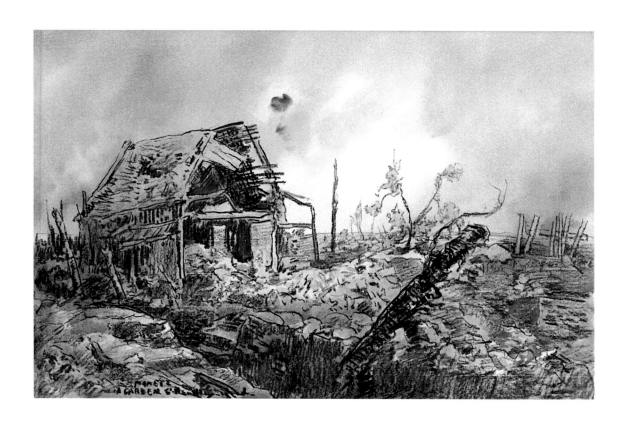

Edward Handley-Read
Mametz: A Garden
c.1916
Charcoal and watercolour
on paper
31.1 × 47.6 cm
Private Collection

While the battlescape may have appeared deserted, the dead lay exposed beneath its ruptured surface and the living led an ordered and disciplined (albeit perilous) existence in underground shelters and deep chambers.[6] It was one of the greatest contradictions of modern warfare: a landscape that, in daylight, gave the appearance of being empty but was emphatically not, teeming with invisible life. Few paintings or photographs captured the immensity of that void. Even the most inventive narrative fails to convey the intensity of its emptiness. Faced with the phantasmagorical lunar face of no-man's-land, the imagination froze. Writer and painter Wyndham Lewis recalls the dreadful panorama of nothingness:

> *I turned to look back at this obnoxious death-trap, as one turns to look back at a mountain whose top one had just visited, once one is down below. The sunset had turned on its romantic dream-light and what had been romantic enough before was now absolutely operatic. A darkening ridge, above a drift of Saharan steppe, gouged and tossed into a monotonous disorder, in a word the war-wilderness; not a flicker of life, not even a ration-party—not even a skeleton; and upon the ridge the congeries of 'bursts', to mark the spot where we had been. It was like the twitching of chicken after its head had been chopped off. We turned away from this brainless bustle, going on all by itself, about an empty concrete Easter-egg. In a stupid desert.* [7]

Reflecting on the uncanny sight of a deserted but dangerous battlefield, writer, Reginald Farrer, noted that it was misleading to regard the 'huge, haunted solitude' of the modern battlefield as empty. 'It is more', he argues, 'full of emptiness … an emptiness that is not really empty at all'.[8] The young English artist and frontline officer, Paul Nash, visualised this idea (borrowing Farrer's phrase, the 'void of war') of populating its emptiness with latent violence.[9] Artists from Britain, Australia, Canada and New Zealand were equally challenged to picture the vacuum of the deserted battlefield.

To compound the contorted spatial dimensions artists faced, one of the most extraordinary features of the Great War was the comprehensive inversion of night and day—the night was busy and industrious, daylight hours were outwardly calm, with opposing soldiers

(6)
William Redmond, *Trench Pictures from France*, 1917, p.39, cited in Paul Gough, 'The empty battlefield: Painters and the First World War', *Imperial War Museum Review*, (8) 1993, pp.38–47.

(7)
Percy Wyndham Lewis, *Blasting and Bombardiering*. Berkeley: University of California Press, 1967, p.159.

(8)
Reginald Farrer, *op. cit.*, p.25.

(9)
For an exploration of Paul Nash and the void, see Paul Gough, 'Brothers in Arms', *John and Paul Nash and the Aftermath of the Great War*. Bristol: Sansom and Company, 2014, pp.49–63.

remaining out of sight of each other. Hearing became more important than sight. Scrutiny of the 'other' had to be gleaned using proxy measures, such as trench periscopes or listening devices. During the Gallipoli campaign, every human sense was attuned to the tract of land that lay between the frontlines. In places, no-man's-land was little more than a few metres wide and became a debatable, fluid and near-mythical zone soldiers learned to fear, but which also exercised a dread fascination. Although the soldier–poet David Jones may not have been typical of many in the ANZAC force, some shared his poetic understanding of the liminal qualities of no-man's-land as a threshold between two different existential spaces:

> *The day by day in the wasteland, the sudden violences and long stillnesses, the sharp contours and unformed voids of that mysterious existence profoundly affected the imaginations of those who suffered it. It was a place of enchantment.* [10]

(10)
David Jones, *In Parenthesis*, London: Faber, 1937, p.x.

At the intersection of these two worlds—the hazardous emptiness of the daylight battlescape and the crowded business of the benighted no-man's-land—came one of the critical moments of a soldier's experience of war: the moment they left the relative safety of the frontline and stepped into the danger zone:

> *The scene that followed was the most remarkable that I have ever witnessed. At one moment there was an intense and nerve shattering struggle with death screaming through the air. Then, as if with the wave of a magic wand, all was changed; all over 'No Man's Land' troops came out of the trenches, or rose from the ground where they had been lying.* [11]

(11)
Arthur Stuart Dolden, *Cannon Fodder: An Infantryman's Life on the Western Front, 1914–1918*. Blandford: Blandford Press, 1980, p.39.

Moving from the horizontal to the vertical, from subterranean security to maximum vulnerability, was the ultimate transformation for every combatant. It compounded the central tenet of militarised service: the transformation from civilian to soldier, from innocence to experience and, in many cases, from youth to adult. The peculiarly strict proximity of the Allied and Turkish trenches on the battlefield of the Dardanelles and the imperative for the Allies to maintain the offensive or be pushed back into the sea, made the sight of ANZAC soldiers charging over the tense tract of no-man's-land the central *leitmotif* of this conflict. This recurrent theme informs many of the most memorable post-war canvases in the major

collections of Australian and New Zealand war art and has entered the high diction of battle iconography as recounted in movies, documentaries and still photography. [12]

Significantly, the landscape of the Dardanelles plays a different pictorial role to that of the flat (and further flattened) terrain of much of northern France and Belgium where the ANZAC forces would fight later in the war. In glaring contrast to the grim and deadly terrain immediately around the trenches and dugouts of Flanders, the picturesque hills and the Aegean Sea were a striking backdrop to war: a beautiful landscape of steep cliffs carpeted with flowers. The headland around the small town of Krithia was described by an official British historian as looking onto 'a smiling valley studded with cypress and patches of young corn'. [13] This rich visual topography became a powerful context for painters when they came to compose vivid re-enactments of momentous skirmishes and infamous attacks on the Turkish lines.

From a military perspective, what the battlescapes of Flanders and the Dardanelles had in common was the urgent need by the opposing armies to dominate the physical terrain and control space. As the fixed trench warfare became more drawn out and intractable, there grew an urgent need to control the enemy line and the hazardous zone beyond. However, the enemy space could not always be seen: it might be heard or smelt or experienced in some other non-visual way. Explaining their term 'smooth space', Deleuze and Guattari say 'it is a space of affects more than one of properties. It is haptic rather than optical perception'. [14] In the smooth space of no-man's-land, things are felt, intuited, located by sound and smell or grasped in the dark while crawling across the tortured ground during night patrol. In stark contrast, exacting observation by trained soldiers sees the enemy lines ceaselessly scrutinised, recorded, registered and calibrated whenever possible.

Military sketching for reconnaissance (or to aid artillery fire through target indication carried out by forward observation officers) played an important part in harnessing the talents of a significant number of artist–combatants who turned their skills to military purposes. [15] In the Gallipoli campaign, several drawings and watercolours (made on land but also significantly from the

(12)
For example, see Peter Weir's seminal feature film, *Gallipoli* (1981).

(13)
Garrie Hutchinson, *Pilgrimage: A Traveller's Guide to Australia's Battlefields*. Melbourne: Black Inc., 2006, p.29.

(14)
Gilles Deleuze and Felix Guattari, *A Thousand Plateaus: Capitalism and Schizophrenia*. Trans. Brian Massumi. Minneapolis: University of Minnesota Press, 1987, p.479.

(15)
For military sketching, see Paul Gough, 'Calculating the future—Panoramic sketching, reconnaissance drawing and the material trace of war', in Nicholas Saunders and Paul Cornish (eds.) *Contested Objects: Material Memories of the Great War*. London: Routledge, 2009, pp. 237–251.

decks of naval vessels offshore) aimed to schematise the act of looking, using basic and well-tested methods of measuring and calibration by eye and hand. In the hands of a trained observer, even the most complicated terrain could be simplified, its salient features were clarified through a process of careful analysis and rendered as a drawn panorama that could inform and augment other surveillance work. With this approach, graphic information proved superior to coastal or land-based photography, as it eliminated unnecessary or distracting detail, using a pictorial language to identify essential elements and relying on shared graphic codes to inform tactical actions.

There is a further understanding of the battlescape worth noting, as true of Gallipoli as it was of Flanders or Salonika. Combatants came to be wary of being attracted to or gathering around distinctive landscape features. In France, the well-known cartoonist Bruce Bairnsfather recalls:

(16)

Bruce Bairnsfather, *Bullets and Billets*, 1916. At Project Gutenberg, accessed 29 May 2018, gutenberg.org/ebooks/11232.

> ... *a farm was a place where you expected a shell through the wall any minute; a tree was the sort of thing the gunners took range on; a sunset indicated a quality of light in which it was not safe to walk abroad.* [16]

Battle immediately brings about a new order in any landscape. The nondescript, the contingent, the marginal and the outwardly featureless space quickly became prioritised and valued. Danger spots became well-known, widely shared and greatly feared. In the ANZAC trenches at Gallipoli, there were many notorious points that were open to enemy sniping, where little could be done to screen soldiers as they undertook the potentially deadly act of passing them.

Consequently, terrain was rarely neutral; it was divided unequally between the safe and the unsafe, between refuge and prospect. An officer recalls one terrifying foray into no-man's-land in Flanders where everything seemed suddenly (and almost irreversibly) inverted:

> *Straight lines did not exist. If one went forward patrolling, it was almost inevitable that one would soon creep around some hole or suspect heap or stretch of wired stumps, and then, suddenly one no longer knew which was the [enemy] line, which our own ... willow-trees seemed [like] moving men.*

Frank Hurley
A 'Hop Over'
c.1918
Composite photograph
© Australian War Memorial
E05988B

Compasses responded to old iron and failed us. At last by luck or stroke of recognition one found oneself.

Although straight lines rarely existed on any battlefield, there was an acute awareness of a spatial 'other', especially the tract of unknown land that existed only in the future tense. This has many spatial manifestations:

> *This side of the wire everything is familiar and every man a friend; over there beyond their wire, is the unknown, the uncanny, there are the people about whom you accumulate scraps of irrelevant information but whose real life you can never penetrate.* [17]

If in front lay the unknowable, beyond lay the unreachable. Soldiers in the few privileged elevated positions on the Western Front could glimpse a green, distant strip of land that was always out of reach, forever locked in an unattainable future:

> *I could ... see unspoiled land beyond the Hindenburg Line, undulating hills ... woods, villages fit to live in, trees that had leaves, a hillside without shell-holes. It was a Promised Land.* [18]

This idea of a 'promised land' that could only be mentioned in the future tense became a standard trope among memoir writers; a recognition that they were situated in an irreversible 'here-and-now'. From the British lines around Ypres, the promised land appeared as the distant gently rising crests of land to the east. On the Somme, it took the form of the green and verdant horizons way beyond the deadly slopes and valleys of that fated battlefield. On the Dardanelles Peninsula, the distant hills of the Sari Bair Range played the same role, tantalisingly offering the ultimate prize and prospect, but cruelly denied to Allied troops.

Visualising emptiness: Contemporary interpretations of the void

We look now at these spatial, aural and haptic phenomena through the eyes of two artist–practitioners, Frank Hurley in Belgium in late 1917 and Ellis Silas on the slopes above Anzac Beach in May 1915.

Photographer and cinematographer Frank Hurley arrived in London in early 1917 as an Australian national hero,

(17)
Edmund Blunden, *Undertones of War*. London: Collins, 1928.

(18)
Charles Carrington, *Soldier from the Wars Returning*. London: Hutchinson, 1965, p.87.

having sensationally survived the catastrophe that beset Shackleton's Imperial Trans-Antarctic Expedition of 1914 to 1916. Commissioned by the Australian War Records Section when it was formed in mid-1917 and attached to the Australian Imperial Force (AIF) as an honorary captain, he was overwhelmed by the horrors of the Western Front and stunned by its scale, complexity and omnipresent dangers. Although his imagination was ignited by the spectacle of war, he struggled with its speed and intensity. Hurley and his assistant, Hubert Wilkins, did what they could to embrace the battlescape's visual sweep. On one occasion, they hazarded out of their fragile shelter to capture the random instantaneity of an aerial bombardment, but it was a futile business. 'In spite of heavy shelling by the Boche, we made an endeavour to secure a number of shell burst pictures … I took two pictures by hiding in a dugout and then rushing out and snapping'. [19]

Despite his determined pursuit of a convincing image, Hurley felt the results were disappointing. He realised that the face of modern war was too elusive for a single snapshot. 'Everything is on such a vast scale. Figures are scattered—the atmosphere is dense with haze and smoke—shells will not burst where required—yet the whole elements are there could they but be brought together and condensed.' [20]

Hurley acknowledged that the difficulties were 'insurmountable' and proposed that he create composite photographs. He later told an audience that 'if negatives are taken of all the separate incidents in the action and combined, some idea may be gained of what a modern battle looks like'. [21] Composite printing was a well-established staple technique of photographers at the time, used extensively for mural-sized exhibition prints for display. Hurley was aware that the Canadian Expeditionary Force had recruited photographers who willingly embraced the technique. He was determined, in his words, to 'beat them'. However, as is now widely known, the official war historian for Australia, Charles Bean, firmly prohibited the practice. Officially responsible for an eyewitness record of the Australian effort, Bean wanted nothing to do with 'scoops, competitions, magnification and exaggeration', which he regarded as falsifying the authentic evidence of war and out of harmony with 'what is best for the country'. Photographs were

(19)

Frank Hurley, *The Diaries of Frank Hurley, 1912–1941*. Robert Dixon and Christopher Lee (eds.) London: Anthem, 2011, (6 October 1917). The establishment of the Australian War Records Section is given in the Australian War Memorial record as May 1917. However, elsewhere (usually sources in the UK) the date is June.

See awm.gov.au/blog/2007/06/12/the-australian-war-records-section, accessed 29 May 2018.

(20)

Martyn Jolly, 'Composite propaganda photographs during the First World War', *History of Photography*, 27 (2) 2003, pp 154–165. Jolly cites Hurley, *Sydney Morning Herald* (20 March 1919), n.p.

(21)

Frank Hurley, press cuttings, National Library of Australia, MS883, series 2, items 29–36, n.d.

Frank Hurley
Supporting Troops of the 1st
Australian Division Walking on
a Duckboard Track Near Hooge
1917
Silver gelatin photograph
14 × 19 cm
© Australian War Memorial
E00833

Frank Hurley
An Advanced Aid Post
1917
Composite photograph
© Australian War Memorial
E01202A

regarded as sacred records—standing for future generations to see forever the simple plain truth. [22]

Hurley refused to regard his photographs as either a sacred relic or an indexical account of the front, nor did he think Bean's reductive ruling could reflect the extraordinary bravery of the ANZAC soldiers he witnessed in action on the frontline. Their row was a bitter one:

> Had a great argument with Bean about combination pictures. Am thoroughly convinced that it is impossible to secure effects, without resorting to combination pictures ... Had a lengthy discussion with Bean re pictures for exhibition and publicity purposes. Our authorities here will not permit me to pose any pictures or indulge in any original means to secure them ... as this absolutely takes all possibilities of producing pictures from me, I have decided to tender my resignation at once. I conscientiously consider it but right to illustrate to the public the things our fellows do and how the war is conducted. They can only be got by printing a result from a number of negatives or re-enactment. This is out of reason and they prefer to let all these interesting episodes pass. This is unfair to our boys and I conscientiously could not undertake to continue to work. [23]

Hurley eventually reached a compromise with Bean and AIF headquarters and retracted his resignation. Hurley could make six composites for a London exhibition devoted to Australians fighting in France, provided they were captioned as composites. In later exhibitions and publications, these captions somehow disappeared and the public assumed that Hurley's pictures were real. For his London show in May 1918, he showed these composites enlarged to mural size and a 130 further images describing military activity and actions on the Western Front and Palestine where the AIF was stationed and where Hurley was posted in November 1917.

Hurley revelled in the public and press attention and was delighted by the success of his 'action pictures'. He regarded them as truly authentic visions of a war that had so far proved absurdly elusive:

> The exhibition was well patronised today. The colour lantern is working excellently. The colour slides depict scenes on the Western Front, Flanders and

(22)
Charles E. W. Bean, diary, Australian War Memorial, AWM38, cited in Michael McKernan, *Here is Their Spirit*. Brisbane: University of Queensland Press, 1991, p.42.

(23)
Frank Hurley, letter dated 26 September 1917.

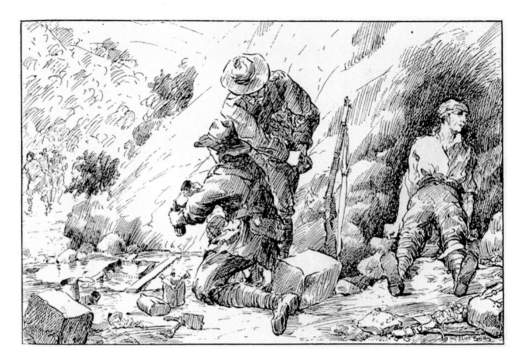

Ellis Silas
The Waterhole
1915
Ink on paper, page from
sketchbook sketch from
'Crusading at ANZAC. AD 1915'
© Australian War Memorial

(LEFT)

Ellis Silas
Dead Man's Patch
1915
Ink on paper, page from
sketchbook sketch from
'Crusading at ANZAC. AD 1915'
© Australian War Memorial

(RIGHT)

Ellis Silas
The Snipers
1915
Ink on paper, page from
sketchbook sketch from
'Crusading at ANZAC. AD 1915'
© Australian War Memorial

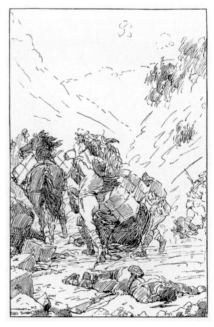

also Palestine. They are gems and elicit applause at every showing. A military band plays throughout the day …

Another sensational picture is 'DEATH THE REAPER'. This remarkable effect is made up of two negatives. One, the foreground, shows the mud splashed corpse of a Boche floating in a shell crater. The second is an extraordinary shell burst: the form of which resembles death. The Palestine series are magnificent … It is some recompense to see one's work shown to the masses and to receive favourable criticism after the risks and hardships I have taken and endured to secure the negatives. [24]

Hurley would always assure his audiences that the elements of each composite picture were taken at great risk during battles and were not 'fancy pictures faked from a safe position behind the lines'. No one questioned his frontline credentials. Even Bean recognised that Hurley had 'been nearly killed a dozen times'. [25]

But do these vast collages capture the face of total war? Do they compete with the works of frontline painters who set out to interpret what they saw as official war artists? Do they tell us much about the unique conditions of the frontline? The answer to each of these questions is probably no, not as much as Hurley believed they would. They add little to the iconography of modern warfare. To echo one historian's critique of his composite works, they are little more than 'quaint historical footnotes'. [26]

In fact, Hurley's large composite works fell into the same trap as the epic cavalry-laden tableau of the high Victorian and Edwardian battle art they mimicked, over-anxious to promote heroic gesture and martial zeal. Wishing to be considered equal to the vast canvases that lined the walls of the royal academies, Hurley's mural-sized prints may seem little more than overblown compendiums in ornate frames. Now, none of the effort seems necessary. Hurley was an impressive documentary photographer. He was deeply committed, fearless and authentic. His technical innovations, particularly in flash photography, established him as a pioneer. His single shot photographs of the battlefront help visualise the intangible and virtually indescribable aspects of modern war. When observed alongside his

[24]
Frank Hurley, letter dated 4 June 1918.

[25]
Charles E. W. Bean, *Wilkins and Hurley Recommendations*, Australian War Memorial, AWM38, DRL6673, item 57, 24 October 1917.

[26]
Martyn Jolly, 'Australian First World War Photography', *History of Photography*, 23 (2) 1999.

powerful war diary, Hurley's documentary photographs recount an extraordinary tale of commitment, zeal and pictorial innovation.

Born in 1885, the same year as Hurley, painter Ellis Silas sailed to Australia from England in 1907. He painted in Sydney, Melbourne and Adelaide before settling in Perth. In 1914, he joined the AIF as a signaller. He was trained in Egypt and landed in Gallipoli with the 16th Battalion AIF early in the evening of 25 April 1915. His unit went straight into action at Pope's Hill at the head of Monash Valley where they spent the night hurriedly digging in, while under intense enemy rifle fire. Silas later recorded these first traumatic hours in his painting *The End of the Great Day*. [27] His unit held its precarious position without relief for the next five days and nights. Later, Silas found time to record his reactions in a diary and to make drawn records of the events. 'The repetition of shrapnel in each sketch is not a fad of mine, but just the natural order of things.' [28]

In his diary, he recalls that only hours after landing ashore there was a curious phenomenon in the middle of 'this frightful hell of screaming shrapnel and heavy ordinance, birds were chirping and buzzing from leaf to leaf'. [29] Such bucolic dissonance was a common feature of the battlefields of the Great War, characterised as 'ridiculous mad incongruity!' by Nash, another painter on a different battleground two years later. [30] As a signaller, Silas had to constantly reveal himself in full view to relay his messages to others on distant parts of the battlefield. It was a fraught occupation. In contrast to his fellow combatants, a signaller must be more attuned to the peculiarities of space and distance.

As Silas took in his surroundings, his artist's eye was drawn to the few distinctive motifs of the sandy landscape: the single fir tree on the ridge opposite where a unit from New Zealand was advancing. But he quickly became aware that danger lurks in those places identified by enemy snipers as patently empty, most obviously the gaps in the breastworks and temporary defensive lines. He later made a drawing of one such danger spot known as 'dead man's patch', a notorious open space so well covered by Turkish sharpshooters that 'few men have been able to get across it—a stream of dead marks its length'. [31]

(27)

'The End of the Great Day: The 16th Battalion, AIF digging the original trenches on Pope's Hill on the evening of the landing at Anzac, 25 April 1915'. By an eyewitness (Signaller Ellis Silas, 16th Battalion AIF).

(28)

Ellis Silas, *Crusading at Anzac AD 1915*, London, 1916.

(29)

Ellis Silas, diary entry, 26 April 1915.

(30)

Paul Nash, *Outline: An Autobiography and Other Writings*. London: Faber and Faber, 1948, p.186.

(31)

Ellis Silas, diary entry, 28 April 1915.

All along the route, scrambling along the side of the exposed incline, my comrades offered me a dug-out for me to take cover as the snipers are getting our chaps every minute, but as the messages are important I must take my chance. All along the route I keep coming across bodies of the poor chaps who have been less fortunate than I. [32]

(32)
Ellis Silas, diary entry, 26 April 1915.

To Silas and his fellow combatants, the landscape of Gallipoli was a truly malign place, offering little succour or respite, where every element seemed to conspire against them. On one occasion, he was about to make a dash from the cover of some bushes to cross a bare patch when he found himself momentarily ensnared by a sharp branch. 'The seat of my pants caught in the bushes, and I hung by them! I was in a terrible funk, for then the snipers got busy'. Illustrated in his book, *Crusading at Anzac*, Silas's drawing creates a dissonant impression: sprawled among the flowering foliage and billowing clouds are the prone bodies of his comrades, impaled and forlorn in grotesque Goyaesque postures. [33]

(33)
Reproduced as 'Dead Man's Patch' in his book, *Crusading at Anzac AD 1915*.

Despite the intense dangers and deliriums that befell him after a week of non-stop sniper fire, Silas managed to maintain a record of his experiences, although he apologises to himself (and any future readers) that he was keeping little but notes and 'making no effort to keep a concise diary'. He found time to sketch, amusing himself one evening in rest camp (11 May) by designing stained glass windows and, on another, making a reconnaissance sketch of a position for his superior officers; possibly, he thinks, for General Birdwood. He complains frequently in his diary that as daylight recedes 'his sight is going', a terrible dilemma for any signaller, let alone artist.

Silas describes an occasion when he mistakes the shifting spatiality of the narrow battlefield when returning from delivering a message and takes the 'wrong side' of a road, one that is open to enemy observation. 'Keep to the right!' his captain shouts out. 'Don't you know which is the right side? Run for it.' [34] As battle continues, Silas observes one of the characteristic fusions of the new order of things: 'the shrapnel is now ever in the sky, it is as much a part of the landscape as the clouds.' A few days earlier, on 7 May, he records that the distinction

(34)
Ellis Silas, diary entry, 2 May 1915.

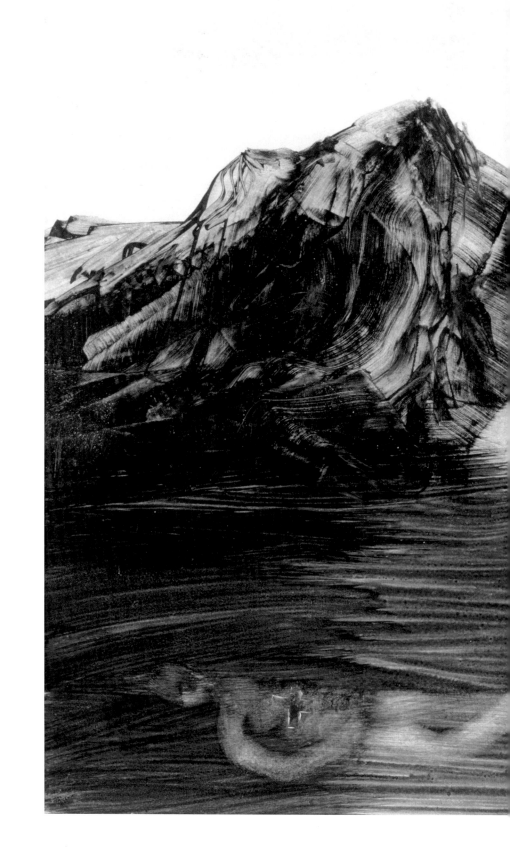

Sidney Nolan
*Drowned Soldier
at Anzac as Icarus*
1958
Textile dye, sgraffito, coloured
crayon on coated paper
25.4 × 30.4 cm
© Australian War Memorial
ART91309

Sidney Nolan
Gallipoli Landscape
c.1961
Textile dye, wax on coated paper
25.4 × 30.4 cm
© Australian War Memorial
ART91235

between day and night is becoming blurred. 'All last night the Turks have been bombarding heavily with shrapnel; a quite unusual occurrence, as they never used to commence before dawn.' [35]

Silas lasted little more than three weeks on the front. His nerves were shredded and he was evacuated. By his own reckoning, he felt he played a part and had done 'his bit' for his country and fellow soldiers. He had shown 'a sneering world that artists are not quite failures on the battlefield'. Although he freely admitted that 'we are not quite cut out for this sort of work'. [36]

He saw out the war, first in Egypt as a medical orderly with those evacuated from the Dardanelles and then as a convalescent in England. In 1916, he gathered his battlefield notes and sketches, which were published as *Crusading at Anzac AD 1915*, a searing but compassionate account of the landing, its aftermath and his recovery. The ink drawings trace a traumatic account of his brief time on the headland and conclude with an image of a wounded soldier comforted by a nurse at Palace Hospital, Heliopolis entitled *Heaven!* [37]

Ellis Silas holds the distinction of being the only participant in the Battle of the Landing to produce paintings from personal experiences. The Australian War Museum purchased three of his large paintings, which focused on the combatants and their heroic plight. By comparison, the emptied battlescape, which featured so much in his hair-raising experiences on the peninsula, were demoted to little more than a backdrop in these evocative works. [38]

Memoryscapes as an exploration of the void

Today, few painters can approach the topic of Gallipoli without reference to the extraordinary suite of images created by Australian artist Sidney Nolan during the period from the mid-1950s to the late 1970s. These images are different from anything thus far considered and offer a wholly new perspective, unlike the eyewitness accounts by Ellis Silas, the post-war topographical views by Horace Moore-Jones or the epic canvases depicting infamous battle charges re-created after the conflict by George Lambert. 'The power and the energy of Nolan's

(35)
Ellis Silas, diary entry, 7 May 1915.

(36)
Ellis Silas, diary entry, 28 April 1915.

(37)
With an introduction by General Sir William Birdwood and a foreword by General Sir Ian Hamilton, who wrote a rather backhanded compliment: Silas' drawings might seem a little 'slight, they seem solid and serious enough to such of us as were there'.

(38)
Roll Call, Ellis Silas, 1920, oil on canvas, 101.8 × 153.1 cm [AWM ART02436].

Drawing on a sketch in his book, Silas executed this painting in London around 1920 on commission for the Australian War Records Section along with two other works, *The Attack of the 4th Brigade, AIF* and *Digging in at Quinn's Post or the End of a Great Day*. It was hung in the Australian War Memorial.

Gallipoli works are palpable', claims Lola Wilkins. 'It is as if Nolan found a way to breathe life into what had become a long-repeated story, giving a uniquely personal perspective on a subject that has been largely treated as history.' [39]

In 1978, Nolan donated 252 pieces from his Gallipoli series to the Australian War Memorial in Canberra. Much has been written about Nolan's mythical treatment of the campaign and how he had long wanted to explore heroic themes, delved into Homer's Iliad and visited the archaeological museum in Athens. There he became fascinated by classical Greek black vases exquisitely painted with representations of warriors in combat.

In 1956, he took an opportunity to visit the preserved site of Troy and spent a single day on the peninsula of Gallipoli, a visit that left its mark on his keyed-up imagination:

> *I stood on the place where the first ANZACs had stood, looked across the straits to the site of ancient Troy, and felt that here history had stood still ... here and there I picked up a soldier's water bottle or some other piece of discarded equipment ... I found the place on top of the hill where the ANZAC and Turkish trenches had been only yards apart and the whole expedition balanced between success or failure.*
>
> *I visualised the young, fresh faces of the boys from the bush, knowing nothing of war or of faraway places, all individuals, and suddenly all the same—united and uniform in the dignity of the common destiny. And that is how I came to paint the series.* [40]

A substantial number of the series are outwardly empty. Charles Green describes them as 'fields of colour from which soldiers are almost wholly absent'. [41] Sombre and tonal, they depict the barren topography of the headland, its impenetrable scrub, remnants of trenches, sharply cut gullies, low distant hills and the ocean that cradled the peninsula.

During his sustained preoccupation with the Gallipoli campaign, Nolan took his fascination with the landscape myths of his homeland and merged them with the idea that Australia's national identity was born with the Anzac legend of Gallipoli. This became a potent combination.

(39)
Lola Wilkins, 'Sidney Nolan: The Gallipoli Series', essay in *Sidney Nolan: The Gallipoli Series*, exhibition catalogue, Canberra: Australian War Memorial, 2009, pp.1–14.

(40)
Sidney Nolan, 'The ANZAC Story', *The Australian Women's Weekly*, 17 March 1965, p.3.

(41)
Charles Green, 'The Gallipoli Series: An Artist's Perspective', essay in *Sidney Nolan: The Gallipoli Series*, exhibition catalogue, Canberra: Australian War Memorial, 2009, pp.24–29.

Nolan fused the bare hills of Asia Minor with the harsh landscape of the Australian bush, blurring 'one iconic landscape with another'. [42] In its colour, textures and light he drew ready parallels between the ancient Turkish landscape and the Australian outback. Others did too. British journalist and war correspondent Ellis Ashmead-Bartlett described in a written dispatch:

> It is indeed a formidable and forbidding land. To the sea it presents a steep front, broken into innumerable ridges, bluffs, valleys, and sand spits, which rise to a height of several hundred feet. The surface is either a kind of bare yellow sandstone which crumbles when you tread on it, or else is covered with very thick shrubbery about six feet in height. [43]

Nolan absorbed these narratives and other eyewitness accounts, he talked lengthily to eminent historians and spent time in London at the Imperial War Museum viewing contemporary photographs of the campaign. Embedding, indeed saturating, himself in the milieu of a subject before embarking on any series was a standard approach for the artist. 'Experience, knowledge, and imagination' writes Laura Webster, 'would interact in his mind before he got down to the business of creating the work. In this way the works became ruminations but produced with great rapidity and arising out of an almost unconscious, emotional response.' [44]

Steeped in the geographical and mythological history of Gallipoli, Nolan painted a succession of memoryscapes that exude the core ideas of a crowded emptiness. He was in awe of the place and assured by his creative process. Using his trademark materials—textile dye, polymer medium, coloured crayon, coated paper—he created bare, almost minimal, images suffused with colour and executed hastily, without any wasted effort. They eschew perspective and depth. With few details and anecdotal touch points, the planes are distorted and bent. As with so many of his landscapes, they are 'geographically tentative and uncertain'. [45]

What is it that makes this extended series of paintings so convincing? Is it because they are so elusive and stripped down, little more than a wash of saturated red and pink on striated cliffs? Is it because they seem to have been achieved so effortlessly, with pleats of

(42)
Ibid., p.25.

(43)
Ellis Ashmead-Bartlett, *Despatches from the Dardanelles*. London: George Newnes, 1916, p.72.

(44)
Laura Webster, 'Nolan's Gallipoli Landscapes', essay in *Sidney Nolan: The Gallipoli Series*, exhibition catalogue, Canberra: Australian War Memorial, 2009, pp.44–51.

(45)
Daniel Thomas, *Outlines of Australian Art: The Joseph Brown Collection*. New York: Harry N. Abrams, 1989, p.37.

colour folded over and over to conjure up the friable geology of the beachhead? Or is it that Nolan recognised that every landscape—the bush, outback or beachhead—had its own story to tell, each with its own innate power of embedded multiple narratives?

Absorbed by the mythological intensity of Gallipoli, Nolan knew that less was more. Interviewed at the Australian War Memorial in 1982, he suggested that threat, menace and unease lay close to the surface, just as the personal detritus of the retreating armies still littered it. 'The landscape', he reflects of that distant boneyard, 'becomes darker and more fissured.'[46] Nolan's bleak minimal vistas impart a knowledge that something awful happened on this fractured ground. They evoke rich layers of memory and emotion, rendering the landscape silent witness to historical and contemporary events.

In the last two decades, as the mystique surrounding the Gallipoli campaign broadens, deepens and intensifies, other Australian and New Zealand artists have been stimulated to create equally pared down representations of the scarred cliffs and once-fatal ridges of the peninsula. For example, Idris Murphy's representation in *Gallipoli Evening* (2013) borrows much of its stripped back and simplified design from Nolan.[47] However, his is a hard act to follow and most comparable painting pales in comparison.

Nolan's dozens of landscapes speak eloquently of the crowded emptiness of fated ground. They represent the most distilled essence of a brutalised and blighted battlescape, as Paul Nash told a bitter truth without resorting to legions of soldiers and hackneyed narratives. Nolan would have known such paintings and he would have been keenly aware of Australian precedents by First World War artists at Gallipoli, such as George Benson, Frank Crozier and George Lambert, although they meant little to him:

> *I'm very interested, in fact, compelled and dedicated to transmitting emotions and I care for very little else. I care for that process so much that I'm prepared to belt the paint across the canvas much faster than it should be belted. I don't care as long as I can get that emotional communication. I will sacrifice everything to it—and that I've done.*[48]

[46]
Interview with Gavin Fry, 26 February 1982, AWM recording 359.

[47]
Andrew Taylor, 'Gallipoli Letters Add Poignancy to Idris Murphy's $20,000 Art Prize Win', *The Sydney Morning Herald*, 24 April 2017.

[48]
John Buckley, *Sidney Nolan: Works on Paper*. Sydney: Australian Gallery Directors' Council, 1980, p.3. See also Jon Cattapan on the art of war, where conflict meets creativity; art150.unimelb.edu.au/articles/art-of-war-where-conflict-meets-creativity, accessed 29 May 2018.

Exploring the idea of emptiness and its application to the battlescapes of Turkey and Europe in the First World War, each of these three artists—Hurley, Silas and Nolan—responded to the scenes before them and to the smooth space of the sensorial landscape, where the haptic, visual and aural senses entwine in the complex layers of an horrific battleground. While Hurley and Nolan knew already the stark, empty and threatening landscapes of the Australian outback and polar wastelands, nothing prepared them for the boneyards of Gallipoli, the Somme or Ypres. They responded imaginatively and with a unique creative vision.

After months in recuperation from the traumas of his service in the Dardanelles, artist and signaller Ellis Silas was finally able to use his unique experiences to ask the pertinent question of the 'legacy of emptiness', a dense and sodden aftermath that would gradually suffuse the desolate landscape of that doomed peninsula:

> Fighting still continuing with unabated vigour—will this frightful noise never cease? I wonder what this valley will be like when there is no longer noise of fighting, no longer the hurried tread of combating forces—when the raw earth of the trenches is o'erspread with verdant grass. Perhaps here and there equipment of War will be lying with fresh spring sprouts of grass threading through interstices—underneath the sad little mounds resting sons of a great nation—in the clear sky overhead, instead of the bursting shrapnel, little fleecy clouds—the scream of shrapnel, the Hell noise of the firing, giving place to an unbroken stillness save for the chirping of a bird or the soft buzzing of the bee! I wonder would it be thus![49]

(49)
Ellis Silas, 'The Diary of an Anzac', p.5, typescript, ML MSS.1840, Mitchell Library, State Library of New South Wales.

'RIDICULOUS MAD INCONGRUITY!'

THE LEGACY OF PAUL NASH AS AN ARTIST
OF TRAUMA, WILDERNESS AND RECOVERY

Paul Nash
Wire
1918
Watercolour, chalk
and ink on paper
72.8 × 85.8 cm
© Imperial War Museums
(IWM: ART 2705)

Paul Nash: 'This tree sense'

Of all the British artists of the last century, Paul Nash is perhaps the one most readily associated with the sanctity and loveliness of trees. Absorbing the 'pathetic fallacy' into his very being, he regarded them as an extension of his own body. Enthusing about their properties in 1912, he wrote:

> I have tried ... to paint trees as tho' they were human beings ... because I sincerely love & worship trees & know they are people & wonderfully beautiful people—much more lovely than the majority of people one meets. [1]

As a visionary painter, Nash also understood their metaphysical potential, sensing how trees linked the underworld, the earth's surface and the skies. [2]

His early work as a student at the Slade School of Fine Art in London gave little indication of the artist he was to become; his drawings displayed a strong attachment to the Pre-Raphaelites, especially to Dante Gabriel Rossetti and his fresh-faced visions of romantic death. Faces soon vanished from his work (though an often-invisible human presence never did), to be replaced with strange moonlit landscapes, which fused ancient landmarks with anthropomorphised natural forms. [3] All of this changed when warfare overwhelmed the natural order in Northern France and Belgium, and Nash was drawn into the maelstrom of the war. Across the verdant plains of Flanders, Artois and Picardy, trees offered vantage and protection, they provided raw materials and nourishment and they lay in thick forests as well as neat copses. Their decimation was remembered by all who witnessed it:

> I never lost this tree sense: to me half the war is a memory of trees; fallen and tortured trees; trees untouched in summer moonlight, torn and shattered winter trees, trees green and brown, grey and white, living and dead. They gave their names to roads and trenches, strong points and areas. Beneath their branches I found the best and the worst of war. [4]

Amid the devastation, human relationships with nature—and with trees especially—were forced to change. 'Wood, leaves, roots and branches took on new symbolic meanings and sensorial qualities.' [5] Camouflage mimicked their elegant

(1)

Claude Abbot and Anthony Bertram (eds.) Poet and Painter: Being the Correspondence between Gordon Bottomley and Paul Nash, 1910–1946. London: Oxford University Press, 1955, p.42.

(2)

James King, Interior Landscapes: A Life of Paul Nash. London: Weidenfeld and Nicholson, 1987.

(3)

Anthony Bertram, Paul Nash, the Portrait of an Artist. London: Faber and Faber, 1955.

Andrew Causey, Paul Nash. Oxford: Oxford University Press, 1970.

(4)

Richard Talbot Kelly, A Subaltern's Odyssey: A Memoir of the Great War, 1915–1917. London: William Kimber, 1980, p.5.

(5)

Nicholas Saunders, correspondence with the author, 15 June 2009.

patterns, fake trees concealed snipers and observers, copses hid batteries of artillery, subterranean dugouts were filled with the smell of freshly hewn wood and ancient willows were bent into shape as revetments for frontline trenches. Woodlands were transformed into strongholds that were fiercely fought over by both sides. Single, isolated trees became a registration point for enemy artillery. Soldiers soon learned to avoid such places:

> The 'Lone Tree' was the assembly point for the wounded, and all around on the grass there were dozens of wounded on stretchers waiting to be taken down by the ambulance column. This tree was a favourite for the German artillery and I could never understand why the wounded, transport, cookers and ambulances were allowed to congregate in this area. Apparently, somebody later recognised the danger and the tree was felled. [6]

Surely this was one of the cruellest ironies of that terrible war? A once attractive, freestanding tree was now to be feared and regarded as a point of maximum danger. What was once an icon of nature, to be cherished as a place of refuge and shade, had become horribly inverted by the chaos of war. During the course of the fighting, trees and especially small woods, were to become notorious death traps. Mansell Copse, Inverness Wood, Thiepval Forest and dozens of others, some no larger than a hockey pitch, were to become infamous killing grounds—sites of extraordinary mayhem fought over for months. [7] On trench maps, the very words—'copse', 'wood', even 'forest'—soon became irrelevant as trees were felled by artillery shells, reduced to splinters, charred by fire and felled for military use. So systematic was the destruction and so ruthless the cutting, it was estimated that it would take half a century for many areas to be able to produce decent timber again. French horticulturalists coined the term 'forest trauma'. [8] Today a few ancient trees remain: a hornbeam that miraculously survived the utter devastation in Delville Wood, its trunk still speckled with fragments of metal; another rooted in a barrel of cement, marking the point in no-man's-land where hundreds of inexperienced soldiers from the Newfoundland Regiment collected in search of a gathering point, only to meet a sudden, bloody and unnecessary end in the first 40 minutes

(6)
Arthur Stuart Dolden, *Cannon Fodder*. Blandford: Blandford Press, 1980, p.39.

(7)
Paul Gough, 'Sites in the Imagination: The Beaumont Hamel Newfoundland Memorial on the Somme', *Cultural Geographies*, 11 (3) 2004, pp.235–258.

(8)
Hugh Clout, *'After the Ruins': Restoring the Countryside of Northern France after the Great War*. Exeter: Exeter University Press, 1996, pp.30–34.

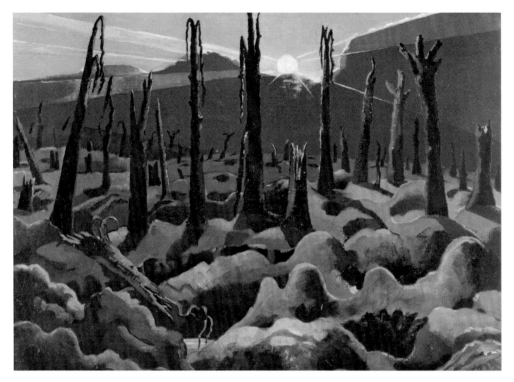

Paul Nash
We Are Making a New World
1918
Oil on canvas
71.1 × 91.4 cm
© Imperial War Museums
(IWM: ART 1146)

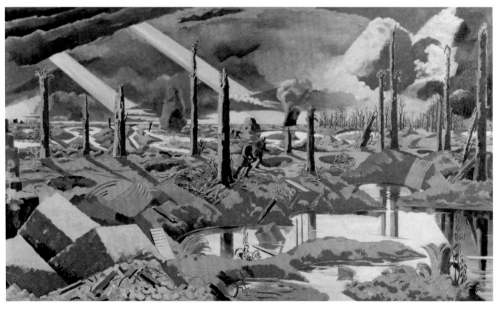

Paul Nash
The Menin Road
1919
Oil on canvas
182.8 × 317.5 cm
© Imperial War Museums
(IWM: ART 2242)

of the first day of the Battle of the Somme. It stands today, an ashen stalk once promising succour, but delivering only pain and death.

Nash saw all of this. In the Ypres Salient he was aghast at the sight of splintered copses and dismembered trees, seeing in their shattered limbs an equivalent for the human carnage that lay all around and even hung in shreds from the eviscerated treetops. In so many of his war pictures the trees remain inert and gaunt, failing to respond to the shafts of sunlight; their branches dangle lifelessly 'like melancholy tresses of hair', mourning the death of the world and its values, which Nash held so dear. [9] Was Nash aware that a century earlier, another young British painter had devised an extraordinary image of an equally poisoned and murderous landscape? At its centre was the notorious 'upas tree':

> This fabulous tree was said to grow on the island of Java, in the midst of a desert formed by its own pestiferous exhalations. These destroyed all vegetable life in the immediate neighbourhood of the tree, and all animal life that approached it. Its poison was considered precious, and was to be obtained by piercing the bark, when it flowed forth from the wound. So hopeless, however, and so perilous was the endeavour to obtain it, that only criminals sentenced to death could be induced to make the attempt, and as numbers of them perished, the place became a valley of the shadow of death, a charnel-field of bones. [10]

The fable of the dreaded upas tree is based on the tale of the poisonous anchar tree, first revealed by the eighteenth-century botanist Erasmus Darwin. During the Romantic era it became a familiar and potent image adopted by poets such as Samuel Taylor Coleridge, also occurring in Lord Byron's *Childe Harolde's Pilgrimage* and in Robert Southey's epic poem *Thalaba*. But probably the most significant evocation of this bizarre plant is in the vast canvas painted by the Bristol-based painter Francis Danby. He painted *The Upas, or Poison-Tree, in the Island of Java* in 1819 when he was just 26; a year later it heralded his triumphal arrival on the London art scene. By the standards of its time, it is not a huge painting—some five feet by seven—but its sense of scale is striking. A cowering figure is dwarfed by the landscape, the tree—little but a vertical stalk—dominates the surrounding

[9]
Richard Cork, *A Bitter Truth: Avant-Garde Art and the Great War*. New Haven: Yale University Press, 1994, p.201.

[10]
Richard Redgrave, *A Century of Painters*. London: Graves and Armstrong, 1886, p.483.

(11)

Francis Greenacre, *Francis Danby: 1793–1861*.
London: Tate Gallery Publications, 1988, pp.89–91.

(12)

Claude Abbot and Anthony Bertram (eds.) *Poet
and Painter: Being the Correspondence between
Gordon Bottomley and Paul Nash, 1910–1946*.
London: Oxford University Press, 1955, p.98.

(13)

Paul Gough, *'A Terrible Beauty': British Artists and
the First World War*. Bristol: Sansom and Company,
2010, p.148.

terrain and the rocky valley, said to have been modelled on the Avon Gorge near Bristol, is a hazardous, leafless place of crags and fissures, surrounded by the wasted corpses of fated men. [11]

The painting was equally doomed; after mixed reviews it sold for £150, but the fee went straight to a host of creditors, Danby having worked up an impressive personal debt during his stay in Bristol. Within years the picture declined in quality; untested technique and thick varnish rendered the image almost unreadable. By 1857 the picture was barely visible—it was as if the poisonous exhalations of the motif had spread to the painting's very surface. Extensive cleaning and removal of layers of dark varnish have since revived the picture, but even after laborious conservation it still catches the light and is difficult to see. Like the eponymous tree itself, one approaches the vast canvas with squinting eyes and a cautious tread.

Ninety-nine years after Danby finished his painting, Paul Nash—also in his late twenties—was struggling with his own magnum opus, the huge canvas now known as *The Menin Road*—the painter's first foray into oil paint, an act (as he put it) of 'great audacity'. [12] Like Danby's image it describes a blighted land—the dystopian wilderness of the Western Front, a pestilent waste of shattered trees, toxic soils and scattered bones. Perhaps here, for the first time since Danby depicted the corrupted 'poison anchar of Java', might *The Upas* be found in its modern incarnation.

In fact, Nash served for only a very short time on the frontline. In May 1917, after less than eight weeks in Flanders, he was injured in a bad fall and invalided home only days before many of his fellow officers were killed in an offensive. However, what he saw in that short time had a radical impact on him and his art. Most notably, he was stunned at the uncanny perseverance of nature. [13] Although war had wreaked havoc, nature was proving extraordinarily resilient. Nash wrote of walking through a wood, or at least what remained of it, after the shelling, when it was just 'a place with an evil name, pitted and pocked with shells, the trees torn to shreds, often reeking with poison gas'. Weeks later, to his great surprise, this 'most desolate ruinous place' was drastically changed. It was now 'a vivid green':

The most broken trees even had sprouted somewhere and in the midst, from the depth of the wood's bruised heart poured out the throbbing song of a nightingale. Ridiculous mad incongruity! One can't think which is the more absurd, the War or Nature ...[14]

Nash was both bemused and maddened by the strange absurdities all around him, unsure whether to aim his eloquent anger at the war, at nature or at 'we poor beings [who] are double enthralled'. The war radicalised his painting; gone were the rather sentimental and derivative ideas borrowed from his Pre-Raphaelite phase; sidelined was the chivalric idealism of his late youth, to be replaced by a tougher language that matched the novel and grim conditions he had witnessed. Never before had he been subject to circumstances and places that were so 'pitiless, cruel and malignant'. For possibly the first time Nash was seeing for *himself*, not applying the tired conventions of an art practice or imposing the vision of others. As one astute biographer so vividly remarks, 'He saw it'.[15] His brief service in the frontline trenches blasted him into the public eye. In July 1917 he mounted a show of eighteen small drawings at the Goupil Gallery in London, which marked a distinct shift in his style. Gone were the fluffy elms: to be replaced by splintered woods and panoramic views of the hollowed Salient. Although he knew of the Vorticists and had recently purchased a copy of one of Nevinson's dry points of Ypres, his drawing did not yet display the technical advancement of his contemporaries, nor did it display the scream of tragedy that would fill his later works, but it was instantly memorable. As one observer noted with admiration, the work had 'an actuality, an immediacy, that brought to life everything about the front which people had read and heard but had found themselves quite unable to visualise'.[16] One rather sensitive drawing, tellingly entitled *Chaos Decoratif* (1917), suggests in its very title that Nash was still enamoured of the graceful curves and decorative arcs produced by the fallen boughs of once-elegant trees. Warfare is implied rather than impressed upon the viewer; the sombre tones, scored surfaces and dramatic diagonals that would manner his later war work had yet to emerge and Nash was clearly searching for a graphic language that mirrored his experiences as a soldier. His search took him

(14)
Paul Nash, *Outline: An Autobiography and Other Writings*. London: Faber and Faber, 1948, p.187.

(15)
Anthony Bertram, *Paul Nash, the Portrait of an Artist*. London: Faber and Faber, 1955, p.91.

(16)
Margot Eates, *The Master of the Image 1889–1946*. London: John Murray, 1973, p.22.

in unusual directions: one particularly tense drawing made on leave in Gloucestershire depicts the serried ranks of bald orchard trees, separated from the viewer by ditches, sturdy fence posts and barbed wire, while overhead two birds appear to collide in a dispute over territorial dominance. Nash had rarely been attracted to sites of such strict land management and may have sought refuge in its reassuring symmetry. However, the war does not seem very far away from his thoughts and in these and subsequent war pictures—such as *The Mule Track* (1918) and *The Menin Road* (1919)—Nash proved to himself, and to a growing crowd of admirers, that he could extend his earlier experiments with the southern English landscape into new locations and be equal to its peculiar, even nihilistic, demands.

The legacy of Nash at war: The tree drawings of Gail Ritchie

Few British painters can address issues of warfare and its impact on nature without some recognition of Nash's standing as a painter of panoramic devastation. He recognised with some discomfort, like Wilfred Owen and others, that his dread fascination with the effects of war seemed to fuel his imagination, to hone his talent in ways that he might least have anticipated. Artists, poets and writers may not have sought 'awe-full' experience but they did not shy away from its uncomfortable aesthetic, at times embracing the 'negative sublime' that was a constant accompaniment of modern warfare on a global scale. [17]

Painter Gail Ritchie is aware of the contradictions in Nash's art; of his fascination with the aesthetic of conflict and his abhorrence at its impact on the natural order. Ritchie grew up in a military family, her grandfather and great grandfather both serving in the Royal Inniskilling Fusiliers, the latter dying just outside Albert on the Somme during the Great War, and her upbringing in Northern Ireland was peppered with the worrying news of random sectarian violence. For many years her work has addressed the visual rhetoric of remembrance, most recently in an extensive suite of ink drawings, *Memorial Series* (2009). In this developmental piece, 36 sheets of gridded paper are arranged in a six by six display. On each sheet a drawing made in fine-tipped red

(17)

Paul Gough, *A Terrible Beauty: British Artists and the First World War*. Bristol: Sansom and Company, 2010, pp.226–27.

ink shows a battlefield monument from a range of countries—
the Newfoundland Caribou at Beaumont-Hamel on the
Somme, the Brandenburg Gate in Berlin, the Canadian's
double-pylon at Vimy Ridge. Others are taken from monuments
of all shapes, sizes and scales in Italy, Russia and the USA.
Ritchie has drawn each memorial to the same size on each
sheet of paper—scale is irrelevant—and each monumental
form is described in the same unwavering neutral outline
with a modicum of finely hatched tone. As non-partisan
diagrams of monumental memory, Ritchie has attempted
to encode the essential features of all memorial markers, to
systematise them rather than identify their idiosyncrasies
or their own symbolic properties. She has used equality of
scale to convey the equality of loss. 'It would', she writes:

> … be difficult to convey accurately the scale of the
> Thiepval Memorial against a plinth-based unknown
> soldier in a town square. Both stand for the same
> thing—loss—and it would again be difficult to
> measure the weight of one person against another.
> The monuments of the Great War, with regard to the
> name lists, gave equality to the dead and I tried to
> carry this through in the drawings. [18]

Thus, shorn of context,
Ritchie has taken to display them in various ways: the choice
of 36 drawings is an echo of the famous 36th Ulster Division
in which her grandfather served. In one show they were
arranged as a huge 'W', in others as a double pyramid, in
another like a huge tablecloth. Such decorative arrangements
contest the symbolic gravity and the nationalist context of the
memorials themselves and to this end the work has aroused
strong responses in viewers who feel the neutral language, the
singular tonality and the deadpan presentation is improper for
such icons of grief and remembrance. Diagrams, it has been
argued, deny compassion and empathy.

Ritchie often worked in
sequences; each watercolour in her suite of *Wounded Poppies*
(2009) is named after Irish and Northern Ireland soldiers who
were shot at dawn during the Great War. [19] Like Nash's paintings,
flowers represent human beings. Where he paints 'headless'
stumps of blasted trees, Ritchie uproots this most brittle of
flowers, emphasising its frailty and transience, its rhizomatic
nature and its associations with opium and the sleep of reason.

(18)
Gail Ritchie, interviewed by the author, 8 January 2010.

(19)
Gail Ritchie, *Gail Richie Art*. Accessed 10 March
2018, gailritchie.com.

Gail Ritchie
Memorial Series
2009
Red ink on gridded paper,
each sheet 29.7 × 21 cm

Gail Ritchie
Somme Poppy Series
2009
Watercolour on paper
30 × 20 cm

But possibly Ritchie's most contentious recent work is her ambition to create an open-ended suite of 'Tree Ring' drawings. The origin of this long-term project lies in a serendipitous moment when glimpsing a log pile in Albert on the former Somme Battlefield in France at the same moment as browsing a pictorial spread in a British newspaper that carried portrait photographs of the dozens of British servicemen who had died in the fighting in Afghanistan. 'Growth rings', also known as 'tree rings' or 'annual rings', can be seen in any horizontal cross-section cut through the trunk of a tree. They indicate new growth in the vascular cambium and result from the change in growth speed through the seasons of the year. Invariably, one ring marks the passage of one year in the life of the tree.

Ritchie saw a connection between dendrochronology (the scientific method of dating based on the analysis of patterns of tree rings) and the lives of soldiers killed in action. Drawing a parallel between the passage of time marked on each tree and the abbreviated lives of dead soldiers, Ritchie has created a suite of portraits that connects the two sets of stunted 'lives'. Each drawing is painstakingly executed in a hard 6H pencil and engraved marks, as if to inscribe each year of tree growth into the body of the paper; a softer 8B pencil is used to fill out the deeper, darker tones. Her first exploratory drawings were simply captioned 'Captain – 29', but now the rings are arranged in sobering sequences of age—a row of three 24-year-olds; a row of five 18-year-olds, each uniformly entitled as 'Larch 35' or 'Larch 23'. As in the *Memorial Studies* suite, the presentation—deadpan, unadorned, unframed—is deliberate, even provocative and there is an outright refusal to offer more than the most economic explanation about the historic origin of the image or the conflation of fallen (or chopped) trees and the 'fallen' of the battlefield.

Fifteen tree rings were shown in Paris in 2009 and aroused an array of responses and readings from visitors, some choosing to see faces, brain scans, targets or even bullets embedded in the outer carapace of the tree's cross-section. Many were clearly shocked at the simple but telling parallel between annual growth and sudden termination. As Ritchie notes, the project has no end point; it is open-ended, predicated on the duration

of the war in Afghanistan and an unknowable number of British dead. Far from being provocative she sees these artworks as reconciliatory, a joining of natural forces with lost lives, but she recognises the parallels with premature logging, the felling of immature organisms by violent means. In Northern Ireland, notes Ritchie, such artworks are inevitably seen through the prism of The Troubles, especially when many of the *Poppy* watercolours have local names—John, Shaun, Patrick—and the tree rings draw harsh attention to numbers, age and the duration of conflict. Felled trees as surrogates for corpses appeared often in Paul Nash's post-war work. He used the motif of log piles many times, neatly stacked in *Landscape at Iden* (1929) and again in the funeral pyre of wood for his illustrations in *Urne Burialle* (1932). Here, in both Nash and Ritchie, we see echoes of the tension between formalised spaces—parks, arboreta, plantations—and the informal, outwardly chaotic appearance of untrammelled nature.

In her most recent drawings of ancient gnarled trees, standing sentinel in the Northern Ireland landscape, Ritchie has become enthralled by how they function as repositories of local and collective memory. She has been visiting and drawing one veteran specimen, which has over the years been impregnated with votive offerings, studded with nails, coins and political logos and strewn with paraphernalia. Under siege from those who wish to preserve it and those who want it burned down, this tree epitomises for Ritchie the uncomfortable issues of violation, despoliation and political division, which run invisibly through the social and topographical sub-strata of Northern Ireland. Ritchie's forensic drawings of these ancient wizened stumps brings us back to Paul Nash and the poison tree of Java as an icon of dread fascination that both lures and repels. There is also a parallel between Ritchie's drawings of stunted lives and felled saplings and the emergence at Alrewas of the Ulster Ash Grove, the 1000 trees planted to commemorate each member of the security forces killed on active service between 1969 and 2000. In a reversal of Ritchie's images of truncated growth, the Ash Grove proposes enduring memory through strategic planting and tight numerical design.

Gail Ritchie
Tree Ring Series
2009
Pencil and engraving on paper
40 × 100 cm

Gail Ritchie
Tree Ring 37
2009
Pencil and engraving on paper
30 × 30 cm

Julian Perry: Creating places of enchantment

Describing him as one of the most intelligent of the British modernist painters, Julian Perry has also made explicit references to the impact of Paul Nash on his own writing and painting. Perry recognises how Nash fused the innovations of European Surrealism with the British Romantic tradition and how he oscillated between informal and formalised renditions of the natural order. He is keenly aware of how Nash's career shifted from the borrowed language of the Pre-Raphaelite Brotherhood through the emotional crisis of the First World War into the spiritual mysticism of the *Vernal Equinox* series. Through catalogue essays and interviews [20] Perry writes about their common approach to nature (and in particular to trees), their joint understanding of trees as 'potential emblems of nihilism' and a shared use of motifs, designs and compositional devices.

A landscape painter with a long record of exhibitions and commissions, Perry's exhibition *Testament* (2004) exemplifies his affinity with Nash and draws interesting comparisons between the painter's fascination with carefully chosen tracts of southern England in the 1920s and 1930s and Perry's recent expeditions on the imperilled coast of Suffolk, along London's Lea Valley (site of the 2012 Olympics) and particularly in Epping Forest during 2003–04. [21]

Perry was attracted to Epping Forest for its geographic and historical character. Secured in 1882 by the Corporation of London and bounded by the M11, M25, the A112 and the North Circular Road, the forest functions as an invaluable, if slightly choked, lung for east London and harbours some of its most memorable historical venues, not least of which is the site of highwayman Dick Turpin's 'cave' tucked into the side of the two-thousand-year-old ditch surrounding Loughton Camp. It is, as Perry notes:

> ... one of the few surviving examples of medieval woodland management [in England]; a complex system of cyclical harvesting, based on the paradox that trees grow faster, produce different leaves and live longer, if you drastically cut them back at intervals of approximately twenty years. [22]

Intensively and skilfully managed, the forest has, for over a thousand years, been

(20)
Julian Perry, *Julian Perry: Testament*. London: Guildhall Art Gallery Publications, 2004.

(21)
Julian Perry, *Julian Perry: A Common Treasury*. London: Austin Desmond, 2007.

(22)
Julian Perry, *Julian Perry: Testament*. London: Guildhall Art Gallery Publications, 2004, p.24.

a vital source of food for people and animals, yielding food (nuts and berries), fuel (charcoal and kindling) and timber (from fencing poles to building materials).

Perry brings his deep understanding of the historical and biological rhythms of the forest to his paintings, but his motifs are often drawn from more mundane sights: *I saw this* (2004) depicts a vehicle hubcap trapped in the branches of a small tree, the detritus of urbanism litters the forest's glades and clearings, offstage the sound of cars is omnipresent. Perry exhibited seven large canvases and twelve smaller works at the Guildhall Art Gallery (in association with Austin Desmond Fine Art) in Autumn 2004. One of the most memorable pieces was a large oil painting showing what appears to be a circular pond under ice surrounded by thin, spare saplings, their shadows black across the frozen veneer of the pond, the surrounding woodland heavily covered in piled snow. However, this is no ordinary pond. From September 1944 to March 1945 a number of V-2 rockets fell on Epping Forest. Launched from northern Europe in the dying months of the war, they fell harmlessly in the woods creating sizeable craters, war wounds now rendered as a civic amenity.

> This pond did not exist until early in 1945 ... [T]he rocket, launched from Belgium 6 minutes earlier, was over 40 ft tall and had travelled at more than three times the speed of sound. The explosion could have been heard more than twenty miles away; a double boom, first the explosion and then the sonic shock wave. In the 1960s the pond was surveyed and found to be home to four species of fish; it now has two Corporation of London 'No Fishing' signs. [23]

(23)
Julian Perry, interviewed by the author, 9 January 2010.

There is something in Perry's image that is reminiscent of Paul Nash's extraordinary painting *Totes Meer* (1940)—the German words for 'dead sea'—that was inspired by the sight of a dump of wrecked aircraft at Cowley in Oxfordshire. Nash described the weird sight thus: 'The thing looked to me suddenly, like a great inundating sea ... the breakers rearing up and crashing on the plain. And then, no: nothing moves, it is not water or even ice, it is something static and dead.' [24] Unlike Nash's writhing and jagged shards, Perry's militarised pond is actually frozen over, catching long blue shadows in snow the colour of silence, the noisy cataclysm of its origins long blown

(24)
Simon Grant, 'A Landscape of Mortality', *Tate Magazine*, 6, 2003, accessed 13 April 2018, tate.org.uk/magazine/issue6/nash.htm.

Julian Perry
Rocket Crater Pond in Snow II
2004
Oil on panel
122.5 × 215 cm

away in the westerly winds. But Perry has a knack of finding and describing places that are latent with the potential for sudden noises and unexpected violence. His most recent project has been along the vulnerable eastern shoreline of Lincolnshire where the soft land is being irreversibly eaten away by a voracious sea. Just north of Dunwich, says Perry, the countryside appears to continue eastward and then literally stops dead at precipitous and alarmingly recent cliff edges. On the newly laid beach, healthy recently growing trees are left sticking out in the sand.

Just as Nash was drawn to such landscapes, Perry has 'a feel for in between zones, for places where boundaries waver and enclaves are created'. [25] He has a natural affinity for in-between or liminal places in the southern English landscape, places that are ostensibly empty, but full of latent energy and unexpectedness. These phenomena found their most extreme form in the disputed territory of no-man's-land on the Western Front. Painters, poets and writers developed a morbid obsession with its phantas-magoric terrain. Welsh poet David Jones describes its topography as haunted by 'sudden violences and long stillnesses', likening it to a place of enchantment. [26]

Perry makes explicit reference to a parallel land of trenches, duckboards and liminality in a number of paintings, most notably in a series called *Viewing Point* (2000), which was painted at a tract of woodland near Waltham Abbey. Working alongside forest rangers, Perry came to understand that many of the non-indigenous tree types were actually invasive foreigners that had to be eradicated, sometimes by adopting rather extreme measures. Other parts of the forest had to be made accessible by laying raised wooden walkways that could penetrate the interior of the woods, especially those thicker patches of foliage that were the preferred habitat of rare birds and shy species. His new 'interior' knowledge permeates the canvases. In *Coppicing for Nightingales* (2000), a wooded causeway zigzags into the thickets, evoking, as William Feaver has noted, 'the tenuous, but unavoidable, parallels to be drawn with the zigzagging duckboards of the Western Front in the paintings by Paul Nash, whose images of martyred trees and suppurating shells holes recur'.

(25)
William Feaver, 'Julian Perry', in *Julian Perry: Testament*. London: Guildhall Art Gallery Publications, 2004, pp.6–9.

(26)
David Jones, *In Parenthesis*. London: Faber, 1937, p.x.

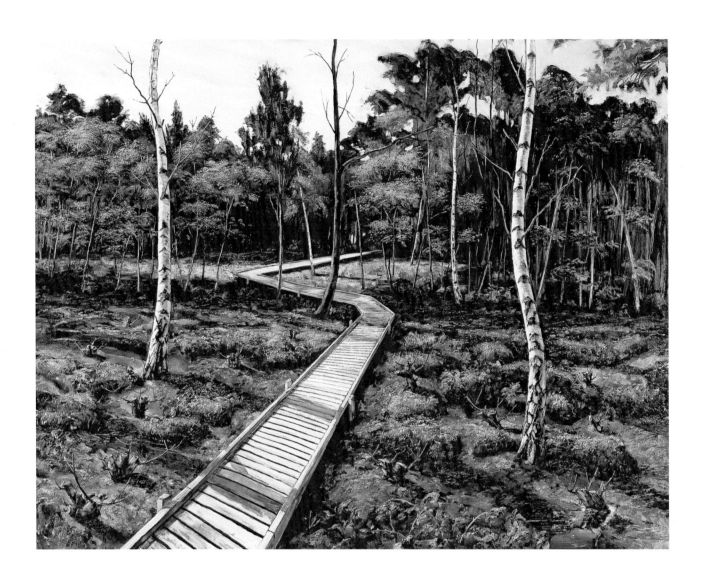

Julian Perry
Coppicing for Nightingales
2000
Oil on panel
122.5 × 215 cm

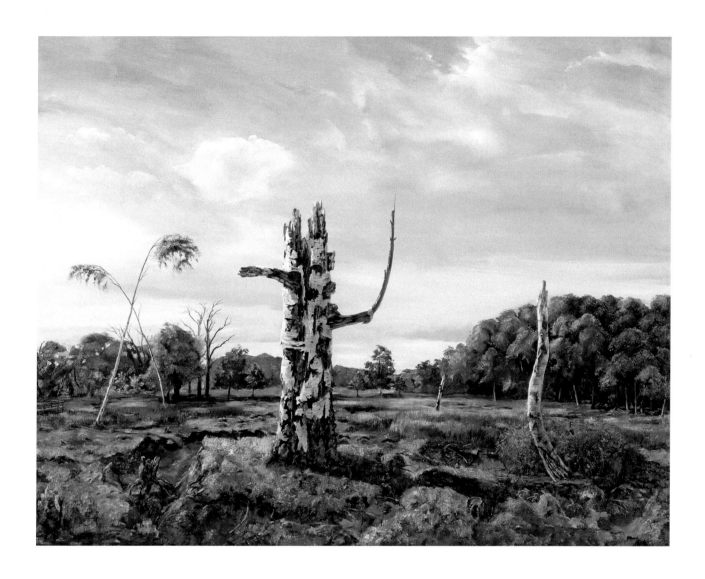

Julian Perry
Long Running
2004
Oil on panel
122.5 × 158 cm

Perry actually feels the links are much less tenuous. He recognises the parallels between his use of duckboard tracking through 'nature rambles' and Nash's war paintings *The Mule Track* (1918) and *The Menin Road* (1919). He speaks of them as seminal paintings in recent European art history, which explores how fragile, temporary routes can tease a way across violated land. He is also aware in these large paintings of the subtle pictorial parallels made between brambles and barbed wire, between large puddles and shell craters.

In equally large canvases such as *Long Running* (2004), Perry depicts a suite of fragmented and isolated silver birch trees, which have over time encroached on the open space, threatening to destroy its unique character. Not only is the central tree reminiscent of those fake, metal-lined periscope trees that were erected by the Royal Engineers on key parts of the Western Front, but it is surrounded by a deep trench of newly dug earth. The reason is simple, if somewhat surprising: one of the few effective ways of ridding a tract of rhizomatic silver birches is to dig out its roots, exposing them through perimeter entrenchment or as a last resort to blow them up with explosives. Here again there are oblique references to landscapes of war, to places suffused with tension and expectation, those outwardly becalmed and settled tracts that are in reality potent places of sudden noise, disturbance and even danger.

Robert Perry: Nocturnal visions and haunted woodlands
British landscape painter Robert Perry (no relation to Julian) has been visiting and painting the battlefields of the Western Front for the past 25 years. Working outdoors in all weather conditions, Perry often paints at night under the beam of powerful arc lights, which gives an extraordinary spectral quality to his highly wrought paintings and drawings. Familiar with the memoryscape of the old Somme frontlines, he also ventures deep underground to depict the trench systems and craters of the great forts at Verdun, Douaumont and Vaux and the labyrinthine tunnels of the tortured terrain around Vauquois.

Painting *en plein air* on a large scale in difficult, often adverse, conditions will test any painter. Perry embraces the challenge with grit and unbridled zeal. It is evidence of his commitment to taking risks in his art, to not

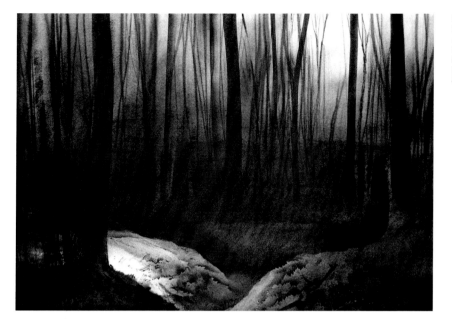

Robert Perry
Lamp-lit trenches, Aveluy Wood,
moonrise, 8.35 pm
18 February 2000
2000
Charcoal and ink on paper
29.7 × 42 cm

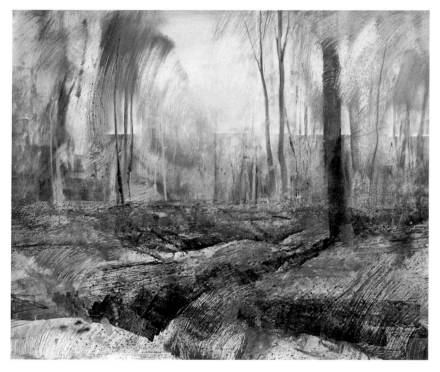

Robert Perry
Trenches in Aveluy Wood (Part A)
4.30 pm, 5 February 2000
2000
Oil on board
84.1 × 118.9 cm

being precious, to avoid falling into mannerisms that can so easily lead into casual over-production. He recognises that the temptation for any painter, especially under harsh conditions or when faced by a crisis of confidence, is to reach out to familiar ways, to take refuge in tried and tested approaches. Few genuine painters appreciate it when their work is described as 'formulaic'. On one of his annual painting expeditions to the Somme, Perry knows he has to take risks. So, he continues in his published diary:

> *Decided to paint big using 2 AO boards on my large 'side by side' easel … Completed two large oil paintings which I think come somewhere near capturing the essence of Aveluy Wood. They still seem a bit tentative, but the depiction of thick woodland is technically unfamiliar territory for me.* [27]

A long day beckons. Perry starts preparing at 9 am and eventually turns to the task of designing and tackling the painting a couple of hours later. He works in 'short, tentative but vigorous bursts', blocking in the substructure of the image, bringing clarity to key components of the composition only to see them lost as he works his way across the rest of the picture surface. The painting progresses in fits and starts. The sun breaks through, bringing a helpful clarity to the trees and the bushes in the mid-distance. It throws deep shadows across the foreground that helps him to establish the contours of the broken ground and the pock-marked interior of the woodland. Cloud cover, however, soon eliminates the sun and by early afternoon a light drizzle sets in, gradually worsening until by 4.15 pm it is a steady downpour. Most painters who work *en plein air* can cope with drizzle, even rain. It is the wind that unnerves and invariably upsets the day, as the drizzle evolves into a downpour. Perry's palette seems to emulsify and then the wind intensifies, making conditions almost unworkable.

Having completed the painting to his satisfaction, Perry now has to pack his gear, protect the surface of the painting and—retracing his steps—secure it to the side of the van as the wind starts to whirl around with increasing power. On this occasion it takes over two and a half hours of desperate clearing and sorting, trudging back and forth laden with kit to the van parked some distance

(27)

Robert Perry, diary entry, 5 February 2000, *An Artist's Diary: Robert Perry in the Somme Battlefields Winter 2000*, privately published, 2001, p.15.

Many of Robert Perry's statements about his art can be found on his website, robertperry-artist.co.uk.

Keith Henderson
Study of a shell burst
1917
Charcoal on paper
17.7 × 32.3 cm
© Imperial War Museums
(IWM: ART 245)

away. It is uncomfortable and frustrating work, made worse by the constant rain, the infamous 'instant' Somme mud and the thick undergrowth that trips and snags his every step. At one point he falls, sprawling, along with two 2.5 litre containers of white spirit, a sketching stool and weighty items of equipment. Reflecting on the strain of those long hours in the dusk and deluge, Perry accepts that his mode of painting will always require a laborious procedure:

> *Everything must be done on site, nothing can be packed away uncleaned, airbrushes, large section of brushes (up to 8 inch) rollers, palette (size 18" × 24") palette knives etc. None of the processes can be hurried or skimped, no matter how heavy the rain becomes. It is intense and arduous labour.*[28]

And what of the painting itself? It is indeed an impressive piece of work, a tour de force of purposeful singularity. Perry's larger oils are very different in style and language than his drawn work. Executed in compressed charcoal with the addition of pen, graphite stick and pencil, his drawings are decidedly controlled in technique and application. To create passages of intense tone, he uses an ink-filled fibre pen to conjure up a matrix of rich cross-hatching that gradually builds the tonal base. This takes patience and persistence. Complimenting these intricate passages of tone, he uses an array of technical 'tricks' to create dramatic tension. Strips of paper or tape are deployed to create sharp edges; shards of leaf and twig are used as mini-stencils; paint is sprayed with an airbrush across these shards and leaves to give a strong silhouette to the foreground. In addition, the eraser is used adventurously, creating its own drawn mark and passages of ghostly delineation.

Through the use of this rich menu of devices, the tonality of Perry's work on the Somme oscillates between a deep velvet-like black to a lighter, quite spectral, white. These painterly techniques give a distinctly theatrical air to his compositions. The trunks of the trees act as columns within the formal architecture of his design; unflinchingly erect, powerfully vertical, they divide the picture surface logically and formally. As they diminish into the mid-distance they allow the eye to wander along the zigzagging valley of the old trench lines or to pause at a flooded crater. The design is dramatic, almost operatic in its impact. Schooled

[28]
Robert Perry, diary entry, 7 February 2000, *An Artist's Diary: Robert Perry in the Somme Battlefields Winter 2000*, privately published, 2001.

in decades of strict observational drawing, Perry's battlefield black and white compositions reflect a mature artist who can combine innovative picture-making with rigorous scrutiny of natural forms.

Where the drawings are calm, controlled and almost classical in their lighting and staged setting, the paintings are buzzing with untrammelled vim and energy. The very large painting *Trenches in Aveluy Wood, Authuille Wood in the background*, completed at around 4.40 pm on 7 February 2000, is more like a still from a cinematic presentation than a completed canvas. The tree line erupts with released energy; the sheer verticals of the young slim trees vibrate with splattered paint applied in diffuse clouds of dots and dashes. It is as if we are witnessing an artillery barrage or are in the midst of a maelstrom triggered by unseen fire. Much of this vortex of painterly energy is due to the vigour of the painted mark, to the sheer energy and urgency of Perry's brushwork. With its scraped surfaces, emulsified patches and restless tactility, the paintings are loud in a way that make the drawings seem quiet and calm. Just as we can almost hear the high-pitched twittering of the field larks in Perry's epic panoramas of the Somme, so are we almost deafened by the war-like clamour of this canvas.

Although Perry most often cites Rembrandt as his painterly talisman, comparisons with eminent British war artists abound. Keith Henderson devised a means of articulating the impact of an artillery shell in his *Study of a Shell Burst* from 1917; a shower of fragments and a flame of jagged form shoots up from the mangled earth. Robert Perry creates an equally energetic form in his canvases but they seem not to emanate from shellfire, rather more from the traumatised history of the wood itself. It is as if he is re-visualising a fragment of time from the prolonged devastation that happened nearly a hundred years earlier. The past master of these iconic battlescapes is of course the British painter Paul Nash. As is true of the other contemporary painters we have examined in this chapter, it is hard not to be reminded of the epic power of his work in Flanders in 1917:

> Huge spouts of black, brown and orange mould burst into the air amid a volume of white smoke, flinging wide incredible debris, while the crack and roar of the explosion reverberates in the valley.[29]

(29)
'Paul Nash to Margaret Nash, 6 June 1916', in Paul Nash, *Outline: An Autobiography and Other Writings*. London: Faber and Faber, 1948, p.153.

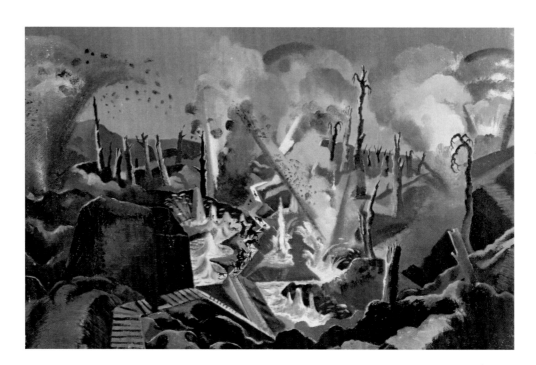

Paul Nash
The Mule Track
1918
Oil on canvas
60.9 × 91.4 cm
© Imperial War Museums
(IWM: ART 1153)

Perry's largest paintings transmit the same energy, the same crack, roar and echo. As we have seen with Julian Perry and Gail Ritchie, any artist working on the former British battlegrounds in France or Flanders will be aware of the painting *The Mule Track*. It is one of Nash's most powerful renditions of the savage inferno of the Western Front. Not only does it capture the chaotic, unpredictable energy and latent violence of the moment but, like Perry's oil, it uses painterly energy and texture in a supremely evocative way. In *The Mule Track* the sense of confusion and dislocation could not be more acute; it is as if we are watching a film with numerous incidents occurring simultaneously in every corner, where explosions are rendered as strange animations, artillery barrages are represented as forcefields and sharp diagonal edges sit uncomfortably next to diffuse patches of paint—the pictorial impact is immediately powerful.

In these troubled pastoral visions, the trauma of war is hinted at; the distant war is a spectral presence trapped in the perimeter of the copse of trees but also entrapped within the paintings' own edges. We are absorbed by the intensity of Perry's pulsating image. There is no escape, no pathway out of the broken ground, no release from the bounded edges of the woods. Violated nature is left to convey the aftermath of war and as with Paul Nash's best work it conveys places that are 'barren, sightless, godless'—a pitiless tragedy on an epic scale.

THE LIVING, THE DEAD

THE IMAGERY OF EMPTINESS AND
RE-APPEARANCE ON THE BATTLEFIELDS
OF THE WESTERN FRONT

C.R.W. Nevinson
Paths of Glory
1917
Oil on canvas
45.7 × 60.9 cm
© Imperial War Museums
(IWM: ART 518)

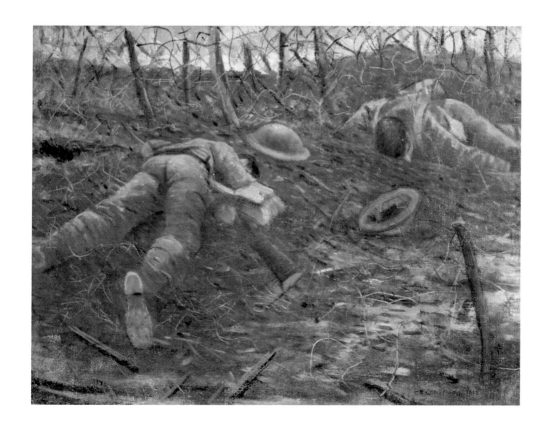

Dying

One was tall, gaunt Tom Gunn, the Limber-gunner of F. Sub-section. As we stood by his corpse someone lifted the blanket that covered his face. It was emaciated and the colour of pale ivory. The other man had died from shell shock. He stood upright by the wheel of his gun unmarked but quite dead. Just a short while before he had invited some of us to share in a parcel of food he had just received from home, but the party had to be cancelled. [1]

Statistically, the loss of young life in the First World War is quite overwhelming. Even when broken down into smaller numbers, the scale of death is numbing. In 1916, Sergeant Richard Tawney went 'over the top' on the Somme battlefield with 820 fellow Manchesters; 450 men died in the initial attack; after the second, just 54 answered the rollcall. [2] During the same battle the 1st Battalion of the Newfoundland Regiment—801 officers and men—were reduced to 68 uninjured men after a single day's fighting. [3] However, as many historians warn, these raw and terrible statistics must be treated with some care. Figures for the hardest hit units must not be projected on to the whole war, nor should one battle be regarded as typical of the experience of every foot soldier. While it is estimated that four and a half per cent of British fighting soldiers died during the Second World War and five per cent in the Boer War, some ten per cent died during the Great War. The daily attrition rate on the British stretch of the Western Front was over 200 soldiers. [4]

Death came in various guises. For many it came anonymously and suddenly. Artillery was the most lethal killer. While most frontline soldiers dreaded the prospect of hand-to-hand fighting, it was the power of cannon and mortar that was the real killer. [5] A wounded man was three times as likely to die from a shell wound to the chest compared to a bullet wound. Not only could distant guns pound a specific tract of earth for hours—sometimes days—but a direct hit from a heavy metal shell would completely obliterate the body, reducing a living being to little more than a putrid whiff of air. [6] For troops under heavy shelling, artillery destroyed not only the body, but the mind, inducing new depths of fear by its random anonymity.

(1)
William Roberts, *Memories of the War to End War, 1914–18*. London: Canada Press, 1974, p.13.

(2)
Richard Henry Tawney, *The Attack and Other Papers*. London: George Allen and Unwin, 1953, p.78.

(3)
Paul Gough, 'Sites in the imagination: The Beaumont Hamel Newfoundland Memorial on the Somme', *Cultural Geographies*, 11, 2004, pp.235–258.

(4)
John Terraine, *The Smoke and the Fire: Myths and Anti-myths of War*. London: Sidgwick and Jackson, 1980.

(5)
Gary Sheffield, *Forgotten Victory: The First World War Myths and Realities*. London: Headline, 2001, p.110.

(6)
Peter Conrad, *Modern Times, Modern Places: Life and Art in the Twentieth Century*. London: Thames and Hudson, 1999, p.215.

Death by bullet was equally hideous. Sniper fire nearly always targeted the head. Machine-gun fire was less clinical, tearing capacious holes in the body. Obscene and random, death was like black magic:

> … *bodies continued walking after decapitation; shells burst and bodies simply vanished. Men's bodies 'shattered': their jaws dropped and out poured 'so much blood'. Aeroplane propellers sliced men in to pieces.* [7]

Death from gas brought an entire new realm of suffering. Chlorine gas irritates the lungs and bronchial tubes, causing vomiting, violent coughing and breathing difficulties. Heavy doses would cause the lungs to deteriorate in seconds—the victim would cough up blood and die in minutes, 'doubled up, fists clenched, in agony'. [8]

Many, however, died without any visible sign of death, perhaps from shell percussion or from a hidden wound, though experienced soldiers would be able to detect the 'tell-tale blood drips on lips, in ears or lungs'. [9] Siegfried Sassoon came across one unmarked body that he lifted upright from its prone state in a ditch:

> *Propped against the bank, his blond face was undisfigured except by the mud which I wiped from his eyes and tunic and mouth by my coat sleeve. He'd evidently been killed while digging, for his tunic was knotted loosely about his shoulders. He didn't look to be more than eighteen. Hoisting him a little higher, I thought what a gentle face he had.* [10]

What happened next depended entirely on the ebb and flow of the battle and the specific conditions pertaining at the moment of death. Individual soldiers killed by sniper fire or shell explosion while holding a frontline post or near a road behind the lines, would be easily identified and buried in small or individual plots near the front or reserve lines. Artilleryman William Roberts' drawing *Burying the Dead after a Battle* captures the poignant scene of gunners, heads bowed gathered around their comrades' grave, while in the near-distance a town burns, an aeroplane falls from the sky and tanks pitch about under billows of shellfire. 'We buried our own dead', he wrote:

[7]
Joanna Bourke, *Dismembering the Male: Men's Bodies, Britain and the Great War.* London: Reaktion, 1996.

[8]
Peter Slowe and Richard Woods, *Fields of Death: Battle Scenes of the First World War.* London: Robert Hale, 1986, p.28.

[9]
Denis Winter, *Death's Men.* London: Allen Lane, 1978, p.206.

[10]
Siegfried Sassoon, *Memoirs of an Infantry Officer.* London: Faber and Faber, 1930, p.112.

... together with some left over from the infantry's advance, shoulder to shoulder in a wide shallow grave, each in his blood-stained uniform and covered by a blanket. I noticed that some feet projected beyond the covering, showing that they had died with their boots on, in some cases with their spurs on too. [11]

(11)

William Roberts, *Memories of the War to End War 1914–18*. London: Canada Press, 1974.

During the static years of siege warfare on the Western Front graves were dug in advance, some regiments setting aside plots of land for their own dead, even barring others from 'trespassing'. Many of these regimental plots would later be retained by the Imperial War Graves Commission as small and compact cemeteries dedicated entirely to particular units—Gordon's Cemetery near Mametz, for example. Most of these small and isolated plots would later be dug up; the bodies exhumed by Graves Registration Units and brought in to one of the vast 'concentration' cemeteries, located nearer villages and roads for easy access for visitors after the war. [12]

(12)

Philip Longworth, *The Unending Vigil*. London: Leo Cooper, 1967, p.14.

Not all of the dead would be buried intact. Souvenir hunters would strip a body of its every article, especially if the dead were the enemy and the further from the frontline the more cleanly picked. As Guardsman Stephen Graham later recalled: 'Those [bodies] nearest our encampment at Noreuil all lay with the whites of their pockets turned out and their tunics and shirts undone by souvenir hunters.' He remembered in particular, a well-clothed, six-feet-three-inches tall dead German, whose boots were taken first, then his tunic, 'A few days later he was lying in his pants'. [13] After a major set-piece battle, the work of the burial parties was unrelentingly grim. Those who had been killed during an attack or patrol might be less easily identifiable, having lain in no-man's-land or other parts of the battlefield exposed to enemy fire. Mass clearance was attempted even when a battle was in progress or where a front was still strewn with the recent dead. In the aftermath of the Battle of Loos in autumn 1915, Scots officer George Craike spent nights with groups of his men scurrying into no-man's-land to hastily cover the bodies of East Surrey soldiers who had died in large numbers a week earlier:

(13)

Stephen Graham, *Challenge of the Dead*. London: Cassell, 1921, p.67.

We crawled out of the trenches with caution in small parties, and dealt with the dead simply by putting them into depressions in the earth, or into shell holes.

William Orpen
A Trench, Beaumont Hamel
1917
Pencil on paper
41.9 × 53.3 cm
© Imperial War Museums
(IWM: ART 2393)

This was not a pleasant task and occasionally the arms disengaged from the bodies. However, the bodies were placed as far as possible in these holes and covered over with a light layer of earth, this earth being brushed or dug in by the entrenching tools. All the work had to be done on all fours, for to stand erect was courting disaster … The work was slow, laborious and difficult. [14]

(14)

Max Arthur, *Forgotten Voices of the Great War.* London: Ebury Press, 2002, p.105.

Once the worst of the fighting had passed, larger burial parties would be organised. Often consisting of soldiers from different units, motivated by the need to maintain morale, to achieve some modicum of hygiene and out of common humanity, they combed the former battlefield, their noses and mouths covered by fragments of gas masks, removing the identity discs if they could be recovered—the red disc destined for the orderly office, the green one left on the body to ensure accurate identification. Pockets would be searched to uncover pay books and other personal effects. There was little time for niceties:

… you put them in a hole ready dug with boots and everything on. You put in about ten or fifteen, whatever the grave will hold, throw about two feet of earth on them and stick a wooden cross on top. [15]

(15)

Winter, *op.cit.*, p.206.

Fragments of British dead were collected in empty sandbags and buried in mass graves as quickly as possible; their grave markers often listing little more than 'an unknown soldier' or possibly some indication of the regimental or unit title. Sapper Richards remembered gathering the remnants of one ghastly bombing accident, rescuing 'bits from telegraph wires where they'd been blown at great velocity' and burying them in a common grave. [16]

(16)

Arthur, *op.cit.*, p.106.

Sometimes the interval between death and discovery was too long and bodies had literally fallen to pieces ravaged by rats, weather and biological processes:

As you lifted a body by its arms and legs, they detached themselves from the torso, and this was not the worst thing. Each body was covered inches deep with a black fur of flies, which flew up into your face, into your mouth, eyes and nostrils as you approached. The bodies crawled with maggots. There had been a disaster here. An attack by green, badly led troops who had had too big a rum ration—some of them had not even fixed their bayonets—against

a strong position where the wire was still uncut. They hung like washing on the barbs, like scarecrows who scared no crows since they were edible. The birds disputed the bodies with us. This was a job for all ranks. No one could expect the men to handle the bodies unless the officers did their share. We stopped every now and then to vomit … the bodies had the consistency of Camembert cheese. I once fell and put my hand through the belly of a man. It was days before I got the smell out of my hands. [17]

Under these extreme circumstances every effort at maintaining decency was attempted. Burial parties tried to give 'these poor bleeding pieces of earth' a Christian burial by reading sections from the Book of Common Prayer. Even if a Minister, chaplain or priest could not attend, all the combatants felt it important that 'you buried your comrades and saw to it that their graves were marked with a wooden cross and a name'. [18] The hope of creating a more decent burial improved with distance from the front; whereas a loose covering of earth might be all that was possible at the trench lines, 'some old sacking' was considered an adequate and appropriate covering further from the front and canvas sheets were regarded as a suitable substitute for coffins in the military hospitals located in the rear zones. [19] Enemy dead were often left until last to be cleared from a battlefield. As Charles Carrington coolly noted they 'came last in priority, and more than once I have cleared a trench of its defunct tenants by throwing them over the parapet where someone might or might not find and bury them'. [20] Experienced soldiers could estimate the date of death from the colour and condition of corpses left out in the open—Caucasians turned from yellow to grey to red and then to black. In death, Senegalese soldiers turned white. [21]

Official War Artist William was astonished at the weird colours of the enemy corpses he stumbled across while roaming the abandoned Somme battlefields in 1917. He made a number of precise drawings describing the polished skeletons of German soldiers 'bleached white and clean' by the fierce summer sun. As he wandered over the emptied downlands of the Somme everything shimmered in the heat; abandoned clothes were baked into strange combinations of colour, 'white, pale grey and pale gold.

(17)
Stuart Cloete, *A Victorian Son: An Autobiography*. London: Collins, 1972, p.121.

(18)
Charles Carrington, *Soldier from the Wars Returning*. London: Hutchinson, 1965, pp.127–128.

(19)
Bourke, *op.cit.*, pp.215–216.

(20)
Carrington, *op.cit.*, p.128.

(21)
William Orpen, *An Onlooker in France*. London: Williams and Norgate: Ernest Benn, 1923, pp.23–24.

The only dark colours were the deep red bronze of the "wire", wild flowers sprouted everywhere ... in the evening, everything golden in the sunlight'.[22] His only companions on these sojourns were distant burial parties who were diligently digging up, identifying and re-burying thousands of scattered bodies in the larger concentration cemeteries. Orpen passed one such group near Thiepval Hill, resting from their unpleasant work and trying to identify the dead from their meagre finds—a few coins, pocket knives, an occasional identity disc—garnered from their long labour. Perhaps it was only artists who, commissioned to seek out the novel and unique faces of war, sought the imagery of death *in extremis*:

> Then suddenly round the bend in the trench I came to a great bay which was full of dead Germans, but they weren't a bit horrible. They had been dead for about six weeks and weather and rats and maggots and everything else had done their stuff. Now they were just shiny skeletons in their uniforms held together by the dry sinews, that wound round their bones ... It was a most weird and extraordinary picture and I was absolutely fascinated.[23]

The desert: Deserted but 'populated'

Not far from where Orpen sat drawing the picked remains of soldiers in foul-smelling trenches, Charles Carrington scanned the scorched earth of the southern battlefield, its few remaining trees snapped short with splintered ends 'like monstrous shaving brushes', everywhere the smell of burnt and poisoned mud, every yard of ground 'ploughed up by shell-fire and ... tainted with high explosive, so that a chemical reek pervaded the air ... and through it one could distinguish a more biotic flavour—the stink of corrupting human flesh'. In fact, Carrington reckoned that the best part of 200,000 men that had been killed in the last few months were somewhere in the 30 square miles around his trench. Buried hastily in shallow graves, or buried and subsequently blown out of those graves, he estimated '7000 corpses to the square mile [was] not much of an exaggeration, ten to the acre shall we say, and your nose told you where they lay thickest'.[24]

To the scrutinising eye the landscape may have seemed deserted but the dead lay

(22)
Ibid.

(23)
Richard Talbot Kelly, *A Subaltern's Odyssey: A Memoir of the Great War, 1915–1917*. London: William Kimber, 1980.

(24)
Carrington, *op.cit.*, p.127.

just beneath its ruptured surface and the living led an ordered and disciplined existence in underground shelters and deep chambers. It was one of the greatest contradictions of modern warfare, a landscape that gave the appearance by daylight of being empty but was not: it teemed with invisible life. Few paintings have captured the immensity of that void; even words failed to convey the intensity of its emptiness. Faced with illusion of the Western Front, the imagination froze. One shrewd observer described it as 'so paralysed in calm, so unnaturally innocent and bland and balmy ... You simply could not take it in'. [25]

Yet, the very concept of space as an undifferentiated, homogeneous void that surrounded solid objects had already been challenged by contemporary artists; cinema was revolutionising the visual arrangement of time; the act of film editing fractured continuous events, reshaping and compressing storylines into new patterns of narrative. Just as geographers were developing regional approaches on the relationship between people and their local environments, scientific research pioneered by Einstein argued for a number of distinct spaces equal to the number of unstable reference systems. [26] Braque and Picasso smashed forever the belief in a neat pictorial system based on the single static eye of one point perspective. It was a period of extraordinary innovation, as if 'an earthquake had struck the precisely reticulated sidewalks of a Renaissance street scene'. [27] War accelerated these changes: when Picasso saw trucks heading out of Paris towards the front he is said to have pointed at their camouflage and exclaimed 'yes, it is we who made that, that is cubism' and to a degree he was right. Deceptive and disruptive camouflage is the perfect exposition of the new way that the world's spaces had to be seen or, to be more exact, not seen. [28] By contrast, the benighted battlescape was always busy as troops set to work repairing their entrenchments, reinforcing the wire, bringing forward fresh troops, food and provisions or setting out into no-man's-land on raid or patrol. The tract of land between the trenches was a 'debatable', liminal and near-mythical zone that soldiers learned to fear but many also exercised a dread fascination with. To those highly sensitised to its weird appearance and sensations, it could even be regarded as a 'place of enchantment'. [29]

(25)
Reginald Farrer, *The Void of War: Letters from Three Fronts*. London: Constable, 1918, p.113.

(26)
S.J.K. Baker, 'Paul Vidal de la Blache: 1845–1917', *Geographers: Bibliographic Studies*, 12, 1988, pp.189–201.

(27)
Stephen Kern, *The Culture of Time and Place* (1880–1918). Massachusetts: Harvard University Press, 1983, p.179.

(28)
Gertrude Stein, *Picasso*. London: Heinemann, 1938, p.11.

(29)
David Jones, *In Parenthesis*. London: Faber and Faber, 1937, p.x.

Out of this fearful emptiness by day and the crowded bustle by night, came one of the critical moments of any soldier's wartime experience; the moment he stepped from the relative safety of the trench, over the parapet and out into the danger zone of no-man's-land. It was the ultimate rite of passage:

> The scene that followed was the most remarkable that I have ever witnessed. At one moment there was an intense and nerve shattering struggle with death screaming through the air. Then, as if with the wave of a magic wand, all was changed; all over 'no-man's-land' troops came out of the trenches, or rose from the ground where they had been lying. [30]

(30)
Stuart Dolden, op.cit., p.39.

This moment, as each combatant emerged from a crouched and hidden posture to one vertical and vulnerable, from subterranean security to maximum vulnerability, was the ultimate transformation for each man. It epitomised the essence of military service: his transformation from civilian to soldier, from innocence to experience and, in many cases, from youth to adult. Indeed, every level of the military experience seemed to be permeated by the rhetoric of transformation and conversion. Not all of it was perceived as wholly dreadful. One officer, for example, relieved from an exposed frontline outpost, described how marvellous it was to be out of the trenches: 'it is like being born again'. [31] Another described those who survived one particular battle as 'not broken, but reborn'. [32] Throughout the memoirs of the Great War, (and perhaps maybe all wars) there is a common language of initiation, of 'baptisms of fire', of inner change and transmutation brought about by ecstatic experience, of 'immense exultation at having got through the barrage'. [33] Edmund Blunden, returning to his lines after a desperately dangerous patrol in no-man's-land, recalled how 'We were received as Lazarus was'. [34] When Siegfried Sassoon discovered that his friend Robert Graves had in fact survived an artillery barrage, the news was celebrated as though he 'had risen again from the dead'. [35] As Paul Fussell has written, it was this plethora of 'very un-modern superstitions, talismans, wonders, miracles, relics, legends and rumours that would help shape the dominant mythologies of the war'. It was a time of 'conversions, metamorphoses, and rebirths in a world of reinvigorated myth'. [36] The transformation of the

(31)
Max Plowman, A Subaltern on the Somme. London: J.M. Dent, 1927, p.54.

(32)
Harold Williamson, Foreword in Patick Beaver (ed.) The Wipers Times. London: Papermac, 1988, p.10.

(33)
Wilfred Owen, quoted in Paul Fussell, The Great War and Modern Memory. Oxford: Oxford University Press, 1975, p.115.

(34)
Edmund Blunden, Undertones of War. London: Faber and Faber, 1928, p.172.

(35)
Sassoon, op.cit., p.128.

(36)
Fussell, op.cit., p.115.

C.R.W. Nevinson
Swooping Down on a Taube
1917
Lithograph on paper
40.1 × 29.8 cm
© National Gallery of Victoria,
Melbourne (NGV 943-4)

Plate 42 from the Building
aircraft set, in *The Great War:
Britain's Efforts and Ideals*
series, commissioned by
the British Department of
Information; published by the
Fine Arts Society, London, 1917

Tyne Cot Commonwealth War
Graves Cemetery, Passchendale
near Zonnebeke, Ypres Salient

body through moments of extreme tension was matched by the transformation of the pulverised landscape both during and after the war. Royal Hampshire's officer Paul Nash saw how war wreaked its havoc but was astonished that nature should prove so resilient. He wrote of walking through a wood—or at least what remained of it after the shelling—when it was just 'a place with an evil name, pitted and pocked with shells, the trees torn to shreds, often reeking with poison gas'. Two months later this 'most desolate ruinous place' was drastically changed. It was now 'a vivid green':

> ... the most broken trees even had sprouted somewhere and in the midst, from the depth of thewood's bruised heart poured out the throbbing song of a nightingale. Ridiculous mad incongruity! One can't think which is the more absurd, the War or Nature ... [37]

Re-membering

In 1919 Paul Nash and his brother John, were provided with a truck load of shards from the Western Front—metal fragments, sheets of corrugated roofing, concrete blocks and other detritus—duly delivered to their studio in the Chilterns to jog their memories as they embarked on paintings commissioned by the British War Memorials scheme. Both were encouraged to revisit the old battlegrounds but having served on the frontline they chose not to, accepting that its cruel complexion was impressed permanently on them. How could they forget the state of northern France and western Belgium after years of siege warfare? Objective measurements attest to the utter scale of desolation across a great tract of northern Europe where some 333 million cubic metres of trench had to be back-filled, barbed wire covered an estimated 375 million square metres, over 80,000 dwellings had been destroyed or damaged, as were 17,466 schools, public buildings and churches and the population of the devastated regions had diminished by 60 per cent. [38] A map drawn up by the British League of Help for Devastated France superimposed the scale of war damage onto the Shires of England with the startling prediction that no fewer than 21 English counties would have been severely blighted by war—a swathe of destruction that reached from Kent to the north Midlands.

While the native populations in France and Belgium toiled to reconstruct

(37)

Paul Nash, *Outline: An Autobiography and Other Writings*. London: Faber, 1949, p.33.

(38)

Hugh Clout, *After the Ruins: Restoring the Countryside of Northern France after the Great War*. Exeter: University Press, 1996.

their homes and land, pilgrims and veterans roamed the former battlegrounds to locate places that might contain the memory of significant events. Outwardly there was nothing to see; the landscape that drew them was an imaginary one. It was a place of projection and association, a space full of history, yet void of obvious topography, where physical markers had been obliterated but the land overwritten with an invisible emotional geography. [39] When the painter Stanley Spencer travelled to the old Salonika front in 1922 he was undertaking a journey made by thousands, indeed tens of thousands, of travellers who were uniting intense memories with places that no longer existed. Indeed, the wasted landscapes in France, Belgium, the Dardanelles and Macedonia were outwardly empty places 'you take your own story to', lacking any identifying landmarks except for painted signposts indicating where things once were—former villages, churches or farmsteads—and littered with war refuse and unspent ammunition. [40]

By 1920, some 4000 men were daily engaged in combing the battlefields in the search for human remains. On the Western Front, the ground was divided into gridded areas, each searched at least six times, but even ten years later up to 40 bodies were being handed over each week to the French authorities. [41] In France a ten-franc bounty was given for each corpse returned to the authorities. A systematic method to identify graves and locate shallow burials had been put in place by the British as early as September 1914, although initial attempts to coordinate the burial and recording of the dead were somewhat haphazard. It was the dedication of Fabian Ware and his Graves Registration Unit that laid the foundations of a systematic audit of British and Empire dead and their place of burial. Once it had been decided that bodies would not be exhumed and repatriated, Ware began to establish a method for graves registration and a scheme for permanent burial sites. He also arranged that all graves should be photographed so that relatives might have an image and directions to the place of burial. By August 1915 an initial 2000 negatives, each showing four grave markers, had been taken. Cards were sent in answer to individual requests, enclosing details that gave 'the best available indication as to the situation of the grave and, when it was in a cemetery, directions as

(39)
Paul Gough, 'The Empty Battlefield: Painters and the First World War', *Imperial War Museum Review*, 1993, 8, pp. 38–47.

(40)
Paul Shepheard, *The Cultivated Wilderness: Or, What is Landscape?*. Cambridge: MIT Press, 1997.

(41)
Martin Middlebrook and Mary Middlebrook, *The Somme Battlefields*. London: Viking, 1991.

(42)

Sidney Hurst, *The Silent Cities: An Illustrated Guide to the War Cemeteries and Memorials to the 'Missing' in France and Flanders: 1914–1918*. London: Methuen, 1929.

(43)

Michael Heffernan, 'For ever England: The Western Front and the politics of remembrance in Britain', *Ecumene*, 2 (3) 1995, pp.293–323.

(44)

Longworth, *op.cit.*, pp.4–5.

to the nearest railway station which might be useful for those wishing to visit the country after the war'.[42] Nine months later Ware's makeshift organisation had registered over 50,000 graves, answered 5000 enquiries and supplied 2500 photographs. Little over a year later the work to gather, re-inter and individually mark the fallen had become a state responsibility. The dead, as Heffernan states, were no longer allowed 'to pass unnoticed back into the private world of their families'. They were 'official property' to be accorded appropriate civic commemoration in 'solemn monuments of official remembrance'.[43] Ware's band of searchers took to their work with zealous diligence. One described it as requiring the patience and skills of a detective 'to find the grave of some poor fellow who had been shot in some out of the way turnip field and hurriedly buried'. After the war, local people, especially young children, joined in the searches, at times with grisly outcomes:

> *It occasionally happens that the grave which we believe to contain the remains of a certain person is, in fact, a pit into which large numbers of dead bodies have been thrown by the enemy. When such a grave is opened we are able not only to identify the body for which we are searching, but also by their discs, the bodies of many others. One example—the latest—will suffice. The trench containing the bodies of Colonel _ , Captain _, Lieutenants __ _, held also the bodies of 94 non-commissioned officers and men. Of these 66 still wore their discs, etc., and thus their deaths were certified, and their graves ascertained. The trench was then prolonged, the bodies laid side by side, and the burial service read over them.*[44]

According to Longworth, a good registration officer quickly came to know the ground allotted to him intimately: he knew its recent military history, every raid, skirmish or significant action, the regiments involved and in which fields unmarked or unrecorded graves were likely to be located. Following up every scrap of information, sometimes gleaned from veterans who had served on that part of the front, he pieced together the scanty evidence so as to identify burials. Graves Registration staff had actually undertaken such work during the war, often within range of enemy gunfire, but after the death of one staff member working in an Ypres

Adrian Hill
The Interior of a Dug-out: Gavrelle
1917
Ink, wash on paper
30.4 × 43.1 cm
© Imperial War Museums
(IWM: ART 342)

cemetery, they were ordered back from the frontlines into safer areas where battle had moved on. This necessary, but unfortunate decision, may explain the extraordinarily high proportion of unidentifiable graves when the count came after the war.

Known and unknown

Between 1921 and 1928, some 30,000 corpses were dug up from their last burial place and reinterred in official cemetery sites. Each body was marked by a standard stone headstone, which carried a modicum of military detail, as much as could be gleaned from the corpse or from its first grave marker—usually a name, rank, regimental number (except for officers) military unit, date of death and age (if supplied by next of kin). Personal inscriptions paid for by the family of the dead man were allowed a maximum of 66 characters, including the spaces between words. [45] It is reckoned that only a quarter could be identified because fibrous identity discs issued before 1916 had disintegrated. In those instances, the headstone would simply state 'A Soldier / of the Great War / Known Unto God'. In some cases, the inscription indicates that the body was known to have belonged to a particular unit but could be identified in no greater detail or that the body lies not directly beneath the stone but somewhere within the plot of the cemetery. Despite the occasional attempt to have an individual body brought home for private burial, the principle—approved by the Imperial Conference of 1918 and endorsed by the British government in May 1920—that all bodies were to be buried near to where they fell was rigorously applied. There was, however, one notable exception—the exhumation and burial in Britain of an 'Unknown Warrior'.

Many individuals have been credited with the idea of exhuming the body of an unknown soldier and entombing it in the sacred centre of the British State, 'the Parish Church of the Empire', at Westminster Abbey. Most scholars agree, however, that the idea originated with a young army padre, the Reverend David Railton MC, who wrote first to Sir Douglas Haig and then to the Dean of Westminster, the Right Rev Herbert Ryle in August 1920. *Our Empire* later explained his motives:

(45)

Sonia Batten, 'Exploring a Language of Grief in First World War Headstones', in Paul Cornish and Nicholas Saunders (eds.) *Contested Objects: Material Memories of the Great War*. London: Routledge, 2009, pp.163–177.

He was worried that the great men of the time might be too busy to be interested in the concerns of a mere padre. He had also thought of writing to the King but was concerned that his advisors might suggest some open space like Trafalgar Square, Hyde Park etc ... Then artists would come and no one could tell what weird structure they might devise for a shrine! [46]

(46)
Michael Gavagan, *The Story of the Unknown Warrior*. Preston: M & L Publications, 1995. See also: Ken Inglis, 'Entombing unknown warriors: From London and Paris to Baghdad', *History and Memory*, 5, 1993, pp.7–31.

The popular press railed against 'weird artists' and were aghast at the exhibitions of official war art that were being shown in London. Railton's letter, however, struck a popular chord and the Dean soon gained the approval of the Prime Minister, who in turn convinced the War Office and the (rather reluctant) King. The Cabinet established a Memorial Service Committee in October. It was hoped that the entombment would take place at the unveiling of the permanent Cenotaph in Whitehall that November.

Necessarily a sensitive act, the selection of a single British body was clouded in secrecy. Historians differ as to the number of bodies actually exhumed, whether four or six. [47] Whichever, a number of unknown bodies were dug up from the areas of principle British military involvement in France and Belgium—the Somme, Aisne, Arras and Ypres. The digging parties had been firmly instructed to select a grave marked 'Unknown British Soldier', one who had been buried in the earlier part of the war so as to allow sufficient decomposition of the body. The party had to ensure the body was clad, or at least wrapped, in British khaki material.

(47)
L.J. Wyatt, 'The unknown warriors of 1920: How one was selected for Abbey burial', *Daily Telegraph*, 8 November 1939, p.23.

Funeral cars delivered four bodies in sacks to a temporary chapel at military headquarters at St Pol where at midnight on 7 November 1920, Brigadier General Wyatt, officer commanding British forces in France and Flanders, selected one of the flag-draped figures (described later by Wyatt as 'mere bones') by simply stepping forward and touching one of them. Before this ultimate selection, each sack load had been carefully picked through to confirm that they were British (or at least British Empire) remains and that no name tags, regimental insignia or any other means of means of identification remained.

While the single selected body was made ready to embark on its highly ritualised journey, the others were quietly reburied. Other countries followed suit.

Will Dyson
The Dynamo. Hill 60.
Lighting the Tunnels
1917
Lithograph, black ink on
white laid Arnold paper
39.2 × 55.2 cm
© Australian War
Memorial 02209

Having chosen their 'Warrior', the Americans returned three bodies to the soil without ceremony. In France, at precisely the same moment that the single chosen body was being buried to great ceremony under the Arc de Triomphe in Paris, seven other bodies that been dug up but not chosen, were re-interred under a cross in a Verdun war cemetery.

After an extraordinary choreography of ceremony and ritual, the coffin—freshly constructed by the British Undertaker's Association from an oak tree that had stood in the parks of Hampton Court Palace—reached Westminster Abbey. After the clamour of the crowds that lined the railway lines from Dover to Victoria Station and the masses gathered on the streets and squares of central London, the abbey was hushed in anticipation. Here, as Geoff Dyer has observed 'the intensity of emotion was reinforced by numerical arrangement'; one hundred winners of the Victoria Cross lined the route to the burial place; a thousand bereaved mothers and widows stood behind them. [48] Lowered into a grave dug in the entrance of the abbey, the coffin was sprinkled with soil from Flanders. Later the earth from the six barrels would be added—'making a part of the Abbey forever a part of a foreign field'—and the grave sealed with a large slab of Belgian marble.

On Armistice Day that November, over a million people passed by the Cenotaph in Whitehall in the week between its official unveiling and the sealing of the tomb. By way of lending a sense of proportion to the nation's loss, it was estimated that if the Empire's dead could march four abreast down Whitehall it would take them over three days to pass the monument, a column stretching from London to Newcastle. Not long after, this incredible idea was rendered actual as endless columns of troops marched past memorials all over the country. *The Times* intoned: 'The dead lived again'. In these memorable images it seems as though the soldiers are the deceased themselves 'marching back to receive the tribute of the living'. [49] It is an insight that provokes memories of Eliot's lines in *The Waste Land*:

> *A crowd flowed over Westminster Bridge. So many,*
> *I had not thought death had undone so many.*

[48]
Geoff Dyer, *The Missing of the Somme*. London: Penguin, 1995.

[49]
Dyer, *ibid.*, p.24.

Will Longstaff
Menin Gate at Midnight
1927
Oil on canvas
137 × 270 cm
© Australian War
Memorial 08907

In post-war Britain it would have been almost impossible to avoid the intensity of remembrance. One authority declared it the greatest period of monument building since the Pharaohs of Ancient Egypt. Stanley Spencer's painting of the unveiling of Cookham war memorial captures an event that was repeated countless times as the nation sought to mourn the common man. Indeed, the line of young men who crowd the foreground of Spencer's painting seem less concerned with paying homage to the dead as vicariously acting out their missing townsmen, a surrogate army of ghosts returned home.

The dead rising

In the decade after the war, the image of the dead rising from the tortured landscapes of the old battlefields became a familiar part of the iconography of remembering. During the war, artists had created occasional images of a ghostly figure wandering wraith-like across no-man's-land; poets and the popular press had played with the notion of guardian angels or spectred hosts. There were many legendary (and largely fabled) tales of 'mysterious Majors' or benevolent phantoms who return to help, warn or merely stand alongside comrades in the twilight hours of stand-to. Many combatants found this entirely understandable; sudden departures and unexplained absences were common experiences, in battle soldiers literally vanished into the air, dematerialised before their comrades' eyes, every trace gone. Sudden absences, emptiness and invisibility became the hallmarks of the war. Despite the scale of commemoration in stone, many of those who returned to the former battlefields craved some form of spiritual connection with their vanished loved ones. In part this explains the upsurge in séances and similar activities in the years after the war and perhaps also the fascination with battlefield pilgrimage and the need to gather 'mementos' or relics from the same landscapes that had apparently swallowed whole the sons, brothers and fathers of the massed armies and persists today. [50]

(50)
Paul Gough, 'Conifers and commemoration: The politics and protocol of planting in military cemeteries', *Landscape Research*, 21(1) 1996, pp.73–87.

Many artists wrote of experiencing sensations of haunting while on the Western Front. In 1917, Adrian Hill, the youngest official war artist to have been commissioned by the newly formed Imperial War Museum during the First World War and a painter who had many hundreds of studies of the weird troglodyte world under

The Beaufort Hospital War Hospital,
Fishponds, Bristol, c.1916

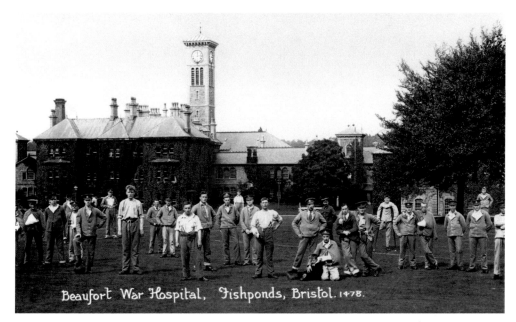

Beaufort War Hospital, Fishponds, Bristol. 1478.

The Sandham Memorial Chapel,
Burghclere, Hampshire.
Architect Lionel G. Pearson

Stanley Spencer
The Resurrection of the Soldiers
The Sandham Memorial Chapel
1928–29

the battlefield wrote of a supernatural experience while sketching near the *Butte de Warlencourt* on the Somme, not far from where his brother had died during the war. He had an overwhelming sense that an unseen presence was hovering very close by. [51]

In contemporary film, painting and even in photography, the disappeared and the dead could be made to live again and images of the dead rising from the earth gained a wide currency. Will Dyson, an artist more known for his rugged and realistic portrayal of Australian soldiers embedded deep in the bowels of the battlefield, produced a striking image in 1927 for the *Melbourne Herald*. *A Voice from ANZAC* depicted two Australian soldiers on the shores of Gallipoli, one of them asking, 'Funny thing, Bill. I keep thinking I hear men marching'. That same year another Australian artist, Will Longstaff, had attended the unveiling of the Menin Gate at Ypres—with Plumer's rhetorical message 'the dead are not missing, they are here'. In response he painted *Menin Gate at Midnight*, which depicts a host of ghostly soldiers emerging from the Flanders battlegrounds and walking, as one, towards the massive monument through fields strewn with red poppies. So struck had Longstaff been by the ceremony at Ypres, that he later had a vision of 'steel-helmeted spirits rising from the moonlit cornfields around him'. He returned to London and, it is said, painted the canvas in a single session while still under 'psychic influence'. [52]

Reproduced in tens of thousands of copies, the painting had an extraordinary reception. It was displayed in London, viewed by Royal Command, toured to Manchester and Glasgow and then sent to Australia where it was exhibited in a darkened chapel-like room at the Australian War Memorial in Canberra. Its appeal was strong in part because spiritualism was in vogue, but mainly because those who wished to communicate with the war dead found some consolation in its pictorial verity. Longstaff's work was championed by the likes of Sir Arthur Conan Doyle who endorsed the spiritualist message it evoked. His work carried none of the venomous acrimony of Siegfried Sassoon's post-war poetry, which by comparison was populated with 'scarred, eyeless figures deformed by the hell of battle ... supernatural figures of the macabre' whom he pitied for the loss of

(51)
Adrian Hill, letter from the front, 12 November 1917. Over 260 of Hill's letters to his parents from the period July 1916 to March 1919 are in the Liddle Collection at Special Collections, Leeds University Library.

(52)
Anne Gray, 'Longstaff, William Frederick (Will) (1879-1952)', *Australian Dictionary of Biography*, National Centre of Biography, Australian National University, accessed 24 May 2018, adb.anu.edu.au/biography/longstaff-william-frederick-will-7231.

(53)

Mark Dollar, 'Ghost imagery in the war poems of Siegfried Sassoon', *War, Literature, and the Arts* 16 (1–2) 2004, pp.235–245.

(54)

Abel Gance, *J'Accuse*. Connoisseur, 1937.

(55)

Kitty Hauser, *Stanley Spencer*. London: Tate, 2001.

(56)

Richard Carline, *Stanley Spencer at War*. London: Faber and Faber, 1978.

their youth. [53] The poet's bitter realism was perhaps more fully shared with the filmmaker Abel Gance, whose 1919 film *J'Accuse* ends when vast hordes of French soldiers—the unjustly dead—materialise out of the tortured earth intent on terrifying the complacency of those who could, if they wished, have ended the war. [54]

Having a studio in London, Longstaff may have been aware of Stanley Spencer's *Resurrection, Cookham* (which was exhibited during February 1927). Spencer had been 23 at the outbreak of war, a student-prodigy and an inspired innocent who would go on to become one of Britain's greatest twentieth century painters, famous (indeed infamous) for the celebration of his home town of Cookham—his 'heaven on earth', as he lovingly called it, and the fusion in his paintings of sex and religion, love and dirt, the heavenly and the ordinary. [55]

Spencer's visionary imagination was realised through many hundreds of paintings, endless drawings and thousands of letters, written to both the living and the deceased. They exposed a complicated reading of his world and an ability to transform the menial and the banal into intense images of joyous delight. Through his work Spencer transformed his 'heaven on earth', the village of Cookham into a visionary paradise where his family and neighbours might daily rub shoulders with Old Testament figures and where it seemed entirely appropriate that Christ would wander in the garden behind the local schoolyard.

In 1915 he had left his protective homestead to serve first as a medical orderly in a converted asylum in Bristol, then in a Field Ambulance on the Macedonia Front—a forgotten theatre of war, where a hybrid Allied force faced a strong Bulgarian army reinforced by German troops. Spencer served at the front until the Armistice, joining an infantry regiment in the latter stages of the war. [56] Some seven years later, as Longstaff was having his vision of exhumed troops marching on the Menin Gate and German artists such as Otto Dix were revisiting their Flanders nightmares, Spencer translated his war experience into an extraordinary series of murals on the walls of a private memorial chapel in Hampshire, which are ostensibly about war, but where death is the 'absent referent' lingering in the wings, not even relegated to a walk-on part.

The Sandham Memorial Chapel is perhaps the most complete memorial to recovery and redemption ever completed in the aftermath of the First World War. There is nothing like it anywhere in Europe. Spencer referred to it as his 'Holy Box', an affectionate reference to the Renaissance chapels in Padua and Florence, whose simple exteriors and busy interiors he revered. Commissioned by two enlightened patrons of the arts, its panelled interior depicts Spencer's chores as a medical orderly in Bristol, his field ambulance work near Salonika and on a vast end wall—some four metres wide by seven high—an epic panorama of recovery and redemption, the *Resurrection of the Soldiers*. For nine months Spencer toiled on this end wall, his small, tweed-suited figure lost high in the scaffolding among the dozens of animated painted figures. After the chapel was opened in 1932 a visitor was heard to pronounce: 'My dear, the Resurrection is not in the least like that!' [57] However, Spencer's idea of resurrection was not one of judgment or of the revival of the dead or the re-appearance of Christ. Instead, it embraced the more holistic idea of the resurrection of the body and the mind. Spencer's social background and his concern for the 'common man' (and woman) meant that his interest lay in an egalitarian and inclusive notion of the body, one that was indifferent to social hierarchy and ignorant of external trappings and trophies of wealth and position. The Oratory was not a resurrection solely of the dead, nor for that matter a resurrection merely of the soul, rather it was 'resurrections of his state of mind at different times'. [58] For Spencer it was a time of 'release & change' whereby even the mules and the tortoises come in for some sort of redemption or re-finding of themselves from their experiences. Even the soldiers under mosquito nets seem to be caught in an act of spiritual transubstantiation, altering from one state to another, and everywhere soldiers emerge from the earth to return their now-redundant crosses to the Christ-figure, just as they had, at the end of hostilities, returned their blankets, uniform and kit to the quartermaster. 'In the resurrection', said Spencer, 'they have even finished with that last piece of worldly impedimenta'. [59]

In a complicated accumulation of ideas Spencer thought of resurrection as a 'Last Day', a time of reconciliation, not judgment. It was without doubt momentous, but it was entirely peaceful and

(57)
George Behrend, *Stanley Spencer at Burghclere*. London: Macdonald, 1967.

(58)
Adrian Glew, *Stanley Spencer: Letters and Writings*. London: Tate, 2001, p.11.

(59)
Carline, *op.cit.*, pp.190–191.

Stanley Spencer
The Resurrection of the Soldiers
(detail of the upper sections)
The Sandham Memorial Chapel
1928–29

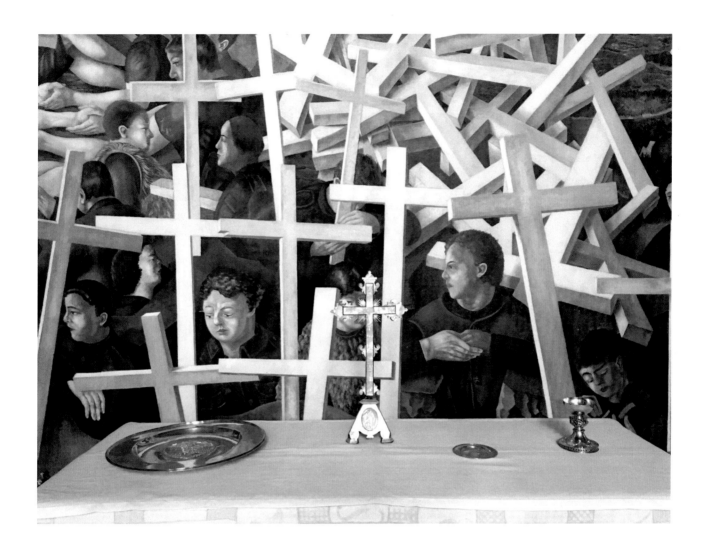

Stanley Spencer
The Resurrection of the Soldiers
(detail of the figures
behind the altar)
The Sandham Memorial Chapel
1928–29

calm, with no need for clarion calls or lofty pronouncements. In his interpretation, resurrection was a redemptory act, a re-finding of oneself freed of the burden of experiences and a reconciliation of friends, lovers, peoples of all creed and colour and, of course, their belongings. One soldier, for example, takes a small red book from his pocket, identified by Spencer as 'a little red leather-covered Bible' that he had been given by his sister Florence but which he had lost. 'Being the Resurrection', he writes simply and matter-of-factly, 'I find it.' However, despite his protestations of innocence, there is an air of apocalypse about elements of the chapel, traceable in its sombre mood, inexplicable incidents and suppressed fears. Not easily could Spencer ignore the terrible past and the recent present, with tens of thousands of displaced and maimed veterans wandering the land, stranded by the fiscal gloom of the late 1920s. [60]

During the war Spencer had buried dozens of soldiers. He painted the chapel during the years when the former battlefields were being combed for the dead and concentrated into cemeteries. In the early 1920s, when he was originating the murals in Poole—in the county of Dorset—quarrymen in nearby Portland were hacking out vast slabs of the shelly, coarse white stone to be chiselled into tens of thousands of headstones bound for the battlefields. The Resurrection Wall at Burghclere is a testament to those thousands of unknown soldiers who were blown into pieces and who are remembered only by their names carved on panoramic slabs of stone. [61]

Spencer's figures emerge from the torn earth intact, unsullied and calm, almost beatific; very different from the homunculi embedded in the Flanders mud as devised by Otto Dix. In his apocalyptic canvas, *Flanders*, the dawn may be epic, but the demise of the small troupe of soldiers is tawdry and banal, their bodies enmeshed in a thicket of webbing, wire and waste. Far from emerging from the glutinous mud, the soldiers are immersed in the land, becoming a part of its subsoil, embedded in a *totendlandschaft*—the dead landscape—where there may be biological metamorphosis, but there is absolutely no hope of resurrection. [62] At least the skyscape holds an element of tentative promise, however ironic. In Jeff Wall's vast panorama of an Afghanistan ambush (1992) even the redemptive

(60)

Paul Gough et al, *'The Holy Box': The Genesis of Stanley Spencer's Sandham Memorial Chapel*. Bristol and London: Sansom and Company in collaboration with The National Trust and the Stanley Spencer Gallery, 2017.

(61)

Paul Gough, *Stanley Spencer: Journey to Burghclere*. Bristol: Sansom and Company, 2006.

(62)

Matthias Eberle, *World War I and the Weimar Artists*. New Haven and London: Yale University Press, 1985, p.30.

possibility of a horizon is stripped out. [63] Instead, in place of Spencer's serene and demilitarised figures or Dix's calcified combatants, we find a platoon of traumatised soldiers with bulging eyes and contorted faces horsing around and stuffing their spilled entrails back into their soiled uniforms. Wall's dystopia shares more in common with Sassoon's bitter verse or Abel Gance's film where the dead don't merely wander the earth, they are disgorged in rotting uniforms with mutilated bodies and torn faces. It has more in common with veteran soldier Max Beckmann's savage panorama *Resurrection* (1918), which is dominated by a black-sphered sun. In their common scale, their subdued tonal range and their powerful sense of camaraderie there is some common ground between Wall and Spencer. But Wall's gurning and abandoned infantrymen bear nothing in common with Spencer's mute and elegiac armies. Dead soldiers don't talk; but in Wall's visionary photo-piece they do. In fact, it's hard to shut them up. His thirteen slaughtered soldiers cavort, play with strips of flesh, smile knowingly at each other and chat from casual slouching positions. But their pain is palpable. How far is this from Spencer's notion of a reverential resurrection? In its unexpurgated depiction of pain, it draws from Callot and Goya, whereas Spencer takes his inspiration from the Italian Primitives. Yet, like Spencer's magnificent murals, there is no eye contact with us; no accusation outwards, no one turning into our world. As Susan Sontag says:

> There's no threat of protest. They are not about to yell at us to bring a halt to that abomination which is war. They haven't come back to life in order to stagger off to denounce the war-makers who sent them to kill and be killed ... Why should they seek our gaze? [64]

Perhaps Wall, like Spencer and Dix before him, knows that we are unable to fully empathise with these wretched souls; we will never understand the dreadfulness of war. We can only peer in and glimpse these momentarily reprieved lives. However, where Wall re-imagines the Day of Judgment as something supremely Sisyphean, Spencer dreams a vision of reconciliation and arbitration, even though the figures in his haunted Macedonian hillside appear isolated, disengaged and rather sedated when compared to the livid lunacy of the doomed Russian platoon capering in their cruel crater.

(63)

Jeff Wall, 1992. *Dead Troops Talk (a Vision After an Ambush of a Red Army Patrol, near Moqor, Afghanistan, Winter 1986)*. Transparency in lightbox, 2290 × 4170 mm.

See: Jean Francois Chevrier, *Jeff Wall: Catalogue Raisonne 1978–2004*. New York: Steidl & Partners, 2006.

(64)

Susan Sontag, *Regarding the Pain of Others*. New York: Picador, 2003, p.112.

'TURF WARS'

GRASS, GREENERY AND THE SPATIALITY
OF COMMEMORATION

Broken ground: fragment of
a battlefield of the Great War

Spaces and places of remembrance

Where once geographers could argue that the ideological issues surrounding English and Empire military cemeteries had drawn little comment, there is now a considerable literature exploring the spaces and places of remembrance. Increasing attention has been paid during the past decade to the value of 'situation' in the discourse of death, grieving and commemoration. In this respect, 'situation' should be understood to be a focus on 'place', 'space' and the geopolitical. [1] The emerging discipline of cultural geography in the late 1990s created the tools necessary to elaborate 'space' in the abstract, to regard 'place' as a site where an individual might negotiate definitively social relations and give voice, as Sara Blair argues, to 'the effects of dislocation, disembodiment, and localisation that constitute contemporary social disorder'. [2] In our post-historical era, further argues Blair, temporality has largely been superseded by spatiality, what has been termed the affective and social experience of space. Almost a century after Freud's treatise *Mourning and Melancholia*, our understanding of how memory and mourning function continues to be challenged, revised and refined. Issues of place have become important to this debate. Once a marginal topic for academic investigation, there is now a body of scholarly work exploring the complex interrelationship between memory, mourning and what might be termed 'deathscapes'. Indeed, this fascination with places of death and dying has given rise to myriad academic explorations, spawning academic enquiry in dark—or thana—tourism, which is an extreme form of grief-incited travel to distant prisons, castles and abandoned battlefields so that anthropological enquiry might be conducted. The release of what has been termed 'recreational grief' following the death of Princess Diana in 1997 has also provided sociologists with considerable material for scholarly attention.

However, I want to focus on the many ways in which horticulture, architecture and planning have been mobilised (to borrow the military term) to transform traumatised battle landscapes into permanent sites of memory. Mosse, Morris and McKay [3] have examined the aftermath of war and observed the creation of what some have also described as 'memoryscapes', a *portmanteau*

(1)

John R. Gillis, *Commemorations*. Princeton: Princeton University Press, 1994.

(2)

Sarah Blair, 'Cultural Geography and the Place of the Literary', *American Literary History*, 10 (3) 1998, pp.544–567.

(3)

George L. Mosse, *Fallen Soldiers: Reshaping the Memory of the World Wars*. Oxford: Oxford University Press, 1990. Mandy S. Morris, 'Gardens "for ever England": Landscape, Identity and the First World War British Cemeteries on the Western Front', *Ecumene*, 4, 1997, pp.410–434. George McKay, *Radical Gardening: Politics, Idealism and Rebellion in the Garden*. London: Frances Lincoln, 2001.

that fuses an appreciation of once-violated landscapes with personal and discursive memories. [4]

 We will focus not only on the torn and traumatised terrain of war, but on its repair—on the intensive attempts to smoothen the surfaces of war and dress them in ways appropriate to civic and personal commemoration to create 'homely' and familiar plots of memory forever landlocked in the proverbial foreign field. We will do so by examining the project to create garden cemeteries on tracts of former battlefields after the Great War. It is an impressive story. Yet, what would appear to be a straightforward narrative of reparation, recovery and rejuvenation is at times tainted by disharmony and argument. After the war there was much disagreement about the 'proper' form of remembrance. There was an intense dispute about the repatriation of bodies and an extended (at times quite bitter) public argument about the best way to mark the sites of burial. What is surprising is that these disagreements can seem as alive and vivid today as they did 90 years ago. Conducted by families, remembrance groups, ex-servicemen, politicians and others, these disputes tell us much about the way we remember our dead, how we create protocols of commemoration and, significantly, how we play out discussions about national identity through horticultural proxies such as trees, shrubs and, most importantly, turfed lawn.

 Why should this be the case? In his seminal text on cultural histories, David Lowenthal argues that landscape is 'memory's most serviceable reminder'. [5] He suggests that certain places can be regarded as key sites in a continuous educational process, where successive generations 'revise or expand their cultural memory through interaction with the artefacts and landscapes of its past'. Former battlefields are critical places in Lowenthal's taxonomy of significance. This is because they are not a single, sealed terrain isolated in a given moment of time, they are multi-vocal 'landscapes of accretion' stratified by overlapping layers of social, economic and occasionally political history. Invariably, they are also politicised, dynamic and open to constant negotiation. [6] Official sites of mass burial, ornamented with august memorials and strict planting regimes have not only long provided 'pegs' upon which national fiction could be hung, but flag posts

(4)
Paul Basu, 'Palimpsest Memoryscapes: Materializing and Mediating War and Peace in Sierra Leone' in Gordon F. de Jong and Michael Rowlands (eds.) *Reclaiming Heritage: Alternative Imaginations in West Africa*. Walnut Creek: Left Coast Press, 2007.

(5)
David Lowenthal, *The Past is a Foreign Country*. Cambridge: Cambridge University Press, 1985.

(6)
Barbara Bender (ed.) *Landscape: Politics and Perspectives*. Oxford: Berg, 1983. See also Barbara Bender and Margot Winer (eds.) *Contested Landscapes: Movement, Exile and Place*. Oxford: Berg, 2001.

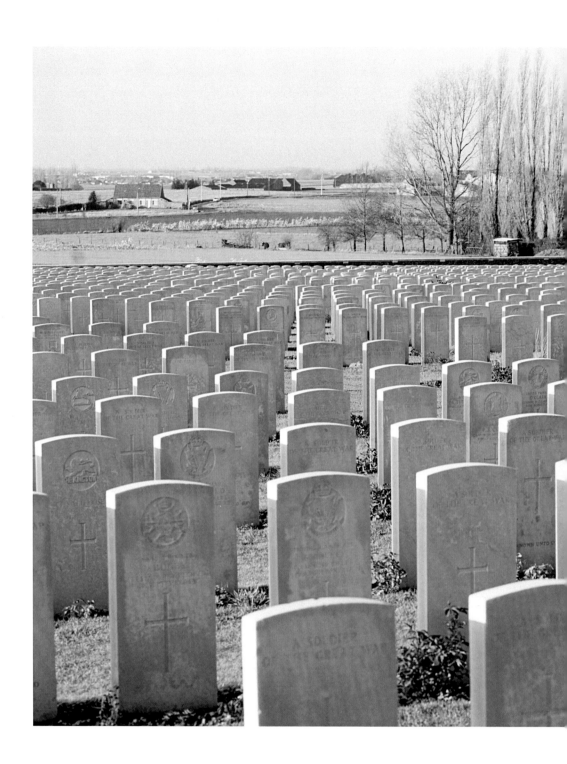

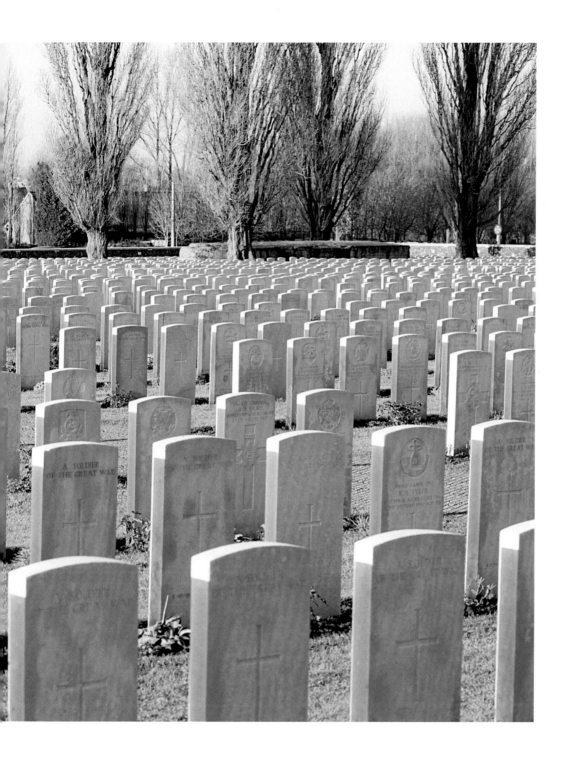

Tyne Cot Commonwealth
War Graves Cemetery,
Passchendale, near Zonnebeke,
Ypres Salient

from which declarations of national identity and purpose can be articulated. Others have argued that the marking of a battlefield with monuments, memorials and markers fulfils a natural human need to understand, possess, classify and control what happened 'so that it is manageable, even if not wholly explicable'.[7] Explication, however, needs a certain quorum of authentication and achieving authenticity is rarely straightforward; it requires careful manipulation and even contrivance.[8] These issues of 'contrivance', 'manipulation' and 'authenticity' will be the key considerations here. Nowhere are such terms more contested than on the British and Empire war cemeteries in northern France and Belgium. To understand why, we will have to first sketch out their origins.

The silent cities

Given the scale of death on the battlefields of the Great War—the total British dead alone was over one million, of which a fifth were from British dominions overseas—the bold decision taken by the British government (on behalf of the entire British Empire) not to repatriate the bodies of the dead created a need for a comprehensive administration to rationalise, routinise and standardise the recording of the dead, their site of burial and their marker stone. Initial attempts by the British and Allied armies to co-ordinate the burial and recording of the dead were haphazard, but under the leadership of Fabian Ware the foundations for grave registration, permanent burial sites and accurate records were soon established.[9] By the close of 1916 the tasks of gathering, re-burying and marking the military graves of the dead had become the responsibility of the state. It was a remarkable achievement: the dead no longer to pass back into the private world of their families and loved ones. They had been rendered 'official property' to be accorded appropriate civic commemoration in 'solemn monuments of official remembrance'.[10]

Attempts to dress the cemeteries and so alleviate their barren appearance were in hand as soon as permanent sites had been agreed. Wooden crosses were fashioned, flowers planted and some attempt at caring for the battlefield graveyards was made where it was safe and practical to do so. As Kenneth Helphand observes in his book *Defiant Gardens*,[11] the bucolic habit was already

(7)
Jennifer Iles, 'Recalling the Ghosts of War: Performing Tourism on the Battlefields of the Western Front', *Text and Performance Quarterly*, 26 (2) 2006, pp.162–180.

(8)
Nicholas Saunders, 'Matter and memory in the landscapes of conflict: The Western Front, 1914–1919', pp.43–67, in Barbara Bender and Margot Winer (eds.) *Contested Landscapes: Movement, Exile and Place*. Oxford: Berg, 2001.

(9)
Philip Longworth, *The Unending Vigil*. London: Commonwealth War Graves Commission, 1967. The phrase 'silent cities' was coined by Sidney Hurst, *The Silent Cities*. London: Methuen, 1929. See also: Fabian Ware, 'The Price of Peace', *The Listener*, II, 1929, pp.636–7.

(10)
Michel Heffernan, 'Forever England: The Western Front and the politics of remembrance in Britain', *Ecumene*, 2 (3) 1995, pp.293–324.

(11)
Kenneth Helphand, *Defiant Gardens: Making Gardens in Wartime*. San Antonio: Trinity University Press, 2006.

well-established: soldiers across the Western Front had created their own flower gardens during the course of the war itself. Amid the squalor and horror of the front, behind the frontlines, in reserve and supply trenches and in the rear zones, combatants from all sides had cleared small plots of land, restored them, laid flower beds or planted seeds and vegetables, tended them and even harvested their fruit. He cites as a typical example the remarkable garden created in the trenches on Hill 59 near Ypres in 1915 by Lothar Dietz, a student from Leipzig:

> As one can't possibly feel happy in a place where all nature has been devastated, we have done our best to improve things. First we built a new causeway of logs, without railing to it, along the bottom of the valley. Then from a pinewood close by, which had also been destroyed by shells, we dragged all the best tree tops and stuck them upright in the ground; certainly they have no roots, but we don't expect them to be here more than a month and they are sure to stay green that long. Out of the gardens of the ruined chateaux of Hollebecke and Camp we fetched rhododendrons, box, snowdrops and primroses and made quite nice flowerbeds. [12]

(12)
Ibid., pp.38–39.

Not far from where Dietz transformed his melancholy desert into an idyllic grove, British troops were also establishing trench gardens. In May 1915 the *Illustrated London News* published a full-page image of a 'villa' garden on a stretch of trench named Regent Street, the garden and a shelter sitting neatly amid scorched undergrowth and shell-torn trees. By the end of the war the British had established a Directorate of Agricultural Production, a large scale initiative to create a system of farms capable of mass-producing vegetables. Decorative and utilitarian schemes survived throughout the war; soldiers planted and nurtured flower gardens with the aim, argues Helphand, of creating an alternative reality and for use as a boost to morale, a soft-edged weapon in the arsenal against the enemy:

> A garden, and especially a plant emerging from the ground, is a sign of regeneration and an indication of the continuation of life. War magnifies our awareness of our human connections to these forces of life and death.

Plugges Plateau Commonwealth
War Graves Cemetery, Gallipoli,
Turkey

These principles persisted in the immediate peace that followed the Armistice.

Arguing soon after the war for the promotion of English gardening principles and ideas in the military cemeteries, the horticulturalist Sir Arthur Hill, Director of the Royal Botanical Gardens at Kew, insisted that 'home flowers' should adorn all soldiers' graves of the British Empire. Where possible, he argued, native species should be used to lend an impression that each of the Empire's dead lay within a garden setting. Through creative and sensitive planting, this was largely achieved, despite indifferent soils, fragment-strewn earth and a northern European climate (where the vast majority of military cemeteries are located) that discriminated against plants associated with the dead from the far reaches of the Empire. So, whereas 'old fashioned double white Pinks, London Pride, mozzy Saxifrages, Cerastium and Thrift ... Polyantha Roses, Lavender, Rosemary, Iris, perennial Iberis, small heaths', [13] thrived in the northern climate, more exotic strands—such as Bougainvillea, intended to commemorate the graves of soldiers from the West Indies—failed. The scale of the task facing the Commission was immense and its achievements equally so. By 1921, its architects and gardeners had established over 1000 permanent cemetery sites in France and Belgium alone—comprising some 200 acres of lawn, 75 miles of flower border and over 15 miles of hedge. [14] On other theatres of war, in the Dardanelles and in Macedonia, the horticultural and architectural effort was no less heroic.

Not everyone agreed that the numerous military cemeteries should be dressed in this way. Rather surprisingly, several noisy factions argued that the appropriation of the military cemetery as the epitome of a certain quality of 'Englishness' was not to be undertaken lightly; floral adornment was seen by some as 'a mere dress parade of the dead rather than a celebration of heroic sacrifice'. [15] Although Rupert Brooke may have articulated an idea that such places were unambiguously a 'corner of a foreign field / That is for ever England', this idea brought together a complex intersection, indeed a clash, of gender, race and class, underlined by Stuart Hall's admonition that the British have a strong tendency 'to "landscape" cultural identities so as to give them an imagined places or

(13)
Arthur Hill, 'Our Soldier's Graves', *Journal of the Royal Horticultural Society*, 45 (1) 1919, p.8.

(14)
Longworth, *op.cit.*, p.87.

(15)
Mosse, *op.cit.*, p.112.

Maintained lawn, Gordon Dump
Commonwealth War Graves
Cemetery, Ovillers-La Boiselle,
the Somme, France

home'.[16] As we shall see, others argued that this tendency to homogenise character and experience led to a synthesised falsehood, a levelling of individuality that reduced the largely volunteer civilian-soldiers to mere ciphers. However, to a grieving public, the military cemetery garden—well-tended, bursting with native species and planted according to a carefully calculated informality, reasserted the principle of historic continuity, promoting it as a powerful declaration of continuity and rootedness that linked nation and soil to a pre-industrial past, even though such myths had apparently been torn asunder by the savagery of the Great War.

From frontline to front lawn

If the planting of flowers, shrubs and trees was, at times, a contested issue then surely the matter of the 'green coverlet', the lawn that surrounded, connected and contextualised the headstones of the dead, ought to be less problematic? Not necessarily so. Once again, there were carefully articulated points of dispute, some historic and others that would recur over the decades more closely attuned to issues of national identity, environmental debate and the cost of maintenance. Such disparate views have deep historical roots. After all, the lawn might be regarded as the most pronounced marker of imperial culture, exported by the English even to those countries with climates or landscapes that make the growing of flat expanses of lush green grass difficult, expensive or time-consuming. Regarding it as *the* pivotal, privileged space of quintessential English sports— cricket, croquet, lawn tennis, golf—McKay suggests that the lawn, and especially the front lawn of one's home, has become the primary formal signifier of one's standing and conformity to social norms. Not to mow, clip or to tend fastidiously to the borders of one's rectilinear tract of turf is not only wilfully unsocial, but also lowers the financial and moral value of the homes around and threatens the very integrity of the community.[17] Such argument is nicely visualised on the front cover of Alain de Botton's book *Status Anxiety*, which shows a well-heeled figure, clippers on gloved hand, standing on the closely clipped turf of an impressively large estate. A lawn, states Michael Pollan, is to be regarded as 'nature under totalitarian rule' or, as radical gardener Lyx Ish puts it, the lawn is little more than 'a symbol of white male civilization'.[18]

(16)
Cited in Morris, *op.cit.*, p.411.

(17)
McKay, *op.cit.*

(18)
Lyx Ish, 'Peeing on a lily pad (and other musings on gardens and art)' in Peter Lamborn Wilson and Bill Weinberg (eds.) *Avant Gardening: Ecological Struggle in the City and the World.* New York: Autonomedia, 1999, pp.117–126. Michael Pollan, *Second Nature: A Gardener's Education.* New York: Atlantic Monthly Press, 1991. See: Alain de Botton, *Status Anxiety.* London: Hamish Hamilton, 2004.

Today's radical responses may not have impressed those in the 1920s, but strong views about the verdant turf were declared from the outset of the Commission's work. Seeking horticultural specialists a year after the war, Arthur Hill doubted that the French might actually be capable of growing a 'good lawn':

> Doubt was expressed by those in authority whether the sowing of grass was worthwhile and the absence of good lawns in France was held up as an object lesson to the Botanical Adviser and the Horticultural Officers. I chanced to be reading Arthur Young's 'Travels in France' at the time and came across the passage in which he refers to French lawns and says he sees no reason why the French should not be able to have lawns as good as those in England, provided they cut them and looked after them properly. [19]

Hill's ideal was based on a visit to Hascombe village, Godalming in Surrey, where the churchyard's smooth green lawn clipped closely to each headstone deeply impressed him as a paradigm of English values. Diligent, thorough and mindful of the peculiar conditions pertaining in western Belgium, he also visited Holkham Hall on the Norfolk coast to study the planting of marram grass on the sand dunes. Although aspirational, he was also realistic about his chances of seeding every military cemetery with grass. He recognised that those on the former battlegrounds in Italy, Macedonia and Gallipoli, although beautifully located on the shores overlooking the Mediterranean, would never hope to emulate the verdant garden cemeteries of northern France and Belgium, which were largely staffed by British veterans of the Great War. Their love of gardening was regarded as a pre-requisite for the task, endorsed by much popular writing during and after the war, which valorised gardening as an essential, even 'inherent' trait of the English. Writing in 'Exciting to be English', Raphael Samuel has located this innate talent in his study of the making (and unmaking) of British national identity. [20]

Hill's antipathy to foreign practice was not new. A resistance to French (or indeed any non-English) gardening practices had been a characteristic of the British stance towards continental farming practices for centuries. During his extended *Travels in France*, written on the eve of the French Revolution,

(19)
Morris, *op.cit.*, p.426.

(20)
Raphael Samuel, 'Exciting to be English' in Raphael Samuel (ed.) *Patriotism: The Making and Unmaking of British National Identity*, 1, London: Routledge, 1989.

Arthur Young, the greatest of all English writers on agriculture, did not hesitate to tell his French readers blunt home-truths about their farming practices, which he regarded as backwards, although he considered their soil superior to the English.

When relocated to the war grave cemeteries of the Great War, the suspicion of foreign habits was magnified. It is brilliantly captured in Julian Barnes' short story, *Evermore* (1995), which tells the tale of the redoubtable Miss Moss who, in the decades after the Great War, undertakes an annual pilgrimage to visit her brother's gravestone in Cabaret-Rouge Military Cemetery in northern France. Her frequent attempts to customise, even personalise, the graveside environs of her brother's stone are frustrated by the strict protocols that are held in the cemeteries:

> There had been problems with the planting. The grass at the cemetery was French grass, and it seemed to her of the coarser type, inappropriate for British soldiers to lie beneath. Her campaign over this with the commission led nowhere. So one spring she took out a small spade and a square yard of English turf kept damp in a plastic bag.
>
> After dark she dug out the offending French grass and re-laid the softer English turf, patting it into place, then stamping it in. She was pleased with her work, and the next year, as she approached the grave, saw no indication of her mending. But when she knelt, she realised that her work had been undone: the French grass was back again. [21]

(21)
Julian Barnes, *Cross Channel*. London: Jonathan Cape, 1996.

While Miss Moss eventually resigns herself to alien turf and 'dusty geraniums', others were less satisfied with the becalmed appearance of the former battlefield. Great War veteran Edmund Blunden harboured a concern that the levelled ground, the even greensward, which characterised each British and Empire cemetery on the former Western Front, was a mask that concealed dreadful truths:

> The beauty, the serenity, the inspiration of the Imperial cemeteries have been frequently acknowledged by more able eulogists; for my part, I venture to speak of these lovely, elegiac closes (which almost cause me to deny my own experiences in the acres they now grace) as being after all the eloquent evidence

Sarigol Commonwealth War
Graves Cemetery, Kriston,
Macedonia, Greece

(22)

Edmund Blunden, *Introduction to Fabian Ware,
The Immortal Heritage: An Account of the Work
and Policy of the Imperial War Graves Commission
during Twenty Years, 1917–1937.* Cambridge:
Cambridge University Press, 1937.

(23)

Paul Shepheard, *The Cultivated Wilderness: Or,
What is Landscape?* Cambridge: MIT Press, 1997.

(24)

Jay Winter, *Sites of Memory, Sites of Mourning.*
Cambridge: Cambridge University Press, 1995.

(25)

Alan Bennett, *Writing Home.* London: Faber and
Faber, 1995, p.28.

*against war. Their very flowerfulness and calm tell
the lingerer that the men beneath the green coverlet
should be there to enjoy such influence; the tyranny
of war stands all the more terribly revealed.* [22]

Others have observed this uneasy tension between the
pristine orderliness of the cemetery and the chaotic causes
of death and destruction just centimetres under the surface.
However, no single consensus holds. Whereas Mosse has
argued that nature has been artificially distorted to reshape,
smoothen and ameliorate the horrors of war, others have
taken a different view arguing that it is the very specificity
of remembrance—the assiduous clip and mow, the attention
to every detail—that prevents the Commonwealth War
Graves Cemeteries from becoming simply mawkish. [23]
By comparison, the sight of unkempt parkland and overgrown
lawn evokes painful associations with traumatised bodies,
disintegration, administrative lethargy and neglect. In brief,
lawns require regular care and maintenance. Closely mown
grass soon shows signs of decay if it is neglected for long and,
by extension, memory requires equivalent levels of attention
if it is not to atrophy. [24]

Reactions to the cemeteries can be
surprisingly polarised. Playwright Alan Bennett, in his edited
diaries, dwells on a visit made in the late 1980s to an obscure
village somewhere between St Omer and Zillebeke, south-east
of the Flemish town of Ypres in Belgium. He is on a quest to
locate the burial site of his Uncle Clarence, who died, aged
20, in 1917. Once located, the cemetery seems typical of the
170 others in the Salient: neat and regular, more orderly than
the surrounding banal suburbs, bungalows and factory farms.
It is, he notes, as if 'the dead are here to garrison the living'.
Uncle Clarence is easily spotted, the stone is in a row back-
ing onto the railway line though his body lies not beneath
it, known only to be buried somewhere in the compact plot.
For Bennett, it is an unnerving moment, made more so by
the unblemished agelessness of the site. The walls, he writes,
are sharp, new-looking, unblurred by creeper, the bleached
Portland stones free of lichen, the turf manicured. 'The dead'
he states, 'seeming not to have fertilised the ground so much
as sterilised it'. [25]

Where he saw only a frigid landscape
populated by the absent dead, the architect Maya Lin relied on
the smooth folds of rolls of turf to help soften the jagged edges
of bitter memory. In her design for the Vietnam Veteran's

Memorial in Washington DC, she used generously grassed lawns to repair the deep cuts in the social and political fabric of a country traumatised by an embarrassing and unpopular war. 'I thought about what death is, what loss is…a sharp pain that lessens with time but can never quite heal over. A scar. The idea occurred to me there on that site. Take a knife and cut open the earth and with time the grass would heal it.' [26] Summarising these many tensions, Morris suggests that the outwardly serene surfaces of lawn, flowerbed and well-tended shrub stand as uneasy interfaces between a sanitised landscape of national grief and the shattered bodies just beneath the pristine greensward, a tense balancing of the official and unofficial, the public and the private; a landscape at peace, as opposed to one with a veneer of decorum that conceals bodies in pieces.

(26)
Arthur Danto, 'The Vietnam Veterans Memorial', *The Nation*, 31 August 1986, p.152.

Environmental sustainability

As the challenges of climate change have become ever more apparent and with a proliferation in the level and intensity of media coverage on the topic, organisations such as the Commonwealth War Graves Commission have had to consider the possible impact of environmental change on their horticultural work. In 2009, the Commission began to engage a series of experiments to test out their preparedness for imminent climate change. Arguing, with some justification, that they had already a great deal of experience in gardening under challenging conditions, they set out their purpose with a series of reflective questions:

> *What pests and diseases might we encounter and what can we do to mitigate those challenges? How can we practically employ in the cemeteries the breadth and wealth of horticultural experience we already have as an organisation and how might the public react to these changes?* [27]

So as to test the validity and durability of its existing environmental policy, the Commission set up a controlled experiment. On the premise that the bulk of the cemeteries it maintained were in northern Europe, it chose two sites in France and two in Belgium as showpieces where it could demonstrate the adaptations that might be necessary to combat climate change. Through making these horticultural, design and sartorial changes, it hoped to engage with the visiting public and assess their reaction to the work.

(27)
Commonwealth War Graves Commission, online.

The four cemeteries were in France, Les Moeres Communal (13 kilometres east of Dunkerque) and Ove-Plage Communal (14 kilometres east of Calais), in Belgium, Oostduinkerke Communal (midway between Nieuwpoort and Koksijde) and Railway Chateau Cemetery (2 kilometres west of Ieper). Two methods were to be tested—at one cemetery in each country—a 'dry landscape' scheme was created whereby the turf was completely removed and replaced with other surfaces; at the two other sites, the existing greensward was replaced with drought tolerant turf. Floral borders in all four cemeteries were planted in the time-honoured way but with plants selected for their ability to withstand periods of drought.

In advance of public reaction, the Commission was keen to point out that such changes were not new or untested elsewhere. In Mediterranean locations—Greece, Turkey, Egypt, Tunisia and Libya—which had sizeable numbers of military cemeteries and where a lack of water, or irregular supply, meant that grass could often not be grown, other options had been pursued and successfully implemented. On such sites pebbles or gravel had been used instead, with and without border planting. However, it was acknowledged that this was the first time such a programme of work had been conducted in northern Europe.

Public reaction was invited. It was not long in coming. In addition to direct communications with the Commission, web-based bulletin boards carried many colourful exchanges. If we take the *ww2Talk* online forum as a typical example of the banter shared between regular visitors to the Western Front, we can discern three slightly overlapping responses to the Commission's experiment. Firstly, some saw it as a rejection (indeed betrayal) of first principles, regarding it as an abdication of responsibility by the commission and an abandonment of an essential component of remembering, which might best be summarised as: 'I've only ever seen them as grassed places. It's just the tradition I've grown up with'. [28] Secondly, other responses (a minority) saw the pilot-exercise as an underhand ruse to cut maintenance costs, hidden behind the unproven arguments of global climate change. Suggesting that Belgium was probably one of the wettest places on the planet, one sceptical correspondent stated categorically: 'I suspect it is simply a cost saving experiment under the pretext of global warming'. [29] A third set of responses congregated

(28)
'Steve G', Commonwealth War Graves Commission, online.

(29)
'Steve G', Commonwealth War Graves Commission, online.

around broader frustrations with sluggish official attitudes to preserving memory. In a revival of Young's xenophobia, many regarded the experiment as yet another erosion of British values, placed under threat by non-specific 'foreign' practices: 'I thought the idea of these cemeteries in a foreign land', said another, 'was to be forever a bit of England'. [30] In several cases, these sentiments were laced with anxieties about a waning sense of patriotism and a betrayal of those we ought to hold in the highest regard:

(30)
'Geoff 501', Commonwealth War Graves Commission, online.

> *I have always been touched by the commissions way of making its cemeteries fit for heroes, and a little piece of England. Gravel just doesnt (sic) work, in my opinion.* [31]
>
> *I am always impressed by the lovely lawns between the headstones. A piece of green, immaculately kept in an oasis of peace.* [32]
>
> *I really don't want to think the world these guys died for is turning into that. Find a way of giving them grass. Don't they at least deserve that?* [33]

(31)
'Owen', Commonwealth War Graves Commission, online.

(32)
'Auditman', Commonwealth War Graves Commission, online

(33)
'James Daly', Commonwealth War Graves Commission, online.

To these passionate respondents the greensward was being threatened not by others but from within; the quintessential English churchyard cemetery was being defiled so that it looked 'more like a goods yard' than a garden. To some it echoed a greater loss of national identity; this was 'a metaphor for what's happening to England's green and pleasant land'. [34] Of course, context is all. The Commission's experiment had taken place against a backdrop of polarising views around the larger environmental debate. Take for example the gardening pages of national newspapers, which offer diverging positions on the ethical proposition symbolised by the well-maintained grass lawn. On the one hand there are such expressions as 'a lush, well-watered lawn is every Englishman's right' and 'if an Englishman's house is his castle then his lawn is most certainly his estate'. [35] While on the other hand, there is the environmental lobby that argues that 'clinging to the grassy elegance of English lawns will be regarded signals of social and moral decadence'. [36]

(34)
'Idler', Commonwealth War Graves Commission, online.

(35)
Tom Fort, *The Grass is Greener: Our Love Affair with the Lawn*. London: Harper Collins, 2001.

(36)
L.Gray, 'Lawns will Become Sign of 'Moral Decadence' Because of Climate Change', *Daily Telegraph*, 1 May 2009.

Caught in the midst of such debate and faced with a barrage of objection, even ridicule, the Commonwealth War Graves Commission brought an end to this phase of the experiment and drew some conclusions.

(LEFT AND ABOVE)

Railway Chateau Commonwealth
War Graves Cemetery, near
Ypres, West Flanders, Belgium

During the trial period, some 250 members of the public had expressed their views through the online survey. 106 of these had actually visited at least one of the four cemeteries, where more comments had been left in the visitors' books. The Commission conceded that, although many supported their work on climate change and many had recognised the need to consider alternative approaches, there was 'little enthusiasm for the hard landscaping approach adopted at Railway Chateau'. [37] As a result of the feedback received, it would be re-established as a typical lawn cemetery in the spring of 2011. However, the experiment was not to be wholly abandoned; that particular cemetery would remain part of the climate change demonstrations as the Commission continued to explore the use of drought tolerant plants in the borders and a drought tolerant grass mix, which would continue to be used at Oostduinkerke Communal Cemetery in Belgium.

Conceding that it had lost the public relations campaign, the Commission restated its original argument that elsewhere in the world, dry landscaping was commonly and successfully used in other cemeteries where grass cannot be grown or maintained, usually due to a lack of a regular water supply. However, this was the first time it had been demonstrated at one of their cemeteries in northern Europe. Perhaps it had indeed been a step too far and too quickly. To this end the Commission reassured interested parties that the demonstrations would continue to run for another four years and would be closely monitored by their officers and gardeners and also by the many visitors who maintain their ideological vigilance on these sites of memory.

As a coda to this charged debate we might dwell a little on the fondness, indeed the urgent need, for green spaces in times of trauma. In defiance of the grim and challenging conditions of wartime Iraq and Afghanistan we find examples of British and US soldiers creating gardens, growing plants and even harvesting fruit from small pockets of earth between the tents and temporary huts of their fortified camps and bases. Where the task of managing a plot is too demanding, possibly too dangerous, we can find evidence of temporary lawns or symbolic strips of grass planted as an emblem of home. Possibly the most idiosyncratic of these is an image of a square of green tarpaulin laid out in the midst of a tent city at US Air base at Al Kharj, Saudi Arabia in 1990-91.

(37)
Commonwealth War Graves Commission, online.

Held down by sandbags and, giving every impression that it is brushed clear of dust and sand daily, the finishing touch to this temporary lawn is a hand-painted sign urging pedestrians to 'Stay off the lawn!'.

Partial closure

Little should surprise us about the intensity of feeling aroused by these proposed changes to the appearance of the silent cities in France and Belgium. Even though the last of the Great War veterans has passed away, the moral commitment to preserve the inherited memory of the war has put renewed pressure on those maintaining the appearance of the cemeteries by assuming the moral high ground over what is grown and nurtured. The disputes, which may seem petty to many on the outside, shed a fascinating light on the attributes of Englishness. [38] They tell us much about the palpable tensions between a public and private agenda of grief and how the individual 'rememberer' can contest the dictates of a centralised administration. In an interesting reversal of topographical fortune, what were once blighted and scarred landscapes, heavily contested by several sides, have (despite their outward calm) remained contested. Wounds that ought to be left to heal are picked at, even allowed to redden, to remain scabrous. Here there is only partial closure. Although the mines, tunnels and dugouts have been capped and fenced off, memory refuses to be parked. As John Rodwell has so eloquently described, 'closure' has many readings—political, social, geographical—and the siting of parkland or a memorial ground is as much an act of policy as it is an evocation of particular remembering. [39]

Given the fixity of the stone monuments, the weight of official histories and the great burdens of the grand narratives of the war, many of those who want to mark their own, unique and individualised memory have had to do so through rogue planting, the laying of flowers, the surreptitious marking of the foreign field with seeds and saplings. Plants, shrubs, even trees and other natural interventions, act as metaphors for collaboration and interaction in a way that hewn stone, shaped bronze and architectural scale cannot. Just as hand-picked flowers allow the private voice to be heard alongside the high diction of official rhetoric, so a carefully manicured lawn speaks of attention to detail, egalitarian values and long-term commitment—of turf wars fought by grass roots communities of interest.

(38)
Paul Gough, 'Sites in the Imagination: The Beaumont Hamel Newfoundland Memorial on the Somme', *Cultural Geographies*, 11 (3) 2004, pp.235–258. Paul Gough, 'Planting peace: The Greater London Council and the Community Gardens of Central London', *International Journal of Heritage Studies*, 3 (1) 2007, pp.22–41.

(39)
John Rodwell, 'Forgetting the land', *Studies in Christian Ethics*, 21 (2) 2008, pp.269–286.

'CONTESTED MEMORIES:
'CONTESTED SITE'

NEWFOUNDLAND AND ITS UNIQUE
HERITAGE ON THE WESTERN FRONT

Tyne Cot Blockhouse,
Tyne Cot Commonwealth War
Graves Cemetery, Zonnebeke,
Ypres Salient, Belgium

Topography and immutable memory

In a lecture commisioned for the New York Public Library and later published as 'The Site of Memory', Toni Morrison suggested that so-called 'fictional' writing is rarely a product of complete invention; it is always an act of imagination bound up with memory. She drew an analogy between site and memory:

> *You know, they straightened out the Mississippi River in places, to make room for houses and livable acreage. Occasionally, the river floods these places. "Floods" is the word they use, but in fact it is not flooding; it is remembering. Remembering where it used to be. All water has a perfect memory and it is forever trying to get back to where it was.* [1]

Morrison's poetic image of a 'stream of memory' compelled to revisit an original site can be seen as integral to the relationship between geographical spaces and the construction of individual and collective remembering. As is explored throughout this volume, such syncretic intertwining of place, identity and memory is rare and subject to a continuous evolution of meaning. Social memory links emotional ties with specific geographies that are anchored in 'places past'. Most often during periods of national commemoration, appropriate emotions have been invested in enduring forms of stone, bronze or brick, [2] in which monumental forms are strewn across our urban landscape. Christine Boyer has described such manifestations as 'rhetorical *topoi* ... civic compositions that teach us about our national heritage and our public responsibilities and assume that the urban landscape itself is the emblematic embodiment of power and memory'. [3] However, as many have argued, the meaning of monuments is problematic. Lewis Mumford has asserted that both monuments and revered sites rapidly become invisible within the collective memory because 'something has impregnated them against attention'. [4] They simply blend back into the undifferentiated landscape. In short, the meaning of monuments, like memory itself, is profoundly unstable. [5] It is hardly surprising that, after each of the world wars of the last century, the dialectic between remembering and forgetting has been a dominant theme in the discourses around commemoration and remembrance. [6] Analysing what he refers to as the 'anxiety of erasure'

(1)

Toni Morrison, 'The Site of Memory' in C. West, R. Ferguson, T.T.Minh-ha, M. Gever (eds.) *Out There: Marginalisation and Contemporary Cultures*. Cambridge: New Museum of Contemporary Art and MIT Press, 1990, p.305.

(2)

For an elaboration of syncretism see Nuala Johnson, 'Mapping monuments: The shaping of public space and cultural identities', *Visual Communication*, 1 (2) 2002, p.294.

(3)

Christine M. Boyer, *The City of Collective Memory*. Massachusetts: MIT Press, 1996, p.321. See also Jeremy Foster, 'Creating a tenemos, positing 'South Africanism': Material memory, landscape practice and the circulation of identity at Delville Wood', *Cultural Geographies*, 11 (3) 2004, pp.259–90.

(4)

Lewis Mumford, *The Culture of Cities*. New York: Harcourt, Brace and Co, 1938, p.435.

(5)

Robert Musil, in Marina Warner, *Monument and Maidens: The Allegory of the Female Form*. Weidenfeld and Nicholson, London, 1985, p.21. See also Daniel J. Sherman, 'Art, commerce and the production of memory in France after World War One', in John R. Gillis, *Commemorations*. Princeton: Princeton University Press, 1994, pp.186–211.

(6)

See Adrian Forty and Susanne Kuchler (eds.) *The Art of Forgetting*. Oxford: Berg, 1994; and Adrian Gregory, *The Silence of Memory, Armistice Day 1919–1946*. Oxford: Berg, 1994.

engendered by bourgeois culture, Lacquer asserts, in a similar vein, that figurative simulation, as epitomised by the plinth-bound statue, has long been inadequate to the task entrusted to it. Instead, 'the thing itself must do because representation can no longer be relied on'. [7]

In many instances, however, 'the thing' is little more than a cleared and uncluttered tract of land to which historic significance is attached. It is possible to trace a developing commemorative strategy vested in locales of embodied potentiality, [8] from the preservation of the battlefield of Gettysburg in 1863 to the barren ash hills around Verdun, through to such Second World War sites as the beaches of Normandy, the 'martyred village' of Oradour and to Hiroshima. [9] In each place the moral resonance of the site itself is seen as paramount. Ditches, mounds, ruins and outwardly barren tracts have been maintained because they are seen as 'historical traces', which have an authority that now eclipses the untenable artifice of the commemorative object—the plinth, the plaque and so forth. Nonetheless, the semiotics of commemorative spatiality are complex because, as Bender points out, spaces are 'political, dynamic, and contested' and so 'constantly open to renegotiation'. [10] This difficulty notwithstanding, a semiotics of place has been clearly articulated by the French sociologist Maurice Halbwachs, who was compelled by the qualities of particular sites and examined their role in the formation of collective memory. 'Space', wrote Halbwachs, 'is a reality that endures', it can unite groups of individuals and believers, concentrating and 'moulding its character to theirs'. [11] When compared to transient phenomena and ill-considered monumentalia, certain geographical locations appear to offer a sense of legitimate permanence that draws pilgrims to sites that 'place' or 'contain' the memory of overwhelming events. The terrain around the Brandenburg Gate, *Les Invalides*, the 'raised knoll' in downtown Dallas, might be considered secular shrines that are capable of rekindling memories of awesome events. [12] Claudia Koonz, in an analysis of the commemorative hinterland around Nazi concentration camps, suggests that, while we know that written texts are 'infinitely malleable' and readily abridged, films edited and photographs airbrushed, the landscape feels immutable. Only geography, she argues, is capable of conveying the

(7)
Thomas Lacquer, 'The past's past', *London Review of Books*, 18 (18) 9 September 1996.

(8)
Jeremy Foster, 'Creating a tenemos, positing "South Africanism": Material memory, landscape practice and the circulation of identity at Delville Wood', *Cultural Geographies*, 11 (3) 2004, pp.259–90.

(9)
For an examination of such sites as spaces for peace and reconciliation and for a comprehensive bibliography on these sites, see Paul Gough, 'From heroes' groves to parks of peace', *Landscape Research*, 25 (2) 2000, pp.213–229.

(10)
Barbara Bender, 'Stonehenge: Contested landscapes (medieval to present day)' in Barbara Bender (ed.) *Landscape: Politics and Perspectives*. Oxford: Berg, 1983, p.276.

(11)
Maurice Halbwachs, *The Collective Memory*, translated F.J.Ditter Jnr. and V. Y. Ditter. New York: Harper Colophon, 1980. First published as *La Memoire Collective*, 1950.

(12)
Claudia Koonz, 'Between memory and oblivion: Concentration camps in German memory', in John R. Gillis (ed.) *Commemorations*. Princeton: Princeton University Press, 1994, p.258.

narrative of extermination: 'At these places of remembering, memory feels monolithic, unambiguous, and terrible'. It is a point endorsed by Mayo, in his epic survey of the contested terrain of native North America, when he simply states: 'the landscape itself is the memorial'. [13]

Such sites of memory, or *'lieux de memoire'*, as understood by Pierre Nora, exist at the intersection between official (or civic) and vernacular cultures. [14] Their inestimable value to the workings of collective memory is recognised by Gillis, who points out that most people find it difficult to remember 'without having access to mementos, images, and physical sites to objectify their memory'. [15] Preservation and 'reconstruction' of such sites has accelerated recently, alongside a compulsive consumption of personal and public history and the democratisation (some might say privatisation) of the past.

As hallowed sites of national memory, the identification and preservation of former battlefields as physical sites of trauma can help maintain a consciousness of the past, which is 'essential to maintenance of purpose in life, since without memory we would lack all sense of continuity, all apprehension of causality, all knowledge of our identity'. [16] Rainey and others suggest that, despite the need for occasional artifice, battlefields are especially significant as memorial landscapes because they 'challenge us to recall basic realities of historical experience, especially those of death, suffering and sacrifice'. [17] If landscape is 'memory's most serviceable reminder', preserved battlefield sites can help to concretise the experience of war and evoke profound reflections— a principle endorsed in the *Vimy Declaration for Conservation of Historic Battlefield Terrain*. [18]

Wandering over the sites of the Battle of Gettysburg (1863) and musing on the manner in which we help to create significant landscapes, Harbison suggests that 'serious tourists' help monumentalise the landscapes they pass through, 'classicising them by concentrating on certain nodes of significance which acquire ceremonial eminence' whatever their outward condition. [19] The role of the 'serious' tourist, he argues, is essentially reconstructive. At no point is this more evident than in the constructions of 'spectacles of memory' often staged on

(13)

James M. Mayo, *War Memorials as Political Landscape: The American Experience and Beyond*. New York: Praeger, 1988, p.172.

(14)

Pierre Nora (ed.) *Realms of Memory: The Construction of the French Past*. Volume 1, *Conflicts and Divisions*; Volume 2, *Traditions*, Volume 3, *Symbols*. New York: Columbia University Press, 1992.

(15)

John R. Gillis, 'Memory and identity: The history of a relationship', in Gillis, *Commemorations, op.cit.*, p.17.

(16)

David Lowenthal, *The Past is a Foreign Country*. Cambridge: Cambridge University Press, 1985, p.103.

(17)

R.M. Rainey, 'The memory of war: reflections on battlefield preservation', in R.L. Austin (ed.) *Yearbook of Landscape Architecture*. New York: Van Nostrund Reinold, 1983, p.76.

(18)

The Vimy Declaration for Conservation of Historic Battlefield Terrain was drafted by participants at the First International Workshop on Conservation of Battlefield Terrain, held in Arras, France, 1–3 March 2000 at the invitation of the Department of Veterans Affairs, Canada. Participating organisations included the Department of Veterans Affairs, Canada; Heritage Conservation Program; Real Property Services for Parks Canada; Public Works and Government Services Canada; United States National Park Service; Parks Canada; the National Battlefield Commission of the Department of Canadian Heritage; English Heritage; the Durand Group (United Kingdom); University College London; City of Arras, France; American Battle Monuments Commission; Ministry of Culture and Communication (France) and the Commonwealth War Graves Commission.

(19)

Robert Harbison, *The Built, the Unbuilt and the Unbuildable*. London: Thames and Hudson, 1991, p.38.

former battlefields. Invariably these take the form of choreographed events focused on a commemorative motif where the annual rehearsal and repetition of commemorative acts—such as Armistice Day or a battlefield pilgrimage—bring about a consensual collapsing of time into place. [20] During such events, public monuments can no longer be considered innocent aesthetic embellishments of the public sphere. Instead, attention has to be re-focused on the 'spatiality' surrounding public monuments, 'where the sites are not merely the material backdrop from which a story is told, but the spaces themselves constitute the meaning by becoming both a physical location and a sight-line of interpretation'.

Parkland

Within months of the Armistice in 1918, as the native populations of France and Belgium returned to the *regions devastees*, individuals and groups from as far afield as Australia, New Zealand and Canada set out on pilgrimages to find for themselves the sites of memory in their homelands. The places that drew them were largely imaginary ones: 'It was not the sites themselves which attracted travellers, but their associations'. [21] Even before the various peace treaties had been signed in 1919 an estimated 60,000 visitors had roamed the battlefields. Individuals who did not wish to hire the services of a professional guide or undergo the vicissitudes of the region's damaged infrastructure could join organised pilgrimages. These varied in scale from the 30 veterans from the Canadian Maritimes who visited in 1927, to the 15,000 Americans who took part in the great American Legion pilgrimage that same year. Unveiling events often attracted vast crowds; most notably the 6000 Canadians who joined the Vimy Pilgrimage in 1936 to witness the unveiling of Walter Allward's immense memorial on Hill 145 on the crest of Vimy Ridge. [22]

As reconstruction proceeded, often at a rapid pace, governments from across the British Empire, along with remembrance groups, veterans and bereaved families, sought to obtain small tracts of land to situate permanent memorials and create protected spaces. [23] Dominion countries and colonies were especially concerned to secure tracts of land. The South African government purchased the site of Delville Wood on the Somme; Australian ex-servicemen's

(20)
Nuala Johnson, 'Historical geographies of the present', in Brian Graham and Catherine Nash (eds.) *Modern Historical Geographies*. Longman: London, 1999, p.254.

(21)
David Lloyd, *Battlefield Tourism*. Oxford: Berg, 1988.

(22)
Jonathan Vance, *Death so Noble: Memory, Meaning and the First World War*. Vancouver: University of British Columbia Press, 1997, p.57.

(23)
Hugh Clout, *After the Ruins: Restoring the Countryside of Northern France after the Great War*. Exeter: University of Exeter Press, 1996.

Relics and refuse of battle,
Ypres Salient, Belgium

organisations (chiefly the Returned Servicemen's League) began to return to Gallipoli to secure land. But probably the largest single scheme of land purchase was instigated by the Canadian government: it acquired sufficient land for eight memorial sites (three in Belgium, five in France) of which the largest is the 250 acres on Vimy Ridge. Such acquisitions presented formidable difficulties: property bournes had to be negotiated, infrastructure had to be instituted; entire villages, woodlands and roads had often been completely obliterated by the fighting. The task of relocating the boundaries and establishing the exact position of sites and roads required prolonged and careful instrumental surveys. There were delays while attempts were made to locate the original owners or their heirs and long legal processes were often necessary. Although frustrating, little of this seems to have deterred civil and public servants from distant bureaucracies. Indeed, the Government of Newfoundland purchased no fewer than five sites, each associated with fierce engagements fought by the Newfoundland Regiment.

The largest of these was at Beaumont-Hamel on the Somme. Purchasing the 16.5-hectare (40 acre) tract of land required prolonged negotiation with nearly 250 landowners and was not concluded until 1921. These arrangements, and the extended task of developing each site and planning for appropriate monuments, was delegated by the government to the Director of Graves Registration and Enquiry, Colonel Thomas F. Nangle, a former wartime padre of the Regiment and Newfoundland's representative on the Imperial War Graves Commission (IWGC).

The action at Beaumont-Hamel on 1 July 1916 will need little introduction. It was at this point on the 11 mile battlefront during the Somme offensive that the great mine of Hawthorn Crater was exploded at 7.20 am and here too the dreadful moment when the 1st Battalion of the Newfoundland Regiment—some 801 officers and men led by Colonel Hadow—were erroneously ordered to attack over open ground into a killing zone that was swept by well-positioned German machine guns, some more than a mile away. By this time in the first hours of the five-month-long offensive, the Newfoundlanders were possibly the only attacking troops visible above ground on that sector. Because their communication trenches were blocked by the dead and

Aerial view of the Beaumont
Hamel Memorial, showing
the orientation of the British,
Allied and German trenches.
Photograph courtesy of Veterans
Affairs Canada/Anciens
Combattants Canada

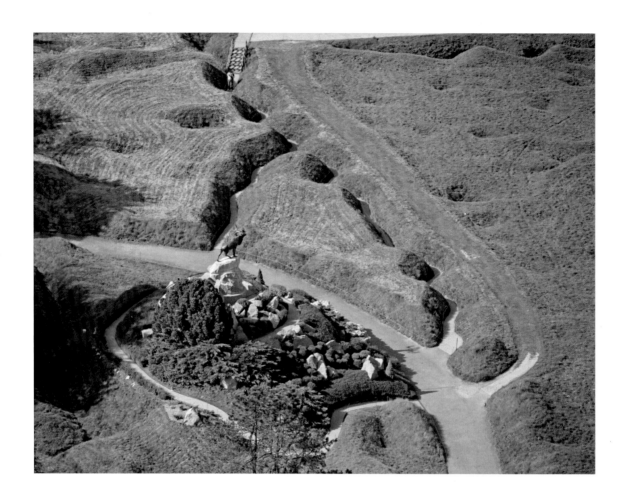

Aerial view of the Beaumont Hamel Memorial, showing the Caribou Monument and the orientation of the front-line trenches and cemeteries. Photograph courtesy of Veterans Affairs Canada/ Anciens Combattants Canada

the wounded, the battalion had to climb onto the open ground under fire and advance without cover some 250 yards before they even reached their own frontline. They had to cross no-man's-land down a slope where, for the first time, some may have glimpsed the German wire over 550 metres away. Forty minutes after they broke cover the Newfoundlander's action was over; as one of the few survivors later noted 'there were blokes lying everywhere'. [24] At roll call only 68 of the unit were unwounded; casualties had been over 90 per cent, not the grimmest statistic of the Great War but certainly among the worst and made more horrible by the high percentage of loss for the small population of Newfoundland. To put this into context: from 1917 Newfoundland, a self-governing colony, provided over six thousand men for the infantry, manpowerfor the Royal Navy, as well as considerable expertise and manpower for the Forestry Corps based in Scotland: in all, a considerable contribution from a total population of only 250,000.

This tract of land at Beaumont-Hamel was fought over again during the war (and again during the Second World War) most notably in November 1916 when the 51st Highland Division gained much of the enemy lines that had so easily repulsed the Newfoundlanders. It is, however, the 'first of July' narrative that dominates the preferred readings of the topography. Once cleared of dangerous materials and debris it was re-shaped by Rudolf Hogo Karel Cochius, a Dutch-born landscape architect and resident of St Johns, Newfoundland. Working with Nangle, he designed the landscape so that it centred on a raised stone cairn surmounted by a huge bronze caribou (sculpted by Basil Gotto) from where the devastated landscape of trench lines and craters could be viewed. Some 35,000 seedlings, plants and small trees were imported from Holland, Scotland and Newfoundland and the caribou was surrounded with species indigenous to eastern Canada—white spruce, birch, dog-berry and juniper. Inside the perimeter of the memorial space are several war grave commission cemeteries, contemporary photographs show their pristine gravestones flanked by plantings and saplings, while behind lies the barren and pock-marked Somme plain. [25] Adding to the sense of drama is a petrified stump of a tree that had acted as a gathering point for soldiers seeking the illusion of shelter during the attack on

(24)
Nigel Cave, *Beaumont Hamel: Newfoundland Park*. London: Leo Cooper, 1997, p.63.

(25)
Sidney C. Hurst, *The Silent Cities*. London: Methuen, 1929, p.265. See also: Philip Longworth, *The Unending Vigil*. London: Commonwealth War Graves Commission, 1967.

1 July 1916. Long since perished, it has been preserved (with the help of a sunken barrel of cement) and stands sentinel halfway across the old no-man's-land. Known as 'the Danger Tree' it has become one of the key memorial emblems along the entire stretch of the Western Front, eulogised and celebrated as an icon of remembrance. The memorial park was formally opened by Field Marshal Sir Douglas Haig, former Commander-in-Chief of the British Expeditionary Force, in July 1925. Upon Newfoundland's entry into Confederation in 1949 it was recognised as a Canadian National Historic Site and is now administered by the Canadian government's Department of Veteran Affairs.

Serious tourists

> *Dick turned the corner of the traverse and continued along the trench walking on the duckboard. He came to a periscope, looked through it a moment, then he got up on the step and peered over the parapet. In front of him beneath a dingy sky was Beaumont-Hamel; to his left the tragic hill of val. Dick stared at them through his field glasses, his throat straining with sadness.*
>
> *He went on along the trench, and found the others waiting for him in the next traverse. 'This land here cost twenty lives a foot that summer', he said to Rosemary. She looked out obediently at the rather bare green plain with its low trees of six years growth. ... 'See that little stream – we could walk to it in two minutes. It took the British a month to walk to it – a whole empire walking very slowly, dying in front and pushing forward behind. And another empire walked very slowly backward a few inches a day, leaving the dead like a million bloody rags. No Europeans will ever do that again in this generation.' ... They came out of the neat re-stored trench, and faced a memorial to the Newfoundland dead. Reading the inscription Rosemary burst into sudden tears.* [26]

(26)
F. Scott Fitzgerald, *Tender is the Night*. London: Allen Lane, 1934, p.6.

Fitzgerald's fictional characters were among the waves of tourists who roamed the old Somme battlefields after the war. Subsequent waves of 'serious' tourists have played a crucial reconstructive role as they bring value to a specific place, nurturing communities of

interest, which eventually leads to such highly choreographed events as re-enactments, pilgrimage and mass anniversaries. In these heightened ritual moments, the sites are not merely the material backdrop from which a story is re-told, but 'constitute the meaning by becoming both a physical location and a sight-line of interpretation'. [27]

To accommodate these shifts in expectation the Beaumont-Hamel site was modified in the early 1960s. Much of the spruce planting around the cairn was cut back because it obliterated both the caribou and the view. A small superintendent's lodge was built on the site and a memorial plaque unveiled. Some landscaping modifications were also undertaken, and several 1916 trench lines were re-excavated and rebuilt so as to clarify and define their orientation and appearance. This act of reconstruction was intended to 'preserve in its original state the shell-pitted ground between St. John's Road and the *Y-Ravine* across which the heroic advance of July 1, 1916 was made'. In this task, the Canadian authorities were assisted by a veteran officer who had fought as a platoon commander during the battle.

Since then the site has changed little and has become extraordinarily popular, especially with British remembrance societies and ex-servicemen's associations for whom it serves as a peerless icon of the trench war. Furthermore, during the past decade it has become an essential 'stop' on the itinerary of tours and educational field trips taken by British school children who are studying the National Curriculum course in history. As a result, its very popularity is now deemed to be a threat to its ecological future. In 2000 the Department of Veteran Affairs Canada undertook research that showed that in a single year one million visits were being made to Vimy Ridge; while over 250,000 people visit the far smaller site at Beaumont-Hamel. The same organisation held the first international gathering of battlefield conservation experts, bringing together archaeologists, conservation architects, ground penetrating radar consultants, military historians and landscape architects, along with the custodians of the many memorial sites in northern Europe. The *Vimy Charter* (which resulted from the 2000 symposium) recognised the impact on the historic terrain in northern France and recommended immediate

(27)
Nuala Johnson, 'Historical geographies of the present', in Brian Graham and Catherine Nash (eds.) *Modern Historical Geographies.* London: Longman. 1999, p.254.

action to safeguard the sites. It was agreed that no further damage should be caused; that any conservation actions should be reversible and 'no more should be done to increase the loss of legibility of the site permanently'. In what proved to be a controversial act, visitors were to be actively discouraged from wandering uninhibited across the battlefield, instead they were required to stay within demarcated areas. Furthermore, semi-permanent footpaths were introduced on certain tracts of the ground so as to minimise erosion and (at Beaumont-Hamel) an enhanced visitor and interpretation centre was created. Less controversially (although more profound in the long-term re-conceptualisation of the site) it was decided that the term 'Park' would be dropped in favour of 'Memorial'. This was done to ensure that the former battlefield was regarded as a 'reverential' space as distinction from a place of recreation or historical re-enactment. Under the direction of the custodian of the site, the induction and training of battlefield guides—usually Canadian students on short-term internships (often the same age as those Great War soldiers who fought across the same ground)—was refreshed, drawing upon expert advice from battlefield archaeologists and historians. An interpretation centre, designed in the architectural vernacular of Newfoundland, was erected near the entrance to the site and the car park was extended to cope with the visiting multitudes.

Soon after these changes had been made, the effect on visiting remembrance groups, schoolteachers and battlefield tourists from the United Kingdom was profound. Through tracking the letters pages of such popular remembrance and armed service magazines as *Stand To!* the journal of the Western Front Association and through follow up interviews and correspondence with the authors of some of the letters, one quickly gathers a sense of their frustration at the changes being wrought on a once-familiar and accessible landscape. One correspondent described his expectation of the site in these terms:

> *One of the central features of our visit to the Somme is to spend at least an hour at Newfoundland Park and conduct in-depth fieldwork in this portion of the battlefield. Regular visitors to this invaluable preserved site will be familiar with its features and the benefits it affords anyone studying trench warfare.*

The events of 1st July 1916 can be followed by standing in the British front-line, looking towards the German trenches and then going 'over the top', timing how long the walk across no mans land takes. The view from the German front-line to the British trenches (both front-line and reserve) brings home why the first day of the Somme was so costly for the British and Newfoundland troops who fought there. [28]

(28)
John Nicholas, 'Letters to the Editor', *Bulletin*, Western Front Association, 60, October 2000, p.48.

Expectations, however, seemed to be compromised by minor factual errors. A number of correspondents were critical of the signage on the site, which was in some places deemed to be 'inaccurate', in other places 'misleading'. [29] For example, the main trench line was marked as *St John's Road* (named after the capital of Newfoundland). However, during the war this was actually the name given to the metalled road between the two villages behind the lines. Another trench halfway across the old no-man's-land (asserted one letter-writer) was not labelled at all, largely because it was created during a later battle and therefore has no part on the Newfoundlander's 'First of July' narrative. [30] As another correspondent wrote, the site was 'replete with errors and misunderstandings—it is plainly inauthentic'. [31] Some regular visitors described their frustration in not being able to roam at will across the site, even feeling 'cheated' of the experience. As an outcome of further interviews carried out on the site in 2004 and again in 2006, one group, leaving the memorial (in April 2006) told how they had started travelling to the Verdun Salient to regain the authentic sense of a sacred site of memory. Beaumont-Hamel, said a member of another group, was now too 'organised'. [32]

(29)
Clive G. Hughes, correspondence with the author, 2001.

(30)
Peter Ayley, correspondence with the author, 2001.

(31)
Alan Hayhurst, correspondence with the author, 2001.

(32)
Scott Fraser, correspondence with the author, 2002.

'Authenticity' is, of course, a term hedged by contingencies. Selective reconstruction in 1922 and 1960 re-inscribed the Beaumont-Hamel Memorial terrain with a particular interpretation of history. By focusing exclusively on the Newfoundlander's story, any parallel exploration—of the German soldiers or the Scottish troops who fought across the same site five months later—remains a subordinate narrative. In order to underpin the dominant narrative, all the captions, markers and signage are required to lend authority to a particular reading of the space. As a consequence, memory is re-assigned and controlled. This is not surprising. Lowenthal has observed that markers celebrating or forbidding access

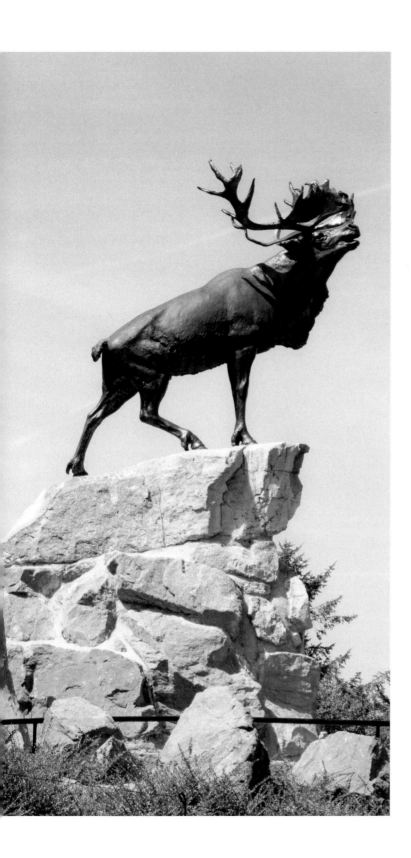

The Caribou designed
by Basil Gotto, 1924–25,
Beaumont Hamel Memorial.
Photograph courtesy of
Veterans Affairs Canada/
Anciens Combattants Canada

(33)

David Lowenthal, *The Past is a Foreign Country*. Cambridge: Cambridge University Press, 1985, p.82.

(34)

Philip Robinson, former Lieutenant-Colonel, correspondence with the author, 2002.

to this relic profoundly influence what we make of them. [33] In the highly charged yet outwardly empty landscapes of the Somme, every visual indicator and signpost effects how history is re-experienced. As has since been realised by those who have custody of the Beaumont-Hamel Memorial site, battlefield preservation demands compromise and the judicious use of the power of suggestion— an endorsement of Lowenthal's dictum, 'One can only allude to the original conditions, not recreate them'.

What are the broader issues aroused by these 'controversies'? And what do they tell us about the changing nature of commemoration and the issues of remembrance in Commonwealth sites of memory?

Firstly, there is the issue of who 'owns' the Beaumont-Hamel site. Clearly, a significant minority of visitors contest the notion that it is exclusively a site of Newfoundland memory. In part, this is justified. Beaumont-Hamel Memorial contains three Allied cemeteries—Y-Ravine Cemetery, Hawthorn Ridge Cemetery No.2 and Hunter's Cemetery— which were established soon after the fighting of July 1916 and passed into the jurisdiction of the Imperial (later Commonwealth) War Graves Commission (CWGC). It also has several monuments, including one to the 29th Division, which had English, Scottish, Welsh and Irish regiments as well as the Newfoundlanders. There are memorials for English military units erected by their regimental associations. It might also be argued that at the time of their investment, many Canadians, Australians and other constituencies of the Empire considered themselves to be British. To this end all those who are commemorated are remembered as belonging to a greater organisation, not one sullied by more recent tribal sentiments and interests. [34] However, as this shared imperial commitment has waned, many British—or to be more exact, English people—have sought a specifically English place of designed commemoration on the Somme. Instead they are presented with national emblems of Scottish, Welsh and Irish contribution and loss; there are hundreds of locally and regionally sponsored sites of memory, from a Sheffield Memorial Park and an Ulster Tower, to a trench preserved to the memory of the Accrington Pals. Within the wider precinct of the 1916 Somme battleground there are constructions dedicated to the Chinese Labour Corps, monuments to Indian

and New Zealand combatants, a South African Museum, memorial plaques to the Australian Expeditionary Force and Allward's imposing monument to the Canadian Corps at Vimy. Arguably, it was the Ypres Salient that was held to be the epicentre of British emotional attachment to the Western Front and this was certainly the case up until the Second World War. However, since possibly the 1960s—with its many 50th anniversary events—it is the Somme that has dominated the popular imagination. This burgeoning sense of a British 'ownership' of the Somme and its military past has clashed with a crisis of the very idea of Englishness, which has been further complicated by the European Union debates about the nation state and the promotion of regionalism across Europe.[35] As a set of values and guiding principles, the role of Commonwealth has only partly steadied this volatile matter of national identity. The cohesion offered by, for example, the burial of a single Unknown Warrior in London who was deemed to represent the British Empire's loss has been steadily challenged by the inauguration of Unknown Warriors in Australia (1993), Canada (2000) and New Zealand (2004). Having lost 18,166 combatants during the Great War, the remains of a New Zealand soldier were selected not from Gallipoli as one might have anticipated, but from the Caterpillar Valley Cemetery on the Somme where the New Zealand Division fought in 1916. It is tempting to exaggerate the 'crisis' of identity felt by many English, especially as Britain is invariably understood as 'Greater England' within the strands of English popular consciousness. And although the symbolism adopted by British and Commonwealth countries can be traced back to a taproot of English values and imagery, there is a nagging anxiety—fuelled by energetic debates about devolution and amplified by recent by-election and referendum results—that Britain is inexorably sub-dividing. Of course, this may manifest itself in a further proliferation of regionally sponsored sites, which tap directly into (and actually strengthen) notions of Englishness and its regional identities.[36] Not even the building of a visitor's centre in Thiepval in 2004, which is run by *L'Historial* in nearby Péronne, seems to have dampened the many anxieties over the inexorable partition of the United Kingdom and its pending separation from the European Union'.

Secondly, we must acknowledge how much specificity matters to those pilgrims who make annual visits

(35)
Ian Baucom, *Out of Place: Englishness, Empire, and the Locations of Identity.* Princeton: Princeton University Press, 1999.

(36)
The original arguments in this chapter were made before the building and opening of the Visitor Centre at Thiepval in July 2004, which is run by L'Historial, Museum of the Great War, Peronne. It was also written and published many years before the United Kingdom European Union membership referendum in June 2016.

(37)

Paul Shepheard, *The Cultivated Wilderness:
Or, What is Landscape?*. Cambridge: MIT Press,
1997, p.227.

to the necropolis of the Somme. The accurate recording of times, dates, actions are augmented by an indexical knowledge of troop deployments, formations, measurements and actions. To these individuals and social groups, exactitude represents a truth that is immutable. It is this attention to incontrovertible detail that makes it possible to so many observers to 'commemorate the dead without glorifying the war'. [37] During the radical changes to the site in 2000 many pilgrims felt that their shared jurisdiction of memory and been compromised, even threatened. Memorial schemes, by their very nature, often have to prioritise one story over another, with the result that entire swathes of memory—and by extent layers of history and topography—can be rendered invisible. The prioritisation of the Newfoundlander's story is felt by some to promote a disproportionate 'visibility', which occludes the part played by others so that it promotes a factional cause. In part this may be due to the extraordinary circumstances of that dreadful morning in July 1916, it may also tell us something about the relationship between Newfoundland and Canada, whose vast historic contribution to the war is commemorated in the equally vast memorial grounds of Vimy Ridge some miles to the north.

As the custodians of Beaumont-Hamel Memorial began to assert their historic ownership of (and responsibility for) the site, access was bought under control. Nothing could have been more calculated to upset English visitors. A freedom to roam is enshrined in the popular imagination of many in Britain despite the fact that British rights-of-way are more restricted than many European countries and over 90 per cent of Britain is privately owned. Recreational walking is a massive pastime of many Britons; some ten million walkers take to the countryside each summer Sunday. [38] However, it is not a birthright and it took prolonged campaigns by rambling clubs and walking activists (before the Second World War) often engaged in mass trespassing events in England to contest draconian restrictions that kept hikers from the northern industrial towns off thousands of acres of nearby privately-owned moorlands. The pitched 'battle' between four hundred walkers and 30 gamekeepers at Kinder Scout in 1932 tipped the balance in favour of wider access and heralded more liberal legislation, even requiring changes to the Countryside Act of 1949.

(38)

Rebecca Solnit, *Wanderlust: A History of Walking*.
New York: Viking, 2000.

The 'Danger Tree',
Beaumont Hamel Memorial.
Photograph courtesy of
Veterans Affairs Canada/
Anciens Combattants Canada

Walking, argues Rebecca Solnit, is the antithesis of owning: 'it postulates a mobile, empty-handed, shareable experience of the land'. Similarly, pilgrimage unites a set of beliefs with simple actions and is usually predicated on a journey that culminates in a walk that is potentially transformative. Combine these aspirations with a libertarian attitude to land access and one begins to recognise the bundle of grievances that have been accumulated by English battlefield tourists, pilgrims and visitors. Their indignant and hurt tone is pithily captured in this extract from a letter to *Stand To!*, the journal of the Western Front Association:

> *You can imagine my surprise and annoyance to find, in July 2000, that the front-line trenches [of the Newfoundland Memorial] of both sides have been allowed to become overgrown with weeds and that visitors have been denied access to them. This is also true of much of No Man's Land...I can understand why access to Y-ravine has been restricted in recent years after the discovery of unexploded shells (albeit a shame), but closing off the front-line trenches indefinitely devalues the experience of the Park for all concerned.* (39)

(39)
John Nicholas, 'Letters to the Editor', *Bulletin*, Western Front Association, 60, October 2000, p.48.

To their credit, the custodians at Beaumont-Hamel have been diligent in explaining the rationale for their acts, not least the need to protect the delicate ecological balance of the parkland where unmanaged access would have threatened to erase history. (40) Poor or misleading signage has been evaluated and largely replaced; the induction and training of the guides is as thorough as it can be given the relative experience of the interns; often, though, it will never match the level of expertise of so many of the amateur and semi-professional historians who visit the site.

(40)
See comparative examples in Andrew Charlesworth, and Michael Addis, 'Memorialisation and the ecological landscapes of holocaust sites: The cases of Plaszow and Auschwitz-Birkenau', *Landscape Research*, 27 (3) 2002, pp.229–252.

Why is it, asks the current custodian, that the vast preserved parkland of Vimy Ridge—only 30 minutes car journey to the north—has not aroused the levels of anxiety, even opprobrium, that has been visited upon those who have jurisdiction for Beaumont-Hamel? (41) Perhaps it is because Vimy Ridge (rather like the Delville Wood memorial site, which is associated with the South African forces, or the land around Villers Bretonneux, which is linked to the Australian Expeditionary Force) is uniquely linked to a Canadian feat-of-arms, so much so that its historic roots are incontestable. Vimy was almost uniquely a Canadian victory, one that has been consciously projected

(41)
Arlene King, correspondence with the author, 2002–2005.

over the decades as a nation-building event. By contrast, Beaumont-Hamel is promoted as a site of memory for an island and a people whose national identity has been in flux for some time. After all, until recently Newfoundland was described as 'England's oldest colony' and was self-governing until 1947 when the population voted for Confederation with Canada. One might further argue that, for Newfoundlanders, the Somme was 'apocalyptic'; its memory still casts a long shadow over the celebrations for Canada Day, which also lands on July 1st; a persistent indication of a trauma-induced loss of identity.[42] Does this more fully explain the need to impress upon visitors the Newfoundland narrative, as if by way of compensation?

And, as we have seen, the site bears the burden of its 'picturesque' topography: it is almost unparalleled as a tract of preserved battleground and is routinely described as 'probably the most interesting place on the whole Western Front', a burden that raises expectations, indeed a sense of entitlement among those who wish to absorb its uniqueness.[43] Arguably, its universal appeal lies in its claim to represent the Great War experience more generally, rather than Newfoundland in particular. It is the challenge of representing the generalities of prolonged conflict with the specificity of a few defining minutes that defines the tensions in managing its geographical histories. Recent events at Beaumont-Hamel have energised the debate about preservation and interpretation of historic remains, adding a fresh dynamic to the orthodoxies of remembrance that regards all customs, all sites and all rituals relating to the 'trench experience' to be immutable and unchallengeable.

If, finally, the Newfoundlanders have 'won' the war of memorialisation it has been a hard-won campaign, requiring fortitude, clarity of purpose and painstaking communication about how a venerated tract of land ought to be treated and cherished. Amid all this effort, it might be regretted that the recent change in title—from 'Newfoundland Memorial Park' to 'Beaumont-Hamel Memorial'—has been at the expense of the specificity, the assiduous 'clip and mow and prune' and the faultless attention to detail that makes the Silent Cities of the Commonwealth schemes such extraordinarily powerful places of war and peace.[44]

(42)
Nigel Cave, correspondence with the author, 2006.

(43)
Martin Middlebrook and Mary Middlebrook, *The Somme Battlefields: A Comprehensive Guide from Crecy to Two World Wars*. Harmondsworth: Penguin, 1991, p.83.

(44)
The author would like to acknowledge the many correspondents cited in this paper, in particular Arlene King, Director/Directrice of the Beaumont Hamel Newfoundland Memorial, colleagues from the Department of Veteran Affairs, Canada and the staff at the Provincial Archives of Newfoundland and Labrador, St Johns, Newfoundland. Part of the original fieldwork for this paper was made possible by a grant from the Canadian Studies Faculty Research Program administered by Canada House, London.

COMMEMORATION OF
WAR AND PEACE
THE ANXIETY OF ERASURE

Roses and headstones,
Tyne Cot Commonwealth War
Graves Cemetery, Zonnebeke,
Ypres Salient, Belgium

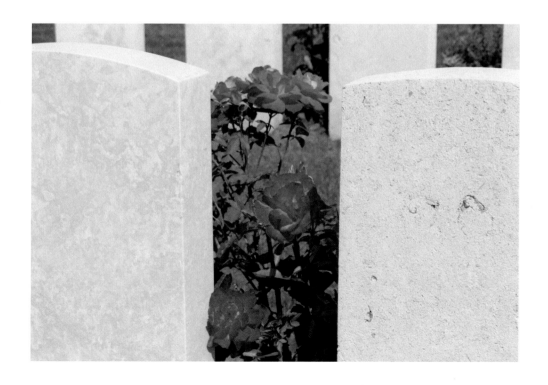

Plinth and place

In the four weeks leading to 11 November 1928, the illustrated newspaper *Answers* published a 'magnificent series of plates celebrating the tenth anniversary of the Armistice'. Under the strapline 'Ten years after, 1918–1928' the plates were published as four pairs of pencil drawings by the former soldier-artist Adrian Hill. They depicted the principle buildings on the old Western Front in Belgium and France as they appeared both in ruins in late 1918 and under restoration ten years later. Arras Cathedral, the Cloth Hall at Ypres, Albert Basilica and the Menin Road had become icons across the British Empire, regarded as the immutable symbols of the trauma of the Great War. Indeed, in the months after the Armistice, Winston Churchill had strongly advocated 'freezing' the remains of Ypres and preserving it forever as an ossified commemoration of the war. Its pulverised medieval buildings, he argued, would be more articulate than any carved memorial or reverential monument. Churchill's predilection for bombed ruins surfaced again during the Second World War when he argued that a portion of the blitzed House of Commons ought to be preserved as a reminder of the bombing of the capital. [1]

As with many grand commemorative schemes, Churchill's vision was not to be realised. Indeed, after both wars many of the grander commemorative schemes floundered; a national war memorial garden in the precincts of St Paul's Cathedral was abandoned in the late 1940s and ambitious plans to house the national war art collection in an imposing 'Hall of Remembrance' came to nothing twenty years earlier, as did a similar architectural scheme in Canada. Although many such ideas were realised, few were achieved without some degree of argument.

The desire to produce a common understanding of the past has resulted most often in material forms such as the plinth and the pedestal, which have become the key visual components of an ideological and rhetorical urban topography. This is contrasted with the concept of 'reified place', in particular preserved or reconstructed battlefields, which have become the focus of commemorative rites—the places to where 'one takes personal narratives'. As has been the case throughout this volume, most of the examples used to illustrate this tension are drawn from the northern European

[1]
Winston Churchill, in Hansard, 25 January 1945.

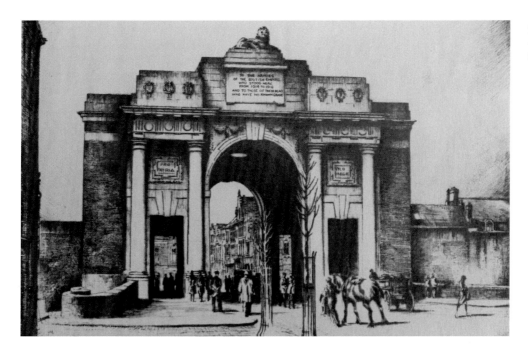

Adrian Hill
The Menin Gate 1928 (TOP), and
The Menin Road 1918 (BOTTOM)
published in *Answers*, 1928

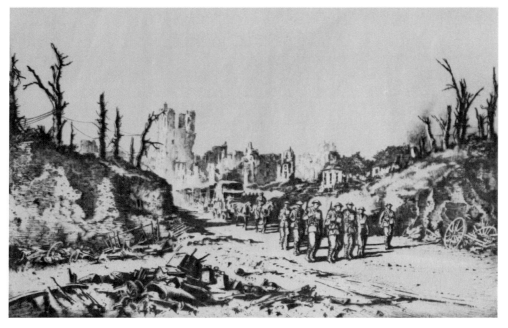

theatres of war, although reference is made to certain far-flung conflicts—such as the Battle of Gettysburg—which became the template for historic conservation and the embellishment of military memory. In concentrating on idealised objects on the one hand and recuperated landscapes on the other, we have to set aside consideration of other acts of commemoration. This includes ritual, song, poetry and the material culture of war, such as artwork, paintings and sculpture, which were commissioned by national governments as both propaganda and as evidence of cultural superiority and are explored elsewhere in this volume.

When considering how warfare might variously be commemorated, it is clear that every act is highly contested. Even the granting of war trophies could stir dissent and disagreement. In 1919, when the small east Lancashire town of Haslingden was offered a tank as a gift from the government in recognition of its contribution to war savings, the local branch of the Discharged Soldiers and Sailors Association rejected it as an inappropriate emblem of commemoration. 'This tank', wrote their President, 'will remind us of things we do not want to be reminded of, and one which would be an expense to the town'.[2] He asked instead that the government send an army hut as a club room for the veterans and ensure them a fitting place in the coming Peace Day celebrations. However, the protocols for the latter proved to be as equally contested as the gift of a redundant military vehicle.

Of course, many of the tensions between 'plinth' and 'place' had been played out long before the Great War. The construction of monuments and memorials on sites of battle has a history reaching back to the classical periods of Greece and Rome.[3] However, the demarcation of battlefield sites to accentuate the material remains of the past is a fairly recent phenomenon. In their analysis of 23 north European battle sites, covering nine centuries (from the Battle of Maldon in 991 to the Spanish battle of Sorauren in 1813), Carmen and Carmen note that only five are marked by contemporary memorials, while all but three are furnished with modern memorials, of which all take monumental form.[4] Six of these sites also host a museum or have heritage status, usually dating from the twentieth century, thus reflecting the idea that such places have only latterly been considered worthy of note and subject

(2)

Haslingden Gazette, 17 May 1919, cited in William Turner, 'The talk of the town: How a Branch of the Discharged Soldiers and Sailors Association fought for a place in Haslingden's peace celebrations', *The Poppy and the Owl*, Leeds University, no.25, 1999.

(3)

See for example Alan Borg, *War Memorials*. London: Leo Cooper, 1991. Alex King, *Memorials of the Great War in Britain: The Symbolism and Politics of Remembrance*. Oxford: Berg, 1998.

(4)

John Carman and Patricia Carman, *Bloody Meadows: Investigating Landscapes of Battle*. Stroud: Sutton Publishing, 2006.

to demarcation, textual display and commodification. Such spaces are invariably politicised, dynamic and contested; they are open to constant arbitration.[5] They are also complex sites of social construction. As we see in our examination of twentieth century wars in northern Europe, it is best not to view such sites as the location of single events but as 'a palimpsest of overlapping, multi-vocal landscapes'.[6]

Commemoration: A definition of terms

Any reading of the historiography related to the commemoration of war[7] will reveal that the words 'monument' and 'memorial' are used interchangeably, their definitions often paradoxical and weakly articulated. Arthur Danto, reflecting on the Vietnam Veterans Memorial in the US, attempts to distinguish one from the other by arguing that whereas many memorials speak of healing, remembrance and reconciliation, monuments are usually celebratory or triumphalist.[8] Although somewhat simplistic, such a definition offers a starting point. According to the Oxford English Dictionary a monument is 'a structure, edifice or erection intended to commemorate a person, action or event'. In contrast, definitions of 'memorial' focus on the preservation of specific memory and their iconographic role in evoking remembrance. In common understanding, a monument should bear the attributes of scale, permanence, longevity and visibility. Memorials, by contrast, are often more intimate, local and personal, though they are still required to be durable and open to public gaze. While the monument has often been built to promote specific ideals and aspirations—from the Statue of Liberty to the Eiffel Tower—the memorial is essentially a retrospective form, idealising a past event, historic figure or deified place. The German cultural historian Alois Riegl distinguished between monuments that are 'wanted'—in the sense of satisfying a commemorative need—and those that are merely remnants, usually in the form of historical or preserved remains that connect us to a revered past.[9] Drawing on Freud's work on mourning and melancholia, others have argued that monuments become memorials as a result of the successful completion of a mourning process:[10]

> ...the object must die twice, first at the moment of its own death and secondly through the subject's unhitching from its own identification. It is only then that the

(5)

Barbara Bender (ed.) *Landscape: Politics and Perspectives*. Oxford: Berg, 1983.

(6)

Nicholas Saunders, 'Matter and memory in landscapes of conflict: The Western Front 1914–1919', pp.43–67, p.37 in Barbara Bender and Margot Winer (eds.) *Contested Landscapes: Movement, Exile and Place*. Oxford: Berg, 2001.

(7)

See: Samuel Hynes, *A War Imagined: The First World War and English Culture*. London: Bodley Head, 1990. George L. Mosse, *Fallen Soldiers: Reshaping the Memory of the World Wars*. Oxford: Oxford University Press, 1990. Jay Winter, *Sites of Memory, Sites of Mourning*. Cambridge: Cambridge University Press, 1995.

(8)

Arthur Danto, 'The Vietnam Veterans Memorial', *The Nation*, 31 August 1986, p.152.

(9)

Aloise Riegl, 'Der Moderne Denkmalkultus', 1903, cited in Robert Burstow, *Materialising Memory: Mementoes, Memorials and Modernism*, catalogue essay for *In Memorium*, Walsall Art Gallery, 22 November 2000–21 January 2001, pp.8–12.

(10)

Michael Rowlands, 'Remembering to forget: Sublimation as sacrifice in war memorials', in Adrian Forty and Susan Kuchler (eds.) *The Art of Forgetting*. Oxford: Berg, 1999, pp.129–147.

The Cross of Sacrifice, designed by
Reginald Blomfield, Commonwealth
War Graves Commission, 1918

object can pass into history and that the stones can be set—for mourning and memorial are a phase apart. [11]

Clearly, there are several distinct phases in the creation of the public monument. Winter proposes a tripartite cycle in the afterlife of *lieux de memoire*: an initial, creative period—the construction of 'commemorative form'—which is marked by monument building and the creation of ceremonies that are periodically centred on the reverential object. During the second phase the ritual action is grounded in the annual calendar and becomes institutionalised as part of civic routine. There is then a critical, transformative period when the public monument either disappears or is upheld as an active site of memory. This final phase, as Winter reminds us, is largely contingent on whether a second generation of mourners inherits the earlier meanings attached to the place or event and adds new meanings. [12] Without frequent re-inscription the date and place of commemoration simply fade away as memory atrophies. Very soon the monument loses its potency to re-invigorate memory; it becomes 'invisible'.

This complex and delicate process is exemplified in the case of monuments to distant wars. Here, as Inglis suggests, the terminological difference is significant: 'Where the French speak of *monuments aux morts*, the English say *war memorials*.' *Memorial* leaves open the form of commemoration that may or may not be monumental. [13] Commemoration, essentially anti-entropic, is often predicated upon the 'monument' being a physical object that arrests the effects of time. It has a temporal as well as a spatial value and might be considered a 'single point [that] continues in the present and into the future'. [14] By comparison, the German word for monument *'denkmal'* (literally 'a means to thought') offers a conceptual vehicle that is more closely attuned to the idea that human perceptions shift and adjust and monuments—like so much rhetorical topoi—can become irrelevant, invisible and yet also able to arouse intense debate. [15]

In largely Protestant countries such as Britain, hospitals, libraries and other utilitarian memorials have long been considered to be structures appropriate for the commemoration of war. Victorian and Edwardian Britain was strewn with the evidence of philanthropic and state benefaction. This was perhaps most evident after the First World War, when small communities, already torn by

[11]
Mark Cousins, 'Inside, Outside', *Tate Magazine*, Winter 1996, pp.36–41.

[12]
Jay Winter, *BBC History*, 22 November 2000.

[13]
Ken Inglis, 'The homecoming: The war memorial movement in Cambridge, England', *Journal of Contemporary History*, 27, 1992, pp.583–605.

[14]
Marc Treib, 'The landscape of loved ones', in Joachim Wolschke-Bulmahn (ed.) *Places of Commemoration: Search for Identity and Landscape Design*. Washington: Dumbarton Oaks, 2001, p.82.

[15]
Paul Gough and Sally J. Morgan, 'Manipulating the metonymic: The Bristol Cenotaph, 1919–1932', *Journal of Historical Geography*, 30 (4) 2004, pp.665–684.

(16)

Alex King, *Memorials of the Great War in Britain:
The Symbolism and Politics of Remembrance.*
Oxford: Berg, 1998, p.68.

(17)

S.D. Adhead, 'Monumental memorials and Town
Planning', *Journal of the Town Planning Institute,*
3 (5) 1917, pp.17–28. 'Long may she drain!' was
suggested by one local as a suitable announcement
at the opening of this commemorative facility.

(18)

Yvonne Whelan, 'Mapping meanings', in Graham
Ashworth and Brian Graham (eds.) *Senses of Place:
Senses of Time.* London: Ashgate, 2005, p.63.

(19)

Gary Owens, 'Nationalist monuments in Ireland,
1870–1914: Symbolism and ritual', in Raymond
Gillespie and Brian P. Kennedy (eds.) *Ireland: Art
into History.* Dublin: Townshouse, 1994, p.103.

(20)

Elizabeth Hallam and Jane Hockey, *Death, Memory
and Material Culture.* Oxford: Berg, 2001, p.90.

grief, were further divided by the need to decide between erecting reverential memorials or building functional utilities. In the latter, memorial schemes varied in object from avenues of trees to pragmatic solutions to local issues and took the form of community halls, recreation grounds, convalescent homes and, in one case, a water pipe to a local school. [16] There were precedents for such decisions. A paper on 'Monumental Memorials and Town Planning', given in 1917, noted the tale of a 'small Urban Council who, with an eye to thrift and economy, decided to commemorate the Jubilee of Queen Victoria by the construction of a new public sewer'. [17] A preference for the utilitarian may, in part, have been a reaction to the frenzy of monument building across Europe in the late nineteenth century. As Whelan points out, the busy furnishing of the urban centres reflected the intense nationalism of the period when plinth-topped statuary became a focus for collective participation in the politics and public life of villages, towns and cities across Europe. [18] Figurative ensembles were readily understood as symbolic devices capable of capturing and imposing the ideals, principles and aspirations of the established regime. 'Frenzy' is the appropriate term. Owens calculates that one statue was erected in central London every four months during the reign of Queen Victoria. [19] In Germany, in a single decade, some 500 memorial towers were raised to Bismarck alone.

However, in 1919 the need to find a tolerable meaning to the vast losses of the Great War demanded a radical break from august statues crowding the over-furnished urban centres of Europe. The scale of loss could not be satisfied by short-term utilitarian solutions. In the absence of bodies to grieve over, the cenotaphs, memorial stones and catafalques erected in thousands across Britain had to perform several interlocking functions. Initially they acted as a focus for personal, public and civic displays of grief. Their iconic form helped to reassure non-combatants and relatives that the dead had died for a greater cause, one linked to abstract values of nationhood, camaraderie or Christian citizenship. The blank-faced slab of the Cenotaph in Whitehall provided a template for hundreds across the Empire honouring the placeless dead. Along with the equally classless Tomb of the Unknown Warrior in Westminster Abbey, the Cenotaph became a heterotopic site at which the 'multiple memories' of parents, fiancés and widows could be located and fixed. [20]

The very solidity of these monumental forms provided a sense of 'anchoring'—spatial, temporal and perhaps even social—in a mobile and disjointed society. [21] Indeed, stone, brass and metal have become increasingly valued as the material embodiment of memory largely because they seem to act as a counterpoint to fears of a throw-away consumer culture that emphasises the immaterial, the transient and the fleeting.

Annual rituals, such as Armistice services, gradually reinforce the permanence of the material through becoming the locus of communal and individual remembrance and opening up a discourse of healing, regret and reflection. Monumental forms:

> *... should ideally allow the fusion of the living with the dead as an act of remembrance whilst in time providing a way out of melancholia through an act of transcendence.* [22]

As such, they function as palliative topoi that help resolve the conditions of 'negativity and impotence' aroused by violent death, particularly of the young. Of course, not all war memorials act in this way; some are bombastic and celebratory, embellishing the past, promoting pride in distant victories and asserting inflated values of nationhood. Although they play a major part in the creation of place identity in the built environment, the role of monuments during social change is rarely predictable and they are subject to random forces:

> *Existing monuments may be removed and replaced; they may be re-designated and their meanings re-interpreted to express new meanings; or they may simply become ignored and rendered all but invisible, their meanings lost through being irrelevant or unreadable.* [23]

Unsurprisingly, they are also capable of arousing complex passions. Take for example, the furore over the installation of a statue to Sir Arthur 'Bomber' Harris in London in 1992 [24] or the 'desecration' of the Whitehall Cenotaph during May Day protests in 2000. Consider also the recent upsurge in the memorialisation of the Second World War, most notably in central London but also at the National Memorial Arboretum in central England. [25] Amid such contingency we can be certain of two things: firstly, monuments are seldom built to commemorate continuing events or to

(21)
Andreas Huyssen, *Twilight Memories: Marking Time in a Culture of Amnesia*. New York: Routledge, 1995, p.7.

(22)
Michael Rowlands, 'Remembering to forget: Sublimation as sacrifice in war memorials', in Adrian Forty and Susan Kuchler (eds.) *The Art of Forgetting*. Oxford: Berg, 1999, pp.129–147.

(23)
Graham Ashworth and Brian Graham (eds.) *Senses of Place: Senses of Time*. London: Ashgate, 2005, p.11.

(24)
Nuala Johnson, 'Monuments, geography and nationalism', *Environment and Planning D: Society and Space*, 13 (1) 1995, pp.51–65.

(25)
Paul Gough, 'Planting peace: The Greater London Council and the community gardens of central London', *International Journal of Heritage Studies*, 3 (1) 2007, pp.22–41.

National Memorial Arboretum,
Alrewas, Staffordshire,
central England

(26)

David Lowenthal, *The Past is a Foreign Country*.
Cambridge: Cambridge University Press, 1985.

honour those still living. This explains our 'queasiness when we are commemorated'. [26] Secondly, the erection of memorials is intended (but does not always achieve) to be a terminal act, indicating closure and the completion of a segment of historical past. Monuments are crucial icons in the official act of closure, the ultimate solidification in the 'discourse of big words': 'heroism', 'gallantry', 'glory', 'victory' and, though only occasionally, 'peace'.

Naming and knowing

In his account of building the Menin Gate at Ypres, Sir Reginald Blomfield identified the single greatest problem in achieving an appropriate design for his war memorial: 'I had to find space for a vast number of names, estimated at first at some 40,000 but increased as we went on to about 58,600.' [27] Yet despite spreading the names over 1200 panels across walls, arches, columns and even the stairwells, Blomfield could fit only 54,896 names into the elongated tunnel-like arch. Expediently, the names of 'an excess of nearly 6000' were transferred to national burial sites nearby. [28] Further south the design of the gigantic arch at Thiepval was dictated by the need to display the names of 73,367 men with no known resting place who had died during the Battle of the Somme. Designed by Edwin Lutyens, the arch consists of sixteen enormous load-bearing columns each faced by stone panels carved to a height of some six metres, the words never quite beyond legibility. It is, as Geoff Dyer reflects, a monument to the 'untellable' [29] while also being a monument that is 'unphotographable'; no image can capture its daunting scale, its weight and the panorama of names. 'So interminably many', Stephen Zweig notes, 'that as on the columns of the Alhambra, the writing becomes decorative'. [30] It is also unnervingly precise in both its grammar and specificity. Individuals who may have served (and died) under assumed or false names are listed, common surnames—Smith, Jones, Hughes—are further identified by their roll number and the memorial also features an addendum and even a corrigendum. It is a gargantuan roll of honour created in brick and stone. As Shepheard has convincingly argued, it is this painstaking attention to detail—the assiduous 'clip and mow and prune' and the insistence on specificity at every level—that makes

(27)

Reginald Blomfield, *Memoirs of an Architect*.
London: Macmillan, 1932, p.179.

(28)

Philip Longworth, *The Unending Vigil*. London:
Leo Cooper, 1967, p.96.

(29)

Geoff Dyer, *The Missing of the Somme*. London:
Penguin, 1995, p.126.

(30)

Stephen Zweig, in Thomas Lacquer, 'Memory
and naming in the Great War' in John Gillis (ed.)
Commemorations. Princeton: Princeton University
Press: 1994, pp.150–168.

The Menin Gate, designed
by Reginald Blomfield,
1921, Common War Graves
Commission, Ypres, Belgium

(31)

Paul Shepheard, *The Cultivated Wilderness: Or, What is Landscape?* Cambridge: MIT Press, 1997, p.227.

(32)

Alistair Horne, *'The Price of Glory': Verdun, 1916.* New York: Marshall Cavendish, 1984, p.228.

(33)

Fabian Ware, 'The price of peace', *The Listener*, 2, 1929, pp.636–7.

(34)

Michael Heffernan, 'Forever England: The Western Front and the politics of remembrance in Britain', *Ecumene*, 2 (3) 1995, p.302.

(35)

Alex King, *Memorials of the Great War in Britain: The Symbolism and Politics of Remembrance.* Oxford: Berg, 1998, pp.184–185.

(36)

Nicholas Penny, '"Amor publicus posuit": Monuments for the people and of the people', *The Burlington Magazine*, 129, no.1017, December 1987, pp.793–800.

(37)

Thomas Lacquer, 'The past's past', *London Review of Books*, 19 September 1996, pp.3–7.

it possible for the Commonwealth War Graves Cemeteries to commemorate the dead without glorifying war. [31]

Naming, and the evocation of names, was central to the cult of commemoration after the Great War. As a process, it mirrored the complex bureaucracies developed by the industrial armies during years of total war; the administration of death echoed the military machine that had become rationalised, routinised and standardised. [32] However, it was not until Fabian Ware had established a War Graves Registration Unit that a systematic audit of the dead and their place of burial could be achieved. By mid-1916 Ware's hastily contrived organisation had registered over 50,000 graves, answered 5000 enquiries and supplied over 2500 photographs. [33] It was a remarkable achievement; the dead would no longer pass back into the private world of their families and loved ones. They had been rendered 'official property' to be accorded appropriate civic commemoration in 'solemn monuments of official remembrance'. [34]

Lacquer has pointed out the epistemological shift that came out of Ware's founding work; here, a new era of remembrance began—the era of the common soldier's name. This marked a radical break from the customs of the nineteenth century. On monumental structures in France and Prussia, naming dead soldiers of all ranks had been occasionally adopted, but this was not the case in Britain. When such a proposal was considered as a way of honouring the dead of Waterloo, it was turned down by Parliament. [35] It was left to military units to initiate and raise the money for memorials that listed all ranks. Usually only officers were named, rankers simply identified by the number of dead. [36] This was certainly the practice after the Crimea, but by the end of the Boer War it had become commonplace for local military memorials in Britain to contain lists of those who had died, often denoting rank—a practice that was avoided after the Great War largely to connote 'equality of sacrifice' irrespective of class, rank or status.

After the Armistice of 1918, the administration of death and grieving became highly regulated and was marked by a historically unprecedented planting of names on the landscapes of battle. [37] Indeed, the very words chosen for the Stone of Remembrance in each of the larger

cemeteries underlines this fact: 'Their name liveth evermore'—
a phrasing that caused Lutyens to ask, 'But what are names?'.
For the bereaved, however, names were often all that was left.

Place and the 'anxiety of erasure'

While names can be
recovered or even recuperated from the past, language strains
to depict the calamity and depravity of modern war. As T.S.
Eliot wrote, words crack 'and sometimes break under the
burden, under the tension, slip, slide, perish'.[38] John Masefield,
writer and future poet laureate, had no available vocabulary
to describe his first sight of the Somme battlefield in 1916.
'To say that the ground is "ploughed up" with shells is to talk
like a child', he complained, 'to call it mud would be misleading':

> It was not like any mud I've ever seen. It was a kind
> of stagnant river, too thick to flow, yet too wet to stand,
> and it had a kind of glisten and shine on it like reddish
> cheese, but it was not solid at all and you left no tracks
> in it, they all closed over, and you went in over your
> boots at every step and sometimes up to your calves.
> Down below it there was a solid footing, and as you
> went slopping along the army went slopping along by
> your side, and splashed you from head to foot.[39]

Almost every battlefield visitor called it 'indescribable'. And
yet, every battlefield visitor tried to describe it in words;
indeed, many thousands of pages were filled trying to define
and describe the trauma that had been visited upon this
small tract of northern France. The spectacle of abject
ruination drew pilgrims, just as it draws tourists today, to
dwell and stare in dread fascination and awed respect.
However, when considering these as commemorative sites,
the 'spectacle' was often little more than a cleared tract of
land to which historic significance had to be attached. It
often took negative form; it was a spectacle of absence, a
potent emptiness of flattened earth, ruined and shattered
forms. As sites of memory though, these obscure places
loom huge in the popular imagination.

Identifying, conserving
and managing these 'places we want to keep' because they
are deemed to have layers of significance is strewn with
competing demands. As Freestone argues, the structures

(38)
Thomas Stern Eliot, 'Burnt Norton', *Collected
Poems: 1909–1962*. London: Faber, 1963.

(39)
John Masefield, letter to his wife, 21 October 1916,
reproduced in Constance Babington Smith, *John
Masefield: A Life*. Oxford: Oxford University Press,
1978, p.164.

Headstones, Commonwealth
War Graves Commission,
Ypres Salient, Belgium

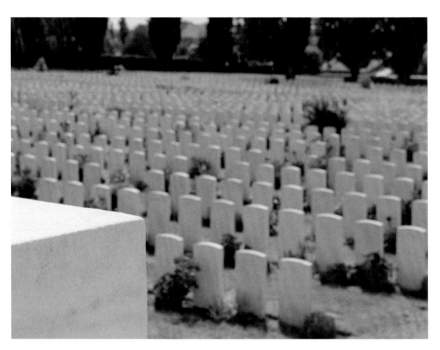

Ataturk Memorial, with words
attributed to Mustafa Kemal
Ataturk, Anzac Cove, Ariburnu,
Canakkale battlefield Gallipoli
historical area, Turkey

and relationships between the many sets of stakeholders who have some authority over a given 'site of memory' are 'complex, incomplete, sometimes unfair, confused, and conflicting'. [40] Elsewhere in this volume, we have explored the challenge of preserving former battlefields. We have seen the tracery of commemoration since Gettysburg in the mid-1860s through the cinder-fields of Verdun and Vaux, the razed villages of Oradour and the bloodied beaches of Normandy, to the horror of Hiroshima and more recent killing fields in Cambodia. On each of these sites of trauma, the moral resonance of the site is paramount. In so many of these places the grassed over trenches, mounds, lumps and apparently barren tracts have been preserved because they are held as iconic historical traces that have assumed an air of unassailable ethical authority. In previous sections of this volume, we have seen visitors and pilgrims have been continuously drawn to places that seem to contain the memory of overwhelming events. The commemorative terrain around the Bastille, the grassy knoll in downtown Dallas or the ash hills of Fort Douaumont are now regarded as secular shrines capable of evoking memories of breathtaking events. Landscapes of trauma are still regarded by many as inviolable spaces that cannot be airbrushed, digitally manipulated or edited beyond recognition, though many such sites have indeed been purposefully levelled or razed, buildings ground to dust to try to erase a sordid past. As Claudia Koonz states so eloquently, only topography may be capable of conveying the narrative of extermination. 'At these places of remembering, memory feels monolithic, unambiguous, and terrible.' [41] There is a palpable tension between the need to identify sites of trauma and their permanent preservation as places of memory. Designation as a heritage site forever alters the character of an area, which 'thus becomes monumental and historic with potential consequences for the sense of place held by insiders and outsiders'. [42]

The former battlefields perched on the tip of the Dardanelles peninsula in western Turkey offer a telling example of a heritage site that has been spasmodically contested by 'insiders and outsiders' since British Empire troops evacuated its bloody ridges and exposed beaches in December 1915 and early January 1916. The defence of Gallipoli was a victory for the Turkish army—their single

(40)
Robert Freestone 'From icons to institutions: Heritage conservation in Sydney', *International Journal of Heritage Studies*, 1 (2) 1995, pp.79–90.

(41)
Claudia Koonz, 'Between memory and oblivion: Concentration camps in German memory', in John Gillis (ed.) *Commemorations*. Princeton: Princeton University Press: 1994, pp.258–280.

(42)
Graham Ashworth and Brian Graham (eds.) *Senses of Place: Senses of Time*. London: Ashgate, 2005, p.151.

triumph in five campaigns—but until very recently this might not have been the first impression gained by any visitor.

The peninsula is peppered with war memorials, battlefield museums, facsimile trench lines and military cemeteries. The main period of cemetery planning and memorial building took place in the 1920s when the IWGC assumed responsibility for situating and planning 31 cemeteries and five Allied memorials. [43] They are carved in the restrained neoclassical style that characterises the work of the IWGC, work that was carried out in the most severe climactic, geological and socio-political conditions. The principal architect, Sir John Burnet, bemoaned the insecure ground, poor drainage and the propensity of the impoverished locals to remove stone and metal intended for the Commission. He also had to work in an emotionally charged context, brokering a clamorous lobby by Australian and New Zealand ex-servicemen to designate the entire 'Anzac' area as consecrated ground, a lobby that, while unsuccessful at the time, would later lay the foundation for territory disputes that have become spasmodically inflamed since the Turkish government agreed to the Treaty of Lausanne in 1923.

As for marking their part in the campaign, there was no comparable response from the Turkish authorities until the 1950s and then again in the late 1960s when a number of imposing modernist structures were built at Cape Helles, the most southern point of the peninsula. During the late 1980s a number of traditional Islamic memorial sites were built and, in the last decade, several large figurative statues—some of them strident, even bombastic, in tenor—have been located at Anzac Beach and Helles Point. Although the war ended in Turkey in 1916, a battle for monumental supremacy has been waged ever since. Turkish and Commonwealth memorial sites are located uncomfortably close to each other on the cliffs over the once disputed beaches and immense statues of Turkish heroes stand face-to-face with CWGC obelisks, locked in 'parallel monologues'. [44] On the eve of the 80th anniversary of the Allied landings in 1995, the Turkish authorities supplemented the martial statuary with an ambitious—but not uncontroversial—planting regime designed to dress the battlefield with appropriate symbolic floral designs. [45]

(43)

Philip Longworth, *The Unending Vigil*. London: Leo Cooper, 1967.

(44)

Rosie Ayliffe, Mark Dubin and John Gawthorp, *Turkey: The Rough Guide*. London: Harrap Columbus, 1991.

(45)

Paul Gough, 'Conifers and commemoration: The politics and protocol of planting in military cemeteries', *Landscape Research*, 21 (1) 1996, pp.73–87.

Two years later the Turkish government announced a competition for a new 330,000-hectare park dedicated to peace at Gallipoli. Although a winning design was chosen, there has been little (indeed no apparent) progress in advancing the scheme and the only physical changes on the peninsula have been the unplanned encroachment of villas and an irreversible road-widening programme intended to facilitate the tens of thousands of visitors (many from Australasia, but increasingly from Turkey) who want to visit. In recent years Australian and New Zealand visitors have become concerned at the unsightly violation of a place they deem to be essential to their origins and identity as modern nations. Their objection and resistance appear to be having no impact. Instead the Turkish state has started to reassert its own authority and the moral ownership of the former battle ground has shifted palpably.

As a hallowed site of national memory, the identification and preservation of a battlefield as a physical and inviolable entity can help maintain a consciousness of the past, which is 'essential to maintenance of purpose in life, since without memory we would lack all sense of continuity, all apprehension of causality, all knowledge of our identity'.[46] However, as is evident on the contested ravines and beaches of the Dardanelles, memory, identity and purpose are seldom shared values, especially between nations thousands of miles apart. Nevertheless, if landscape is the most powerful prompter of collective memory, then preserved battlefield sites can help to make material the experience of war and evoke profound reflections. Despite the need for occasional artifice, battlefields are especially significant as memorial landscapes because they 'challenge us to recall basic realities of historical experience, especially those of death, suffering and sacrifice'.[47]

Beyond space: Counter-memorials

Perhaps some of the most radical developments in the evolution of commemorative form emanated in Germany in the 1980s, as a young generation of artists and writers began to face up to the concealed and repressed recent past of their nation. Building on the maxim of John Latham and the Artist Placement Group that asserts that 'the context is half the [art]work', artists and cultural interventionists such as Jochen Gerz worked from the premise that memory is fluid and contingent and that, consequently, it is

(46)
David Lowenthal, *The Past is a Foreign Country.* Cambridge: Cambridge University Press, 1985, p.103.

(47)
R.M. Rainey, 'The memory of war: Reflections on battlefield preservation', in R.L. Austin (ed.) *Yearbook of Landscape Architecture.* New York: Van Nostrund Reinold, 1983, pp.68–89.

See also: Michael Lambek, *The Weight of the Past.* New York: Palgrave Macmillan, 2002.

Reflecting Absence, architect
Michael Arad and landscape
architect Peter Walker,
The National September 11
Memorial, Westfield World
Trade Center, New York, USA

neither possible nor desirable to insist on a single, objective and authoritative reading of any place or historic moment. [48] The key concepts behind these actions produced 'negative' or 'invisible' forms. Anti-matter and the ephemeral were preferred over verticality and solidity, dislocation and disturbance premised over comfort and reconciliation. Now regarded as the origins of the 'counter-monument', the conceptual basis was articulated by contextual fine artists who asserted that fixed statuary induces national amnesia, rather than meaningful acts of remembering. Their principle aim was to register protest or disagreement with the 'untenable prime object' (invariably, the 'hero on the horse'—the plinth-bound exalted statue) and to stage an alternative that might arouse reflection and debate, however uncomfortable or radical. [49]

Through their extraordinary inter-ventions, artists such as Christian Boltanski, Jochen Gerz and Krzysztof Wodiczko were not 'commemorating' particular wars as such, instead they were offering up a complex critique of how nations repressed or subverted uncomfortable memory. One example brilliantly illustrates the radical shifts in the nature of commemoration brought about by such thinking. The *Harburg Monument Against War and Fascism and for Peace* was unveiled in October 1986 by Jochen Gerz and Esther Shalev-Gerz, but had 'disappeared' by November 1993, not through vandalism or theft but to meet the artist's radical agenda. Having asked the critical question 'What do we need another monument for?' and replied, 'We have too many already', they created a monument that would gradually disappear and, in so doing, challenge the traditional connotations of permanence, durability and 'authoritarian rigidity' normally attributed to monuments. [50] In a nondescript suburb of Hamburg in an obscure pedestrian mall, they unveiled a forty-foot-high, three-foot-square pillar of hollow aluminium, sheathed in a layer of soft lead. A temporary inscription in several languages invited all citizens of the town to add their names—and so 'commit ourselves to be vigilant'—and become aware that over time the column would gradually be lowered into the ground. 'In the end', concluded the inscription, 'it is only we ourselves who can rise up against injustice'. As sections of the tower were inscribed with graffiti—names, messages, obscenities, political slogans and aerosol-painted tags—it was lowered into its chamber until all that was left was a simple

(48)
John Latham, quoted in David Harding and Pavel Buchler, *DECADEnt: Public Art, Contentious Term and Contested Practice*. Glasgow: Foulis Press, 1997, p.15.

(49)
Sergiusz Michalski, *Public Monuments: Art in Political Bondage, 1870–1997*. London: Reaktion, 1988.

(50)
James Young, *At Memory's Edge: After-images of the Holocaust in Contemporary Art and Architecture*. New Haven and London: Yale University Press, 2000, p.128.

(51)
Ibid., p.131.

capstone. Provocative and uncomfortable, the vanishing monument returned the burden of memory to visitors. As Young notes, 'All that stands here are the memory-tourists, forced to rise and remember for themselves.' [51] In France, Gerz transformed a stereotypical provincial memorial to Les Morts of the First World War by gathering statements, reminiscences and observations from local inhabitants about their feelings and responses to the existing memorial, inscribing some of them on to plaques that were then affixed to the stonework. The intervention is planned to carry on, possibly for years, each new inscription covering the others and radiating from the locus of 'official' memory.

While counter-monuments are often shocking in their confrontational polemic, can it be said that they have subverted the cultures of commemoration? Have they reinvigorated the material form of memory-creation? In northern Europe, recently built war museums—at L'Historial, Péronne and In Flanders Fields, Ypres, for example—have engaged more fully with their audiences, creating participatory and interactive exhibits that genuinely attempt to engage all levels of involvement and suffering. However, only miles away, the former battle grounds of the old Western Front are being systematically bedecked with monumentalia of uneven aesthetic quality, occasionally based on dubious history. Capital cities such as London are being liberally furnished with additional monuments—from women's contribution in the Second World War to animals who died in wars—arches, memorial gateways and other commemorative *objets de memoire* designed to stave off that 'anxiety of erasure' felt by generations of combatants and their relatives for whom their war contribution is fast fading.

How will the 'war on terror' be remembered? If the 'war' is ever resolved, what commemorative forms might result? If closure is one day achieved, what will be its inscription and markers? Will it find commemorative shape in three dimensions? Pervasive warfare may be matched by pervasive technologies of commemoration. The public space that once housed the reverential monuments of the twentieth century has become fragmented, serialised and digitally accessible as a consequence of the rapid expansion of communications technologies and digital cultures. In an age when the local has exploded, it is now understood that

'the Internet provides a medium in which public art can be created specifically for non-localized, interactive and lasting memorializations'. [52]

One example illustrates this transformation: *The Numbers and the Names* is an online memorial to 9/11. It was created by Mac Dunlop and Neil Jenkins, with a visual prologue by Annie Lovejoy, as a component of an extensive collaborative art project. Eschewing the naming of names, the four-dimensional memorial consists of words drawn from Dunlop's poem '11.09.01'. [53] Using an orbital engine created by Jenkins, they float on a colourless screen in a steady rotation around a central void. The order in which they appear is generated according to an inverse reading of the viewer's IP address and those of previous visitors to the website. The visitor-participant can use the mouse to slow down or re-orient the orbiting words, but they cannot completely stop or reverse the process. As a virtual monument, *The Numbers and the Names* both records and functions because of the history of mourners who have visited the site; it continues to exist only if visited by those who wish to participate or as long as people continue to show any interest. Whereas many virtual memorial sites are in little more than online petitions, Dunlop's interactive site may indeed represent a paradigm shift in the nature of commemoration.

(52)

Annie Gérin, 'The Four-dimensional monument: Public art futures on the world wide web', *Fuse*, 25 (4) 2002, p.11.

(53)

Mac Dunlop, *Here and There*, accessed 11 November 2014, herenorthere.org/11.09.01.

PEACE IN RUINS
GUERRILLA RESPONSES AND RADICAL GARDENING

At Reflecting Absence, the
9/11 Memorial & Museum
recognizes the birthdays of
the men, women and children
whose names are inscribed on
the Memorial by placing a single
white rose at each person's
name on their birthday

So Hiroshima. The girder skullcap and empty eye windows of the ruined trade hall. She went through the museum, she read the English captions, and could not believe the cenotaph was so incompetent. The flensed stone and bleached concrete of the wrecked trade hall was much more eloquent.

She stood on the banks of the river with her back to the Peace Park, watching the shadow lengthen across the grey-brown waters while the sky turned red, and felt the tears roll down her cheeks.

Too much, turn away. [1]

(1)

Iain Banks, *Canal Dreams*. London: Macmillan, 1989, p.175.

John F. Kennedy argued that 'peace is a daily, a weekly, a monthly process, gradually changing opinions, slowly eroding old barriers, quietly building new structures'. He had in mind not physical structures—such as reverential monuments, buildings and memorials—but social, economic and legitimising systems that might be nurtured and supported through osmotic processes of slow, but purposive, change. It was Kennedy's successor, Lyndon B. Johnson, who captured this ideal when he said that 'peace is a journey of a thousand miles and it must be taken one step at a time'. [2]

(2)

John F. Kennedy, speech to the United Nations General Assembly, New York, 20 September 1963. Lyndon B. Johnson's words were made to the same assembly on 17 December 1963, twelve weeks after the assassination of President Kennedy.

Such values have never lent themselves easily to artistic translation or interpretation. The language of gradual change, quiet erosion and incremental growth cannot be easily converted into traditional understandings of three-dimensional form. This difficulty is evident in the aftermath of the Great War in Europe, a period that saw a profusion of sculptures, monuments and memorials to the dead buried across so many foreign countries. So deep and extensive was this era of commemoration across north-west Europe, that it was described as the greatest period of monument building since the Pharaohs ruled Egypt. In 1919, less than a year after the Armistice, the IWGC embarked on a programme to build 1200 cemeteries. By 1921, over 130 were completed in France and Belgium and a further 285 were under construction. More than 40,000 headstones had been carved from the quarries of Portland in southern England. Yet, as the commissioner's historian has recorded, 'the pace was quickening, but it was only a beginning'. [3]

(3)

Philip Longworth, *The Unending Vigil*. London: Leo Cooper, 1967, p.76.

While the victorious populations and their leaders celebrated peace, their artists and designers found it difficult to articulate the idea in plastic terms. For most artists in the British Empire working in the classical style, 'Peace' invariably took the conventional form of a female figure holding aloft an olive branch, palm frond or, occasionally, a dove. Peace rarely appeared on her own, she was a junior partner to the more strident figure of 'Victory' and was usually located at a lower point on a pedestal arrangement. The most popular visual emblem of peace—an olive wreath—can easily be confused with the laurels of victory.

The popular inscription, *Invicta Pax*, tells a great deal about the difficulties of representing peace. It can be translated as 'undefeated in war', 'undefeated by death' or even 'peace to the undefeated'. Just as the concept of peace proved elusive among the League of Nations, so the iconography of most British memorial sculpture implied that peace was the deserved consequence of victory, not an ideal worth promoting as a separate or distinct concept. Even artists who prioritised the idea of peace had to fall back on idiomatic convention. A war memorial designed in 1924 by ex-cavalry officer, Adrian Jones, showed a striding figure of peace, sporting both palm frond and olive wreath atop a 26-foot-high granite column. Jones's approach to the task was radical for the time:

> *I thought we had quite enough memorials that seemed to revive the war spirit rather than to consider peace, which is, after all, the aim and end of every great struggle.* [4]

Vernon March's national war memorial for Ottawa in Canada shows a similar ambivalence. Originally required to 'be expressive of the feelings of the Canadian people as a whole', [5] the winning design was commissioned to encapsulate the core values of post-war remembrance:

> *The spirit of heroism, the spirit of self-sacrifice, the spirit of all that is noble and great that was exemplified in the lives of those sacrificed in the Great War, and the services rendered by the men and women who went overseas.* [6]

[4]
Adrian Jones, *Memoirs of a Soldier-Artist*. London: Stanley Paul, 1933, p.181.

[5]
Jonathan F. Vance, *Death So Noble: Memory, Meaning and the First World War*. Vancouver: University of British Columbia Press, 1997, p.28.

[6]
T. Wayling, *Maclean's Magazine*, 15 December 1938, p.23.

Visitors reading the register in
one of the Commonwealth War
Graves Commission cemeteries
in northern Europe. Each register
has a plan of the plot and rows,
a basic history of the site, and
an inventory of each burial,
occasionally including their home
address, pre-war occupation and
their parent's names

The Statue of Liberty in Upper
New York Bay stands as a
universal symbol of freedom.
It was originally conceived as
an emblem of the friendship
between the people of France
and the U.S. and a sign of
their mutual desire for liberty
and peace

To the artist, the sculpture was intended to have a parallel symbolism:

> The arch in the centre is the gateway to peace, and through it young people representing branches in the war service eagerly seek hope and respite from the travails of battle. At the top, standing on the architrave, are two figures holding up symbols of peace and freedom. [7]

March's original design for the cast bronze allegorical figures at the top of the national war memorial were to be 'either Peace and Victory or Liberty and Freedom'. The sculptor decided on the figure of peace adorned, peculiarly, with a laurel wreath. According to the poet, Charlotte Mew (1869–1928), in her speculative poem, 'The Cenotaph', the two motifs were inseparable:

> We shall build the Cenotaph: Victory, winged, with Peace
>
> Winged too, at the column's head.

During the commemorative era of the 1920s, the representation of peace was ridden with ambiguity and craved a convincing visual form. Whereas monument building across the British Empire was widely regarded as an act of official closure, the promotion of peace became the prerogative of pacifist campaigners who focused their actions on war memorials and their annual rituals. In 1921, the Armistice Day ceremony in London (and elsewhere in Europe) was disrupted by groups of unemployed ex-servicemen with placards stating, 'the dead are remembered but we are forgotten'. In following years, white peace poppies were distributed in London by the Peace Pledge Union. In May and June 1926, the Women's International League for Peace and Freedom organised a Peace Pilgrimage throughout Britain, which focused less on remembrance and more on the campaign for peace legislation and world disarmament. Little of this political activity affected the design or location of war memorials. Occasionally, the pacifist cause might bring about a re-designation of a memorial site. In Norwich in 1938, for example, when the Great War memorial was moved from the Guildhall to its current site, it was located within a garden of remembrance, later renamed the Garden of Peace. A bronze plaque underlines the shift in emphasis stating, 'by remembrance let us create a world of peace'. [8]

(7)
Jim Garner, *Ottawa Citizen*, 27 May 1978.

(8)
Nikolaus Pevsner and Bill Wilson, *The Buildings of England: Norfolk 1: Norwich and North East, Part 1*. New Haven: Yale University Press, 1997.

There is a fundamental difference between a war monument that purports to encapsulate and define memory and a peace monument that aims to extend a process or to further a cause. The problem of political legitimacy is central to that of peace. Its pursuit has never served the state's monopoly on violence. Because it is associated with internationalism, organisations such as the Peace Pledge Union, the White Poppy movement and similar campaigning groups represent a threat to the nation state, which regards an anti-war stance as anti-nation.

It is not until after the Second World War that further examples of public artworks intended to exclusively promote the core ideas of peace can be found. These were often prompted by a fear of the consequences of nuclear proliferation. Accordingly, many of the most memorable pieces are in blitzed cities, such as Dresden, Coventry and Nagasaki. As a designated 'peace city', Hiroshima functions simultaneously as a reliquary, funerary site, former civilian battlefield and a locus of political and social debate. Most peace memorials have taken the form of designed landscapes, preserved ruins and what have been termed 'counter-monuments', each contributing to what Michalski labelled as a succession of iconoclastic waves that 'successfully destroyed the myth of monumental eternalisation'. [9] Where 'peace monuments' exist, they are often presented as fluid, open-ended artworks requiring active cooperation from the public. A peace cairn in County Donegal in the Republic of Ireland consists of a mound of hand-sized stones individually contributed by pilgrims wishing to create a 'permanent monument to peace', which is in a constant state of change and transformation. [10] Such a monument suggests that if peace cannot be represented because it lacks the necessary rhetorical language, it might be promoted by continuous public involvement. A peace cairn symbolises, at one level, the laying down of arms but, at another, the need for a universal commitment to maintenance and patient effort.

Similarly, in Northern Ireland, many of the proposed monumental schemes that explore the imagery of peace and reconciliation have taken the form of landscaped spaces or open-ended cultural interventions developed in collaboration with community and local groups. A national memorial to peace was suggested within days

(9)
Sergiusz Michalski, *Public Monuments: Art in Political Bondage, 1870–1997*. London: Reaktion, 1988.

(10)
Roberta Forsell, 'Rocks build peace symbol', *Montana Standard*, 24 October 2002.

A tree 'available for dedication'
at the National Memorial
Arboretum in Staffordshire, UK.
The site has become a national
repository for individual,
corporate and military memory
located at the 'heart of England'

The Survivor Tree, at the site of
the 9/11 Memorial & Museum has
grown from the charred trunk
of a callery pear tree that was
recovered from the smouldering
rubble of the World Trade Center
site after the 2001 attack

Over 400 saplings have been
grown from the original tree and
seedlings have been donated
to cities in the world that have
endured terrorist attacks.
The tree has become a 'living
reminder of resilience, survival
and rebirth'

of the Irish Republican Army's ceasefire in August 1994. Five months later, the Forum for Peace and Reconciliation in Dublin argued for the need for utilitarian memorials, rather than symbolic monuments. The latter was the focus of much dispute and contestation since partition. [11] As a result, nearly all emblems of peace in the province have taken the form of artist-led interventions, installations, environmental schemes and community collaborations. The few sculptural or memorial schemes have been deliberately transient in nature. In 1995, an artist erected a plywood peace dove on an empty plinth in north Belfast. Although the dove was soon burned and destroyed, further doves were sighted for short periods in other politically significant sites. The following Easter, another artist chalked the name of the 3000 individuals killed during The Troubles on the pavement of the Royal Avenue in Belfast. [12]

As already discussed, public sculptures and monuments have often been positioned to function as a terminal act that closes a period of mourning or martial activity. In contrast, there is little to commemorate about the pursuit of peace. Not only does peace lack a rhetorical visual language, it is a continuous process, rather than one with definable conclusions or endpoint. Because of this, the iconography of peace activism has been developed through the design of landscaped spaces. As a communal and collective act, it could be argued that gardening has become the favoured grammar of peace. This was especially evident in the 1970s with the creation of networks of local, national and international peace gardens and peace parks across the globe. In Central America, they were created as cordons sanitaire to promote trans-national cooperation. In the Middle East, peace parks have been created as de-militarised buffer zones between warring factions. In central Africa they were intended to erase recent military turmoil and protect biodiversity. [13] Although not always successful in achieving their goals, such polemic landscapes are intended to be fluid and dynamic, open to negotiation, time-conscious and visible rather than time-determined and invisible. Official peace landscapes, whether they be vast spaces in South America or intimate gardens in central London, are intended as agents of repair rather than icons of reparation. [14] They are officially assigned spaces, underwritten by law and supported

(11)

Jane Leonard, *Memorials to the Casualties of Conflict, Northern Ireland 1969 to 1997*. A report commissioned by the Northern Ireland Community Relations Council and the Arts Council of Northern Ireland, Belfast: Northern Ireland Community Relations Council, November 1997.

(12)

The artist, Hilary Gilligan, was an art student from the University of Ulster.

(13)

Paul Gough, 'From Heroes' groves to parks of peace: Landscapes of remembrance, protest and peace', *Journal of the Landscape Research Group*, 25 (2) 2000, pp.213–228.

(14)

Elizabeth Hallam and Jane Hockey, *Death, Memory and Material Culture*. Berg: Oxford, 2001.

by local and national governments. By comparison, planting as a form of illicit protest offers an alternative approach to espousing peace.

Planting as a form of protest has an interesting historiography and a surprisingly broad reach. [15] Even in the formal regimen of the Imperial (now Commonwealth) War Graves Cemeteries (CWGC), there are occasional examples of 'rogue' planting. As mentioned earlier, the practice is best expressed in *Evermore*, a short story by the British novelist, Julian Barnes. The central character, Miss Moss, makes regular visits to her brother's grave in a military cemetery in northern France to dig out the 'offending French grass' and plant clean sods of English turf around his headstone. But it was always to no avail. The following year, 'the [offending] French grass was back again'. [16] Such acts of 'vegetative vengeance' take many forms and, in recent years, have been branded as 'guerrilla gardening'.

One of the more recent and most notorious acts of guerrilla gardening took place during the May Day marches through central London in 2000. Protesting against globalism, capitalism and war, marchers not only attempted to reclaim official spaces of state, but also liberally sow seeds of banned substances (with the memorable faux invocation, 'keep off the grass'!) and to stain it with irreverent markers, of which the most memorable is the green 'Mohican' haircut that was placed on the head of the Churchill statue in Parliament Square. To many, it was not the disfiguration of a national icon that was considered most heinous, rather that it should be done with healthy green turf, a material normally associated with manicured lawn, horticultural order and the 'green coverlet' of official commemoration.

How does this act of violation compare with that other extreme moment of urban gardening, the mass grieving for Princess Diana in 1997? In little over one week, 50 million blooms, weighing an estimated 10,000 tonnes were laid outside Buckingham Palace. There, like a floral aneurysm, they burst out of St James Palace across the state avenues of imperial London. Although largely interpreted as evidence of recreational or synthetic grief, the death of Diana took the major British institutions—the media, the Royal Family, the police and the church—by

(15)

For a full bibliography and links see Paul Gough, *Places of Peace*, 2006, paulgough.org/places_of_peace/about.htm.

(16)

Julian Barnes, *Cross Channel*. London: Jonathan Cape, 1996.

surprise, without a pre-planned script and few precedents of procedure and protocol. Some believe the mass public mourning created a new cultural order. Mourning was not restricted to London: hundreds of thousands of 'pilgrims' created shrines to the dead princess, adorned with flowers, teddy bears, balloons, messages and other votive offerings. It is difficult to tell whether this was evidence of media-induced hysteria or a magnification of normal mourning behaviour. However, it is the visual displays of grief that are of interest: the *ex-votos* and material objects of thanks are evidence of a desire to communicate 'with both the object of devotion and with other pilgrims through a visual image'. It was this mass outpouring of artwork and messages that turned central London into a pilgrim shrine. [17] In passing, how do we explain the other question that was so often asked at that time: 'why have we created a cellophane meadow? Why do we leave the flowers wrapped in plastic?' To this frequent question, one English broadcaster responded:

> *Cellophane and ribbons means 'Look, I didn't nick these from the park, I paid good money for them, to prove I care!'* [18]

It is the wrapping that provides the necessary context. As all pilgrims recognise, the act is more important than the effect. By creating these elaborate temporary gardens, millions of pilgrims tapped into a fundamental truth about the link between flowers, mourning, remembrance and love. Flowers die. Gardens reveal the actualities of death. Yet the gardener has the skill to nurture and keep plants alive. A well-tended garden can act as a symbolic bulwark against disorder and the randomness of death.

As with any landscape, the garden develops meaning through the complex interaction between the 'here-and-now' and the 'there-and-then'. As a 'palliative for melancholy' and a congenial environment for solitary contemplation, gardens and flowers are emblematic of the course of human life. [19] Like people, flowers and gardens grow, mature, age and die. The designers of gardens recognise the connections between the individual, the community and greater causes, whether they be religious, aesthetic or political. [20] As a manner of 'dramaturgical' space, the staged setting of the garden can

(17)
Tony Walter (ed.) *The Mourning for Diana*. Oxford: Berg, 1999.

(18)
Libby Purves, *The Times*, 9 September 1997.

(19)
David Coffin, *The English Garden: Meditation and Memorial*. Princeton: Princeton University Press, 1994, p.17.

(20)
Mara Miller, *The Garden as an Art*. Albany: Suny Press, 1993.

Sunset over the Belgian city of Ypres, now known as a 'City of Peace' it hosts the international campaign secretariat of Mayors for Peace, an international Mayoral organisation mobilising cities and citizens worldwide to abolish and eliminate nuclear weapons by the year 2020

(21)

D. Francis, G. Neophytou and L. Kellagar,
'Kensington Gardens: From royal park to temporary
cemetery', in Tony Walter (ed.) *The Mourning for
Diana*. Oxford: Berg, 1999, p.122.

(22)

M. Reuben Rainey, 'The garden as narrative:
Lawrence Hilprin's Franklin Delano Roosevelt
memorial', in Joachim Wolschke-Bulmahn (ed.)
*Places of Commemoration: Search for Identity
and Landscape Design*. Washington: Dumbarton
Oaks, 2001.

represent both physical vulnerability and transience, suggestive of decay and renewal. This effect is exactly matched to the diction of commemoration. Garden memorials have the unique capacity—as with all art forms—to evoke poignant analogies between human existence, the fragility of nature and consolations of cyclic regeneration. As has been observed, a well-tended garden is a 'symbolic bulwark' against atrophy and decay.[21] Indeed, a skilled gardener can appear to postpone, even eradicate, death with judicious and diligent plant management.

Gardens have an almost unique potential over other arts. Foremost, they act as liminal enclaves withdrawn from the customary disruption of urbanisation. In spaces separated from quotidian use, garden memorials and other sculpted forms are placed under the open sky, 'in the eye of God', where they constitute the perfect opportunity for the elegiac, but also to the Arcadian and the Utopian. They offer a new 'perfection' that is at once paradisiacal and simultaneously transient. In addition, gardens are indelibly associated with memory systems, whereby themes, ideas and classical references can be located in statuary, fountains and other formal props. These act as a series of codes that might be strung together into an iconographical programme or narrative.[22] Here, however, the garden-as-mnemonic-text is at its most vulnerable, as over time many cultural references will be lost or displaced, and a proper reading will be at the mercy of the linguistic sophistication of subsequent generations. In such places, the role of explanatory texts becomes an essential component in the proper reading of the garden. This is always the case, whether it be a memorial garden to Vietnam Veterans in Melbourne or the heavily inscribed National Memorial Arboretum in central England. The unique potency of the garden also extends to their role as places that can espouse political ideals, a polemic project that was realised many times in London throughout the 1970s.

Utopian spaces opposing the Cold War

London has several long-established peace gardens. Some have been designed for that purpose and others are ancient sites that have been re-designed and re-designated. For example, the burial ground of St Matthew's Church in Brixton, Lambeth,

has been grassed and laid out as a peace park. In nearby Southwark, the Sri Chinmoy Peace Gardens have been created in the grounds of the Thomas Calton Adult Education Centre and a Tibetan Peace Garden has been designed and laid out on the steps of the Imperial War Museum in Geraldine Mary Hamsworth Park. As if to compensate for the military weight of the museum, this is a rich ornamental scheme with impressive carved stonework and decorative walls. It was opened by the Dalai Lama in May 1999.

After the Second World War, and even more so at the height of the Cold War, such spaces were created on a global, rather than local, scale. International peace gardens at Tashkent, Hiroshima and on the US–Canadian border were expressions of desired reconciliation or overt representations of an ideal state of harmony. While many such parks have become 'de-politicised' over time, the Hiroshima site in Japan continues to serve as a crucial locus of contemporary political and social debate. [23] As a concept, the peace park became a tangible cornerstone for the movement against nuclear warfare and, at the height of the Cold War, satellite sites appeared all over the world. Invariably, these have taken the form of city, state and trans-national peace gardens and parks whose overarching concept is that they should be both 'a commemoration and a warning'. [24]

It was this imperative that led to the crea-tion of several lobby groups based in London during the 1980s. Under the enthusiastic sponsorship of the GLC, such groups as Babies Against the Bomb thrived in a political regime that unilaterally declared the capital city a 'nuclear-free zone'. This claim earned the lasting ire of the Conservative Government, which resulted in retaliatory acts such as draping the logo of the Campaign for Nuclear Disarmament from the council's county hall headquarters directly across the Thames from the Palace of Westminster and displaying London's rising unemployment figures on its roof. In 1983, the GLC created a year of peace. Its first manifestation was six large street murals on the theme of 'Peace through Nuclear Disarmament', which were located throughout London. In addition, many London boroughs committed resources to creating public spaces dedicated to peace. It was understood that these would take longer to design and realise than wall murals, but they were soon under

(23)
Peter Brock, *Studies in Peace History*. York: William Sessions, 1991.

(24)
John McKean, *Places of Peace*. London: Architects for Peace, 1989, p.3.

construction across the GLC domain. Within this environment, several lobby groups emerged. A group of London-based architects, planners and environmentalists formed Architects for Peace in the mid-1980s to work for 'the abolition of nuclear arms and other weapons of mass-destruction world-wide'. It was one of many such ad-hoc groups that came together in the UK to promote the cause of world peace. Simultaneously, similar groups such as Avenues for Peace, Civil Engineers for Nuclear Disarmament and the Nuclear Free Zones Steering Committee invited professionals in the built and landscaped environment to support the aims of world peace and disarmament and to work towards designing physical spaces that conveyed that message.

Among the sites chosen as part of the project were two in central London. One in the north-east of the metropolis (the Noel-Baker Peace Garden in the Borough of Islington, designed by Steve Adams) and another in north London, the Maygrove Peace Park, Camden. The sites were selected to 'serve as a permanent reminder of the Council's commitment to peace and its support for the policies of the Peace Movement'. Sculptures were planned, along with an elaborate planting scheme and frequent festivals and gatherings. Opposition was frequent and loud. A writer for one local newspaper thundered:

> *Peace Parks are typically Eastern European Government intentions which do not serve the interests of true peace. Transplanting such an expensive gimmick to this country is to introduce an entirely alien and unhelpful concept.* [25]

(25)
Correspondent to *Camden New Journal*, 28 July 1983.

The scheme gained unstoppable momentum. Even at this stage in the commissioning process, the iconography of the parks was clearly and readily articulated. It drew from a well-established lexicon:

> *Poetry tablets set into paths with quotations of peace, 'a peace grove' of silver birch, 'stone slabs indicating the names of local councils who have declared themselves nuclear free zones', 'plants directly associated with peace', 'friendship seating at a gathering point called the Meeting of the Ways' ... 'entrance pergola with rambling peace roses', 'a sculptural feature representing a crane', 'the Cherry tree, which continued to bloom through the nuclear holocaust in Hiroshima'.* [26]

(26)
Paul Gough, Places of Peace, paulgough.org/places_of_peace/about.htm.

Places of commemoration and remembrance only became an integral part of the public sphere through regular re-inscription. This is most commonly achieved through routine celebration of annual events, such as the Armistice or Remembrance Sunday. By contrast, remembrance events at most British peace parks and gardens follow a calendar dictated by key events at the end of the Second World War, usually Hiroshima Day or Nagasaki Day. The London peace gardens held 'peace festivals'—distinct from ceremonies— annually in August throughout the 1980s. Accompanied by Irish folk bands, jugglers, entertainers and, in 1985, giant inflatable puppets of Margaret Thatcher and Ronald Reagan. The gardens became a focus for dissent and protest of all hues. They provided a framework and site for those espousing a wide range of causes from 'the scrapping' of nuclear weapons to the ending of battery egg farming.

The peace gardens of central London did not survive the GLC for very long, although they still exist as remnants of the anti-proliferation movement of the 1980s, stripped of their political origins and subject to periodic neglect. They also function as green enclaves situated in larger parklands. Few of the sculptures, plaques or polemic objects survived, although there have been attempts to revive and re-fashion them as accessible spaces for children and families. In Islington, the Noel-Baker Garden was refurbished in preparation for the twentieth anniversary celebrations in 2004. The original beds of white roses that had been planted as an emblem of peace in memory of the victims of Hiroshima were positioned in a new bed to re-invigorate them and to reinstate the original plan. [27] Community interest groups have campaigned successfully to be involved with running Maygrove Peace Park, which has been significantly refurbished in recent years and its original title retained with pride.

[27]
Paul Gough, 'War memorial gardens as dramaturgical space', *International Journal of Heritage Studies*, 3 (4) 1998, pp.199–214. A record of the official opening of the park is reproduced at: paulgough.org/places_of_peace/pnbprog.htm.

Site of protest: Greenham Common

One of the most controversial peace gardens in the United Kingdom is situated at the heart of one of the counties that has been most militarised in the recent past. Greenham Common in southern England has been occupied by the military since the Second World War but grew to infamy in the 1970s when

the US government was permitted to site 96 Tomahawk ground launched cruise missiles under the control of the 501st Tactical Missile Wing in the US Air Force. Six large missile shelters were constructed specifically to house the missiles, the first to be based on British soil.

In 1981, a group in Cardiff opposed to nuclear power and nuclear weapons set out to protest NATO's decision to site these missiles. Thirty-six women and four men under the banner 'Women for Life on Earth', walked 120 miles to Greenham Common. Attracting little attention from the media en route, they chained themselves to the perimeter fence of the airbase and established a permanent peace camp—initially at the main entrance known as 'Yellow Gate'—from where they could espouse their arguments. It was the start of a twenty-year protest occupation. There were nine camps in total. What followed is well-known; mass protests and huge gatherings of supporters. At one time, over 40,000 people surrounded the base and on New Year's Day 1983, 44 women were arrested after breaking through the perimeter fencing to dance on top of the enormous missile silos in the militarised zone. The USA left in the 1990s as the Soviet threat collapsed following the fall of the Berlin Wall; however, there is an archaeology of occupation that is evident today. [28]

Since the American military left the site, there have been numerous schemes to commemorate their role and counteract the memory of their presence. Most of the schemes have focused on how to re-fashion the landscape and, for a time, the common became a zone of intense performative activity, bringing together dancers, artists and urban archaeologists. [29]

Since the mid-1990s, there have been extensive plans to remember and commemorate the recent history of the site. Most of these have been officially sanctioned. They have included a peace garden, a water avenue that symbolically bisected the 10,000-metre runway and a meadow of wild flowers planted over the old tarmac. Yet, none have come to fruition. Very little remains above the surface to indicate the women's long protest: a few painted designs, strips of tape, some scattered remnants, little more above the ground, although clearly much still lies hidden in the earth.

[28] Teams from the Universities of York and Southampton have separately undertaken fieldwork at Greenham Common. There is considerable literature about the site. For example, John Schofield and Mike Anderton, 'The queer archaeology of Green Gate: Interpreting contested space at Greenham Common Airbase', World Archaeology, 32 (2), pp.236–251.

[29] See for example the work of The Common Ground Research Group, which aims to produce materials reflective of its diverse composition: archaeological reports, site map, artefact analyses, interviews and analysis, photographs, videos and other artistic components.

Plastic poppies on a
commemorative stone in
Gallipoli, Turkey. Despite its
ancient association with opium
and forgetfulness, the flower is
now widely regarded as the most
enduring symbol of remembrance.
Poppies were often the first flowers
to grow on the broken soil of
soldiers' graves behind the
trenches of the Western Front

The formal ideas boiled down to a single proposal: a small memorial garden to be planted at the entrance to what is now the business park occupying the southern edge of the common. Looking more 'corporate' than had been originally envisaged, the garden was realised by former protesters who raised over £20,000 (including a substantial contribution from Yoko Ono) to create and plant the plot. It has two sculptures and a planting scheme derived from the conventional arboculture of peace and protest. A modest, informal and low maintenance scheme of highly scented and light-coloured flowers. A ring of seven rough-hewn boulders were brought from south Wales—the home of the first protesters—and one of the metal sculptures is designed to recall the camp fires that burned for over twenty years. Underneath the calm atmosphere, there is some residual anger, which is unusual for a garden dedicated to peace but is perhaps less so for a garden that commemorates an unrequited campaign. This emotion is summarised in the words carved into a stone and steel spiral form, which acts as a water fountain: 'Women's Peace Camp 1981–2000. You can't kill the Spirit'.

At its inauguration, one of the original protesters expressed a hope that the garden, unlike the activists, would be 'adopted' by the citizens of the nearby town:

> This (garden) is gifted to the people of Newbury. I don't want it sitting there doing nothing. I want people, when they drive past, to go in and sit and dwell on what it means. [30]

(30)
Former resident of the peace camp, *Newbury Weekly News*, 18 October 2002.

The historic intervention at Greenham is now enshrined in a semi-formal official garden but the notion of guerrilla gardening has gained wide currency in southern England and is derived largely from precedents in North America. In 2006, newspaper columnists applauded moonlight gardeners who have been 'titivating' roundabouts and roadside verges in south London with shrubs, bulbs and other unplanned regenerative acts. At the same time, artists such as Tania Kovats and Cornelia Parker were creating transient and mobile green spaces that could be imported into sites of urban blight. Kovats transported a floating wildlife meadow atop a barge from Bath to London via the existing canals and industrial inland waterways. In mid-June 2006, it passed within a few miles of the Greenham peace garden.

By creating these miniature *rus in urbe*, we may be seeing another phase in the evolution of the polemic garden; a process in which guerrilla gardening has become adopted as urban pastoral, a form of 'vandalising with plants' achieved in the dead of the night, as the *Daily Mail* reported (without apparent irony) by 'comrades in trowels'.[31] Further, British archaeology has observed an upsurge of enthusiasm for the recent and contemporary past. In the past decade, the traditional boundaries of academic and professional archaeology have been extended, subject to critique and made popular through prime-time television and other forms of broadcast. Organisations such as English Heritage have embraced new approaches to promote our understanding of the time-depth of contemporary and late twentieth century landscapes— its so-called 'stratigraphy'—and are now actively reviewing how we value the heritage of the recent past.[32] Military (and militarised) landscapes have been freshly revealed through this process. Once hidden and secretive spaces (such as Greenham Common) are now subject to pioneering trans-disciplinary study that aims to understand the diversity and complexity of similar politicised domains. The GLC peace gardens lend themselves to this form of trans-disciplinary study, whereby archaeologists, artists and cultural geographers can work together to re-examine and re-invigorate the legacies of a contested space in the material city.[33] As the recent past is revisited (even reactivated), urban garden organisations such as the Groundwork Trust are working to replenish the green spaces of inner cities through renewed community engagement and multiple funding agencies. The future of such once-polemic landscapes as Maygrove and the Noel-Baker Garden may be more promising than it has been for three decades. However, it is likely to be a future that strips the gardens of its political roots, rejects their mnemonic potential and consigns their evocative and unique origins to little more than a footnote in English garden heritage.

(31)
Robert Hardman, 'Guerilla Gardeners', *Daily Mail*, 23 March 2006.

(32)
A Bradley, V. Buchli, G. Fairclough, D. Hicks, J. Miller and J. Schofield, *Change and Creation: Historic Landscape Characterisation 1950–2000*. London: English Heritage, 2004.

(33)
'Historic landscape characterization' is a method for providing a high-level understanding of the time-depth of a given landscape, in an effort to understand the 'broad manifestations of human activity and history that give context to individual sites'.

This book would not have been possible without the enthusiastic collaboration of a great many individuals and organisations in the UK, Europe and Australia. I would like to thank in particular the Bowen Street Press editorial team: Tracy O'Shaughnessy, Justina Ashman, Carina Beyer, Madelaine Geary, Alexandra Milne, Lauren Carta and Ben Callinan, and the designer Kit Tran. I am also indebted to the contribution of Valerie McLeod, Ivan Eastwood and Harry Gough.

I would like to acknowledge the galleries, libraries, museums and private collectors whose works are reproduced with permissions in this book and are credited throughout, in particular the Australian War Memorial, the Bridgeman Art Library, the Behrend Collection at the National Trust, Tate Galleries, Imperial War Museum London and the Stanley Spencer Gallery Cookham. I respectfully acknowledge the organisations who supported the research in this book and staged the events, exhibitions and symposia through which the research was disseminated: the British Council; UK Arts and Humanities Research Council; Australian Research Council; Royal British Legion; National Memorial Arboretum, Alrewas, central England; In Flanders Field Museum, Ypres, Belgium; Canadian War Memorial, Ottawa; Cannakale University, Turkey; Te Papa Museum in Wellington, New Zealand; Carleton University, Ottawa, and Queen's University, Kingston, Canada; Centre for Death and Society, Bath; Conflict, Memory and Material Culture, at University College London and the Imperial War Museum, London; Public History Now, Ruskin College, Oxford; Group for War and Culture Studies Westminster University and the Program Office, European Operations, Strategic Policy and Commemoration, Veterans Affairs Canada, Government of Canada.

My love as ever to Kathleen, Rachel, Harry and Izzy.

INTRODUCTION

p.1 Paul Nash, *After the Battle*, 1918, watercolour and ink on paper, 71.2 × 83.2 cm © Imperial War Museums (IWM: ART 2706).

pp.4–5 Muirhead Bone, *The Chateau, Foucaucourt*, 1918, lithograph on paper, 50.5 × 37.8 cm © Imperial War Museums (IWM: ART 68448).

p.6 Muirhead Bone, *The Battle of the Somme*, 1918, lithograph on paper, 50.5 × 37.8 cm © Imperial War Museums (IWM: ART 6844).

p.8 C.R.W. Nevinson, *La Mitrailleuse*, 1915, oil on canvas, 77.7 × 67 cm © Tate, London 2018.

p.11 C.R.W. Nevinson, *Study for Returning to the Trenches*, 1914–1915, charcoal and crayon on paper, 14.6 × 20.6 cm © Tate, London 2018.

pp.16–17 Robert Perry, *Beaumont Hamel Memorial Park from Thiepval Ridge, 5.45 pm, 20 February 2000*, gouache on paper, 29.7 × 42 cm, Artist's Collection.

MYTHICAL PLACES

p.21 'The Sphinx' seen from North Beach, Anzac Cove, the Dardanelles Peninsula, Gallipoli/Gelibolu, Turkey © Paul Gough.

p.23 W. Cecil Dunford, *Delville Wood*, c.1916, etching, 12 × 16 cm, Private Collection.

p.24 John B. Morrall, *The Abomination of Desolation*, c.1916, watercolour on paper, 8 × 10.5 cm © Imperial War Museums (IWM: ART 202).

p.26 Edward Handley-Read, *Mametz: A Garden*, c.1916, charcoal and watercolour on paper, 31.1 × 47.6 cm, Private Collection.

p.31 Frank Hurley, *A 'Hop Over'*, c.1918, composite photograph © Australian War Memorial E05988B.

pp.34–35 Frank Hurley, *Supporting Troops of the 1st Australian Division Walking on a Duckboard Track near Hooge*, 1917, silver gelatin photograph, 14 × 19 cm © Australian War Memorial E00833.

p.36 Frank Hurley, *An Advanced Aid Post*, 1917, composite photograph © Australian War Memorial E01202A.

p.38 (TOP) Ellis Silas, *The Waterhole*, 1915, ink on paper, page from sketchbook sketch from 'Crusading at ANZAC. AD 1915' © Australian War Memorial.

p.38 (LEFT) Ellis Silas, *Dead Man's Patch*, 1915, ink on paper, page from sketchbook sketch from 'Crusading at ANZAC. AD 1915' © Australian War Memorial.

p.38 (RIGHT) Ellis Silas, *The Snipers*, 1915, ink on paper, page from sketchbook sketch from 'Crusading at ANZAC. AD 1915' © Australian War Memorial.

pp.42–43 Sidney Nolan, *Drowned Soldier at Anzac as Icarus*, 1958, textile dye, sgraffito, coloured crayon on coated paper, 25.4 × 30.4 cm © Australian War Memorial ART91309.

p.44 Sidney Nolan, *Gallipoli Landscape*, c.1961, textile dye, wax on coated paper, 25.4 × 30.4 cm © Australian War Memorial ART91235

'RIDICULOUS MAD INCONGRUITY!'

p.51 Paul Nash, *Wire*, 1918, watercolour, chalk and ink on paper, 72.8 × 85.8 cm © Imperial War Museums (IWM: ART 2705).

p.54 (TOP) Paul Nash, *We Are Making a New World*, 1918, oil on canvas, 71.1 × 91.4 cm © Imperial War Museums (IWM: ART 1146).

p.54 (BOTTOM) Paul Nash, *The Menin Road*, 1919, oil on canvas, 182.8 × 317.5 cm © Imperial War Museums (IWM: ART 2242).

pp.60–61 Gail Ritchie, *Memorial Series*, 2009, red ink on gridded paper, each sheet 29.7 × 21 cm, Artist's Collection.

pp.62–63 Gail Ritchie, *Somme Poppy Series*, 2009, watercolour on paper, 30 × 20 cm, Artist's Collection.

p.66 Gail Ritchie, *Tree Ring Series*, 2009, pencil and engraving on paper, 40 × 100 cm, Artist's Collection.

p.67 Gail Ritchie, *Tree Ring 37*, 2009, pencil and engraving on paper, 30 × 30 cm, Artist's Collection.

p.70 Julian Perry, *Rocket Crater Pond in Snow II*, 2004, oil on panel, 122.5 × 215 cm, Artist's Collection.

p.72 Julian Perry, *Coppicing for Nightingales*, 2000, oil on panel, 122.5 × 215 cm, Artist's Collection.

p.73 Julian Perry, *Long Running*, 2004, oil on panel, 122.5 × 158 cm, Artist's Collection.

p.75 (TOP) Robert Perry, *Lamp-lit Trenches, Aveluy Wood, moonrise, 8.35 pm 18 February 2000*, 2000, charcoal and ink on paper, 29.7 × 42 cm, Artist's Collection.

p.75 (BOTTOM) Robert Perry, *Trenches in Aveluy Wood (Part A) 4.30 pm, 5 February 2000*, 2000, oil on board, 84.1 × 118.9 cm, Artist's Collection.

p.77 Keith Henderson, *Study of a Shell Burst*, 1917, charcoal on paper, 17.7 × 32.3 cm © Imperial War Museums (IWM: ART 245).

p.80 Paul Nash, *The Mule Track*, 1918, oil on canvas, 60.9 × 91.4 cm © Imperial War Museums (IWM: ART 1153).

THE LIVING, THE DEAD

p.83 C.R.W. Nevinson, *Paths of Glory*, 1917, oil on canvas, 45.7 × 60.9 cm © Imperial War Museums (IWM: ART 518).

p.87 William Orpen, *A Trench, Beaumont Hamel*, 1917, pencil on paper, 41.9 × 53.3 cm © Imperial War Museums (IWM: ART 2393).

p.93 (TOP) C.R.W. Nevinson, *Swooping Down on a Taube*, 1917, lithograph on paper, 40.1 × 29.8 cm © National Gallery of Victoria, Melbourne (NGV 943-4) Plate 42 from the Building aircraft set, in *The Great War: Britain's Efforts and Ideals* series, commissioned by the British Department of Information; published by the Fine Arts Society, London, 1917.

p.93 (BOTTOM) Tyne Cot Commonwealth War Graves Cemetery, Passchendale near Zonnebeke, Ypres Salient © Paul Gough.

p.97 Adrian Hill, *The Interior of a Dug-out: Gavrelle*, 1917, ink, wash on paper, 30.4 × 43.1 cm © Imperial War Museums (IWM: ART 342).p.100 Will Dyson, *The Dynamo. Hill 60. Lighting the Tunnels*, 1917, lithograph, black ink on white laid Arnold paper, 39.2 × 55.2 cm © Australian War Memorial 02209.

pp.102–103 Will Longstaff, *Menin Gate at Midnight*, 1927, oil on canvas, 137 × 270 cm © Australian War Memorial 08907.

p.105 The Beaufort War Hospital, Fishponds, Bristol – c.1916, Author's Collection.

p.105 (BOTTOM) The Sandham Memorial Chapel, Burghclere, Hampshire. Architect Lionel G. Pearson © Paul Gough.

p.106 Stanley Spencer, *The Resurrection of the Soldiers*, The Sandham Memorial Chapel, Author's Collection.

p.110 Stanley Spencer, *The Resurrection of the Soldiers*, (detail of the upper sections), The Sandham Memorial Chapel, 1928–29, National Trust / Estate of Stanley Spencer.

p.111 Stanley Spencer, *The Resurrection of the Soldiers*, (detail of the figures behind the altar), The Sandham Memorial Chapel, Author's Collection..

'TURF WARS'

p.115 Broken ground: fragment of a battlefield of the Great War © Paul Gough.

pp.118–119 Tyne Cot Commonwealth War Graves Cemetery, Passchendale, near Zonnebeke, Ypres Salient, Ministry of Defence, UK.

p.122 Plugges Plateau Commonwealth War Graves Cemetery, Gallipoli, Turkey © Paul Gough.

p.124 Maintained lawn, Gordon Dump Commonwealth War Graves Cemetery, Ovillers-La Boiselle, the Somme, France © Paul Gough.

pp.128–129 Sarigol Commonwealth War Graves Cemetery, Kriston, Macedonia, Greece © Paul Gough.

p.134 Railway Chateau, Commonwealth War Graves Cemetery near Ypres, West Flanders, Belgium © Paul Gough.

p.135 Railway Chateau, Commonwealth War Graves Cemetery near Ypres, West Flanders, Belgium.

'CONTESTED MEMORIES: CONTESTED SITE'

p.139 Tyne Cot Blockhouse, Tyne Cot, Commonwealth War Graves Cemetery, Zonnebeke, Ypres Salient, Belgium © Paul Gough.

p.144 Relics and refuse of battle, Ypres Salient, Belgium © Paul Gough.

pp.146–147 Aerial view of the Beaumont Hamel Memorial showing the orientation of the British, Allied and German trenches. Photograph courtesy of Veterans Affairs Canada/Anciens Combattants Canada.

p.148 Aerial view of the Beaumont Hamel Memorial showing the Caribou Monument and the orientation of the frontline trenches and cemeteries. Photograph courtesy of Veterans Affairs Canada/Anciens Combattants Canada.

pp.154–155 The Caribou designed by Basil Gotto, 1924–25, Beaumont Hamel Memorial. Photograph courtesy of Veterans Affairs Canada/Anciens Combattants Canada.

p.159 The 'Danger Tree', Beaumont Hamel Memorial. Photograph courtesy of Veterans Affairs Canada/Anciens Combattants Canada.

COMMEMORATION OF WAR AND PEACE

p.163 Roses and headstones, Tyne Cot Commonwealth War Graves Cemetery, Zonnebeke, Ypres Salient, Belgium © Paul Gough.

p.165 Adrian Hill, *The Menin Road* 1918 and *The Menin Gate* 1928, published in Answers, 1928, Author's Collection.

p.168 The Cross of Sacrifice, designed by Reginald Blomfield, Commonwealth War Graves Commission © Paul Gough.

pp.172–173 National Memorial Arboretum, Alrewas, Staffordshire, central England © Paul Gough © Paul Gough.

p.175 The Menin Gate, designed by Reginald Blomfield, Commonwealth War Graves Commission, Ypres, Belgium © Paul Gough.

p.178 (TOP) Headstones, Commonwealth War Graves Commission, Ypres Salient, Belgium © Paul Gough.

p.178 (BOTTOM) Ataturk Memorial, with words attributed to Mustafa Kemal Ataturk, Anzac Cove, Ariburnu, Canakkale battlefield, Gallipoli historical area, Turkey.

p.182 *Reflecting Absence*, architect Michael Arad and landscape architect Peter Walker, The National September 11 Memorial, Westfield World Trade Center, New York, USA © Paul Gough.

PEACE IN RUINS

p.187 White rose at *Reflecting Absence*, the 9/11 Memorial & Museum © Paul Gough.

p.190 Visitors reading the register in one of the Commonwealth War Graves Commission cemeteries in northern Europe © Paul Gough.

p.191 The Statue of Liberty in Upper New York Bay © Paul Gough.

p.194 (TOP) A tree 'available for dedication' at the National Memorial Arboretum in Staffordshire, UK © Paul Gough.

p.194 (BOTTOM) *The Survivor Tree*, at the site of the 9/11 Memorial & Museum © Paul Gough.

pp.198–199 Sunset over Ypres, Belgium © Paul Gough.

p.205 Plastic poppies on a commemorative stone in Gallipoli, Turkey © Paul Gough.

Bolded entries indicate images.